IMAGES
of America

BROAD CHANNEL

IMAGES
of America

BROAD CHANNEL

Liz Guarino and Dan Guarino
for the Broad Channel Historical Society

ARCADIA
PUBLISHING

Published by Arcadia Publishing
Charleston SC, Chicago IL, Portsmouth NH, San Francisco CA

Library of Congress Catalog Card Number: 2007930184

For all general information contact Arcadia Publishing at:
Telephone 843-853-2070
Fax 843-853-0044
E-mail sales@arcadiapublishing.com
For customer service and orders:
Toll-Free 1-888-313-2665

Visit us on the Internet at www.arcadiapublishing.com

Dedicated to the people of Broad Channel—past, present and future.

CONTENTS

ACKNOWLEDGMENTS

The production of this book required the willing help of many people, with our gratitude to all of them. First thanks to editor Erin Vosgien, who kept the book project on track. Many thanks to the Broad Channel Historical Society which supplied most of the photographs used in this book. Thanks also to society members who plumbed their memories and lent us the historical collection they donated to the Broad Channel Library for facts about yesteryear for us relative newcomers to the community. Many thanks also to individuals like Mario Cina, who—not knowing either of us—entrusted us with precious photographs. Thanks also go to all who pored over their family albums' treasured photographs and lent them to us for this book. We are grateful, too, for those who shared their knowledge of past events and, in some cases, their beautiful memories of days gone by; they have been included where possible. Thank you to people like James J. Ferchland and Ed Wilmarth III, Board Channel Volunteer Fire Department (BCVFD) historian, for providing answers to innumerable questions. To storytellers like Joe Carey who are Broad Channel's living history, we are grateful to have heard your tales and learned from them. Thanks go to Dan Mundy, who helped us in so many different ways, even though we pulled him in at the last minute. Thank you to John Hyslop and to the Queens Borough Public Library for their generous donation of photographs from their archives in the Long Island Division. Also thanks go to the special assistance of Carey Stumm and Laura Rosen of the Metropolitan Transit Authority's archives.

Our biggest thanks go to Barbara Toborg, chairwoman of the Broad Channel Historical Society and our friend of many years. Her dedication, knowledge, support, and assistance to this book are unparalleled. Without her able assistance, and help from everyone else, this book would not have come to fruition.

INTRODUCTION

A Brief History of the Community of Broad Channel states that, "first came the fishermen, then the Rail Road, the hotels, the entrepreneurs, the families." Fishing and crabbing in the waterway shown on navigational maps as "Broad Channel" must have been good since even before the construction of the railroad in 1879 fishing shacks were noted in this area of Jamaica Bay. A year later, the New York, Woodhaven and Rockaway Beach Railroad began service, and Broad Channel became a stop in 1881. A cluster of hotels developed at the station, catering to the anglers and families out for a good Sunday dinner and escape from the heat of summer in the city. Shops and houses were soon to follow. Notable hotels were the Enterprise, Delevan House, and the Atlantic. By 1914, New York City's Department of Docks listed almost 400 leases, including 27 fishing clubs, such as the Broad Channel Yacht Club, Egg Harbor Yacht Club, Anabas Boat Club, and Iroquois Yacht Club, the latter two organizations flourishing to the present time.

The new community's hub was the railroad station, the line having been taken over by the Long Island Railroad. The town was growing, and in 1915, Pierre Noel, for whom Noel Road would be named, leased all of Big Egg Marsh from the city and two years later assigned the lease to the Broad Channel Corporation of which he was president. It was full steam ahead for Broad Channel. The corporation laid out streets, erected boardwalks, filled in marshland, laid water mains, installed fire hydrants, dug a 720-foot well, and built a power house to generate electricity. The lighting would flicker at an appointed hour to signal the end of power for the day and the need to switch to lamplight. The well and the power plant were appropriately located on Power Road, the site today of public school 47. A series of slips, or canals, was created on the west side of town and the dredged sand used to fill in Jamaica Bay Boulevard, later to be known as Cross Bay Boulevard. Realtor Marcel Peysson built several dozen bungalows which could be rented for $50 per year or purchased for $375. As the Broad Channel Corporation brochure put it, Broad Channel "offers you all the fun and healthful outdoor life that the blue bloods spend thousands to enjoy." While often thought of as a summer colony or vacation spot, Broad Channel actually had about 25 families in the 1920s living here year round.

A flair for organization, camaraderie, and perseverance are traits that can easily be ascribed to residents of the "Channel," as the community is often called today. Early on, the volunteer fire association was established, with all able-bodied men expected to join. The biggest threat to a community of wooden houses with no municipal water supply was fire. Their firehouse was completed in 1908. To raise money to build that house and to purchase equipment, the "vollies" initiated the tradition of holding a Mardi Gras, not to mark the beginning of Lent, but to mark the end of summer; many residents did not remain year round.

The next order of business was establishment of schools, houses of worship, and a civic association. A dance hall that floated from neighboring Goose Creek became Public School 47 on Noel Road. Until the churches were built in the 1920s, Catholics attended mass in private homes or at Hoob's Pavilion. Sunday school was held at Marcel Peysson's open-air moviedrome prior to the building of the Protestant church that would eventually become Christ Presbyterian Church by-the-Sea. Not surprisingly, separate clubhouses sprang up for Democrats and Republicans. The Broad Channel Civic Association was not far behind; it meets today in the former Democratic Clubhouse.

The social life in Broad Channel was brisk. Dance cards testify to the "Mid-Summer Festival," "Summer Night's Reception," and the "First Annual Ball of the Broad Channel Ice Handlers." Add to these events sponsored by the yacht and boat clubs, the German Club, and other social organizations such as the Circle of Foresters, it's easy to conclude that Channelites loved to party.

By 1929, progress included bridges to the mainland and the Rockaway Peninsula, as well as the connecting roadway first known as Jamaica Bay Boulevard (later Cross Bay Boulevard). These improvements provided increased access to Broad Channel, especially for those during Prohibition who wanted to frequent the many drinking establishments that gave rise to a nickname for the town, i.e., Little Cuba. Legend has it that one speakeasy would be designated to take the fall each time a revenuer came to town to search for illegal liquor. Other visitors included Mae West and Jimmy Durante, who performed at Hermit's Café.

Other amenities included O'Sullivan's Pharmacy and the Broad Channel Bathing Park, complete with two pools, 16 handball courts, tennis courts, a restaurant, and a ball field. St. Virgilius Parochial School graduated its first class in 1927. By 1928, St. Virgilius Dramatic Society put on the "Bay Breezes Minstrel Show," one of many entertainments in the town. St. Patrick's Day shows would showcase local talent for many years to come.

The 1930s would witness the formation of a Red Cross Auxiliary, a Boy Scout Troop, and establishments such as Weiss' Restaurant and Smitty's Boat Rental that would become synonymous with Broad Channel. The Cardinals baseball team and the Broad Channel Nut Club, a sports group whose members chose to be known as the nut of their choice, started a tradition of organized sports that no doubt influenced formation of the Broad Channel Athletic Club (BCAC) in later years. In 1939, the Broad Channel Corporation leases were taken over by New York City. The "perseverance" trait would soon come to the fore.

During the 1940s, with the population of Broad Channel around 5,200, Channelites not only had to fight a war abroad, but also battle New York City to extend their five year leases. Some organized air raid wardens, while others marched on city hall to defeat the city's proposal not to renew any more leases. Service men and women wrote letters to their public officials wondering what they were fighting for, if not to be able to return to the home they left. After the war, Broad Channel–born attorney Eugene Powers failed in his attempt to buy the land from the city and resell it to the occupants of Broad Channel.

Succeeding years would witness the feisty residents of Broad Channel thwart a variety of schemes by the city to do away with the town, affectionately known as a "poor man's paradise" and the "Venice of New York," after the canals constructed on the west side. But neither an alleged hepatitis scare nor a plan to extend runways at JFK International Airport in the 1960s, nor an earlier proposal by Robert Moses to subsume the land in Broad Channel into a mini Jones Beach–type park succeeded in the town's demise.

In the 1950s, the Long Island Railroad trestle burned for the last time. It had been plagued by interruption of service over the years by fire and the havoc that ice in the bay worked on the miles of open trestle. The line was transformed into a subway line by the New York City Transit Authority, when it struck a deal with parks commissioner Robert Moses to lay the tracks on fill dredged from the bay and implement the creation of two enclosed ponds. These brackish ponds would become the east and west ponds of the Jamaica Bay Wildlife Refuge. later to be incorporated into Gateway National Recreation Area, a part of the National Park Service.

Driving the first subway train to traverse the new line across Jamaica Bay in 1956 was none other than Broad Channel resident Joe Carey.

In the ongoing struggle for Broad Channel residents to buy their land, organization and hard work by the community finally paid off in 1982 when the administration of then Mayor Ed Koch concluded successful negotiations with a united Broad Channel. Amenities taken for granted by other communities would now flow to Broad Channel—a sewer system, a library, parks, and a new Public School 47. The 2000 census put the population of Broad Channel at 2,630 with 1,019 housing units. More than half of the housing units were built before 1939.

If a coat of arms would ever be devised for families in Broad Channel, a pair of boots or waders would be very apt, for "wellies" and waders come in handy during an exceptionally high tide, a nor'easter, or a hurricane. Times of high tide are carefully noted in a community with an average elevation of three feet, with some areas of town actually below sea level. While the community sustained much damage during hurricanes in 1938 and 1944, it was the nor'easter of 1992 that old timers describe as the storm of the century.

Another emblem on the coat of arms would be the American flag. The town has sent its youth to war and welcomed them home, continues to hold parades and services on Memorial Day and Veterans Day, and fly the flag all year round. Events are promoted by the Veterans of Foreign War (VFW) and the American Legion.

In September 2001, residents gazed in horror across the water at the column of smoke clearly seen billowing from the World Trade Center in Manhattan. Firemen, police, and emergency service personnel living in Broad Channel rushed to the World Trade Center, some by private boat. One of the town's ambulances was destroyed when the towers collapsed. The town mourned the great loss of life, including that of a resident and two former residents.

The foregoing history covers only the bare bones of the growth of a vibrant American community. The authors and the Broad Channel Historical Society hope that this book will whet the reader's appetite to learn more about Broad Channel. The Broad Channel branch of the Queens Borough Public Library houses the Broad Channel Historical Collection where readers can peruse many first hand accounts of living in Broad Channel over the years.

—Barbara Toborg, chairwoman of the Broad Channel Historical Society

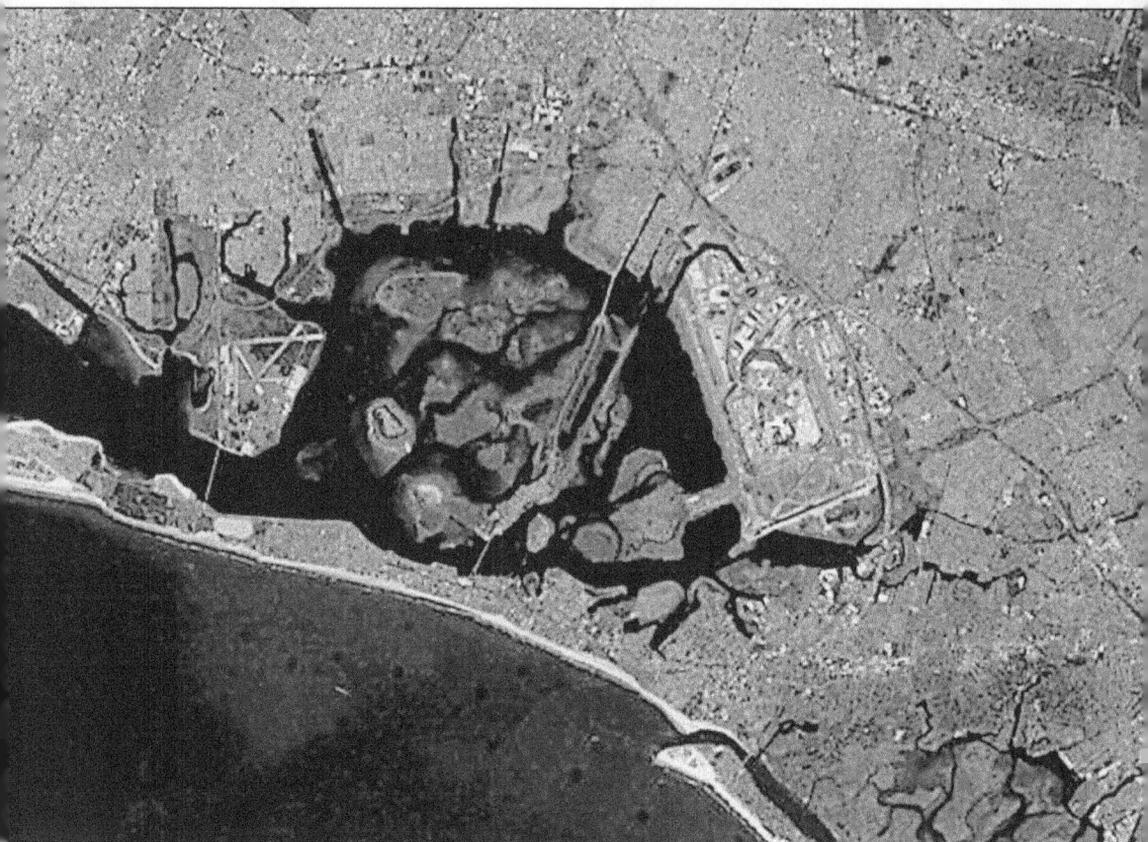

This 2003 photograph of Jamaica Bay from a satellite shows Broad Channel in the center. The island is connected to adjacent land masses by what looks like two taut cords; this is the Crosssbay Boulevard roadway, which leads to two different bridges. North of the island community is the Joseph P. Addabbo Bridge (this replaced the older North Channel Bridge), which connects it to Howard Beach. South of the community is the longer of the two "cords," Cross Bay Veterans Memorial Bridge, which connects the community with the Rockaway Peninsula. To the right of Broad Channel is John F. Kennedy International Airport. (Courtesy of NASA.)

One

WAY BACK WHEN
BROAD CHANNEL OF OLD

In this quiet residential neighborhood in Queens, New York, today, there is little trace of the vibrant Broad Channel past. Gone are the Enterprise and Atlantic Hotels with their interlacing boardwalks, Edward Schleuter's grand Delevan House, Hoob's Pavilion restaurant and dance hall, and the other notable buildings. Even the airstrip, grandly known as Jamaica Bay Airport, and the miniature golf course have faded into the foliage of the Jamaica Bay Wildlife Refuge.

From a group of island fishing stations to becoming a stop on the New York, Woodhaven and Rockaway Beach Railroad in the 1880s, to becoming in 1902 part of the newly incorporated Greater New York, or New York City as it is now known, Broad Channel has come a long way.

And yet, here and there, in a structural outline or in a familiar scene or place, yesterday reaches out to shake hands with today. The A&P and Bohack grocery stores, O'Sullivan's Pharmacy, and even Schmitt's Saloon might be gone, but their counterparts still do business today, often on the same streets and in the same buildings. The old Democratic Club is now the Veterans of Foreign Wars (VFW). In 1904, the train tracks, bridges, and trestles were leased to, and eventually bought by, the Long Island Railroad (LIRR). In the late 1950s, after much rebuilding, they became part of the New York City subway system. The "A" train runs along that route and over the same waters today.

Tides and time have come and gone, but this has not dulled the special affinity between Channelites and timeless Jamaica Bay. The boardwalk at East Twelfth Road still exists and goes out to houses on stilts stretched out over the bay. One now hosts the occasional art exhibition.

Noel, Walton, Shad Creek, Van Brunt, and Church Roads are all paved and sidewalk lined today, but they have seemingly not forgotten that beneath them lies their sandy beginnings and a living path to the past.

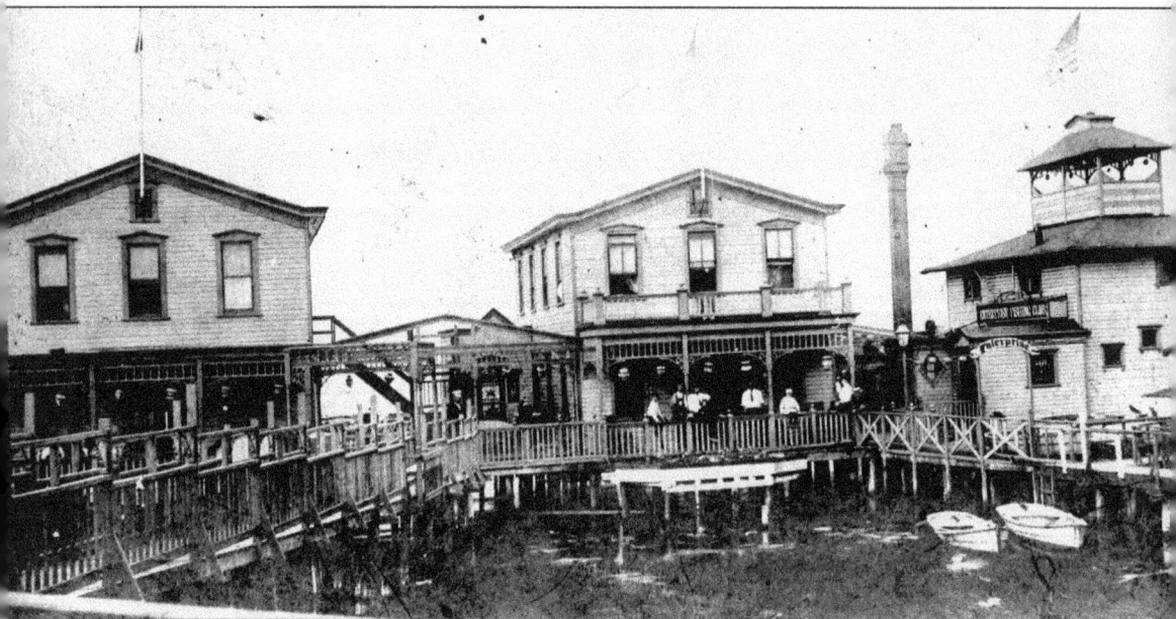

Located on the east side of the train tracks, these three buildings made up the Enterprise complex. Built as a fishermen's hotel, the Enterprise attracted the families with Sunday dinners. In this 1915 photograph the Enterprise boardwalk had a curved sign to greet guests overhead. The boardwalk on the left side of the photograph led from the train platform. The Enterprise was built by Eugene Bollerman after the Broad Channel LIRR station was constructed. (Courtesy of Frank Fischer, Joan Stemmler Christian, and the Broad Channel Historical Society.)

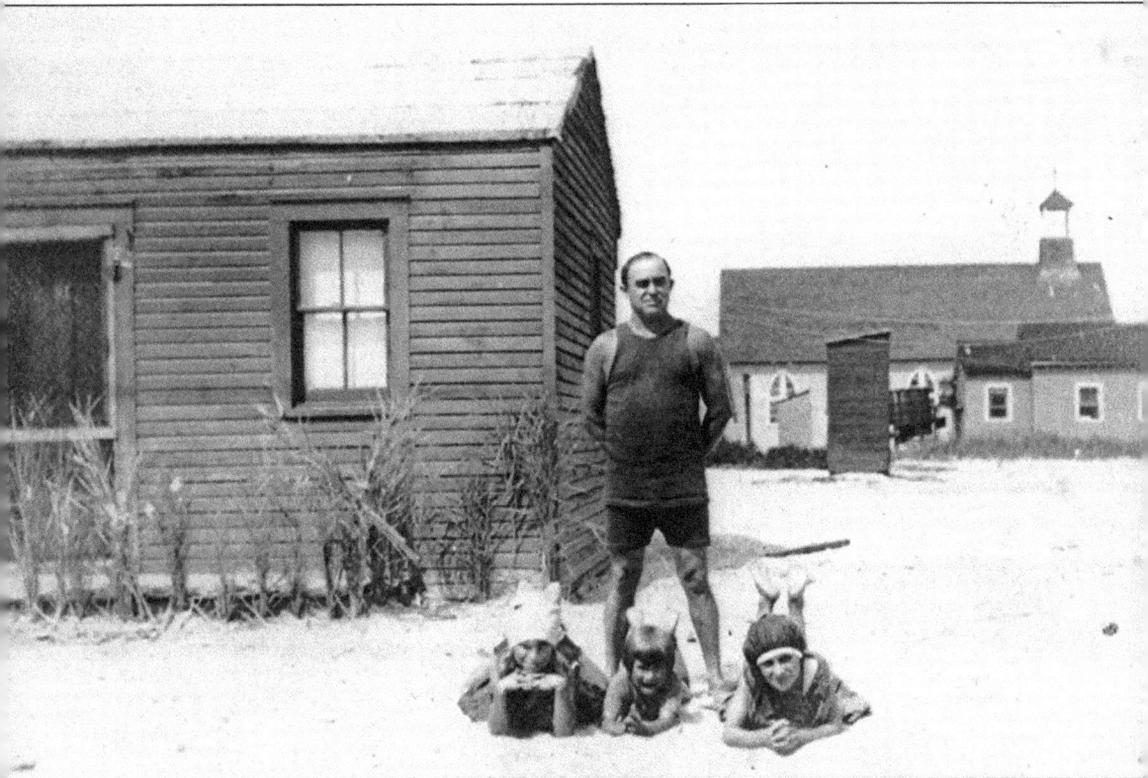

Daniel Powers stood over son Eugene (center) sprawled on Tenth Road beach. Eugene, who claimed to be the first child born on the island community, later opened a law practice on the island community. He also published the *Broad Channel Record*, a now defunct newspaper. He wrote a memoir in which he recalled being both a summer and later a year-round resident on the island. (Courtesy of Eugene Powers and the Broad Channel Historical Society.)

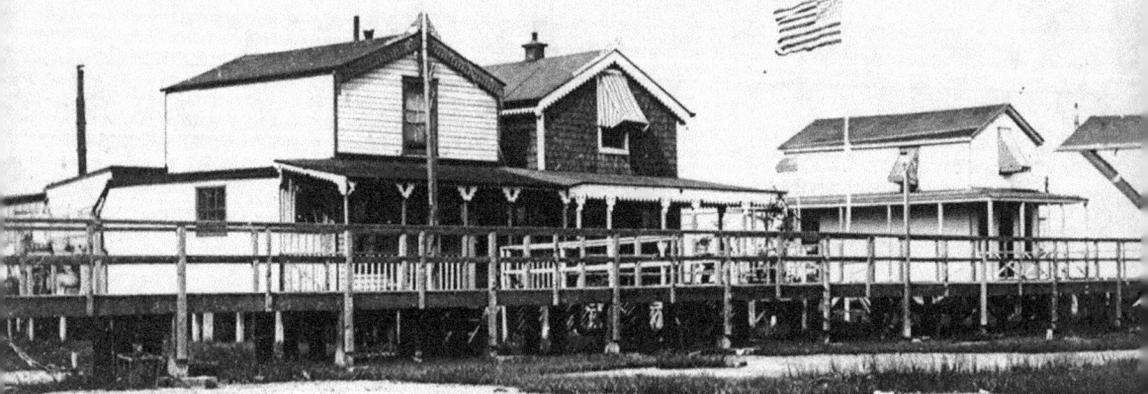

A wooden boardwalk stretched along the length of East Sixth Road. At high tide, it was impossible to get to the train station without it. Initially the boardwalk was three feet wide and later rebuilt to six, with all residents sharing construction costs. New residents were not allowed to break into the boardwalk, until they paid their share of expenses through an annual assessment. (Courtesy of Broad Channel Historical Society.)

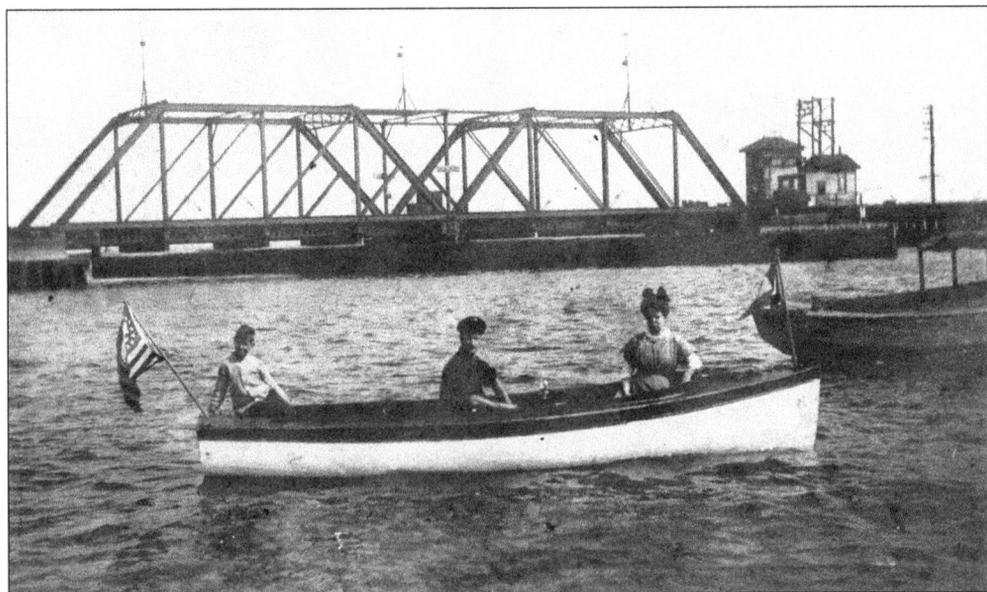

This 1915 photograph shows a family in a boat near the train trestle that sat over the Jamaica Bay waters which surround Broad Channel. This swing bridge pivoted in the center to accommodate boats wishing to access the bay waterway or bay channel from which Broad Channel drew its name. The LIRR stretched between the island community and the Rockaways to the south, Howard Beach to the north. The ability to reach the island by train spurred building and led to growth of the community. (Courtesy of Frank Fischer, Joan Stemmler Christian, and the Broad Channel Historical Society.)

The boardwalk in back of these Mardi Gras revelers sits on dry land. When heavy rains coincide with high tides during full moons, this street fills with water to this day. During these tides, it is not unusual to see a kayak or canoe being paddled up and down the water-filled street in the 21st century. (Courtesy of Jean Bohne Ryan and the Broad Channel Historical Society.)

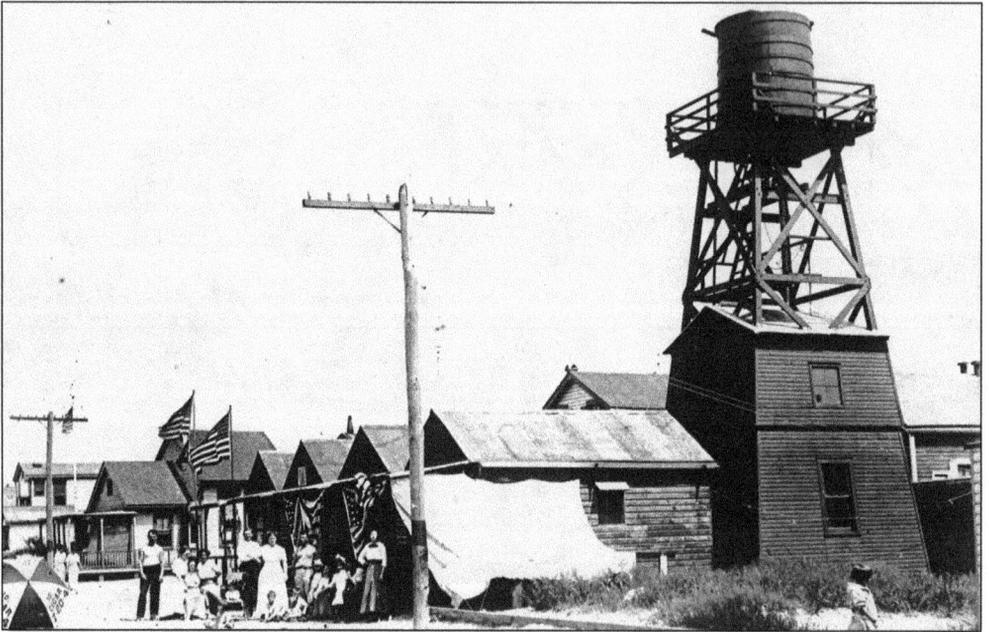

The water tower dwarfs the three one-story bungalows near it and was much taller than two-story homes. It stands high above the surrounding structures at public school 47 site in this *c.* 1918 photograph. A large umbrella advertises a five-cent cigar. People gathered in front of one-story bungalows, which are festooned with bunting. Varied hemline length was the norm in women's wear at this time. (Courtesy of Tim Tubridy.)

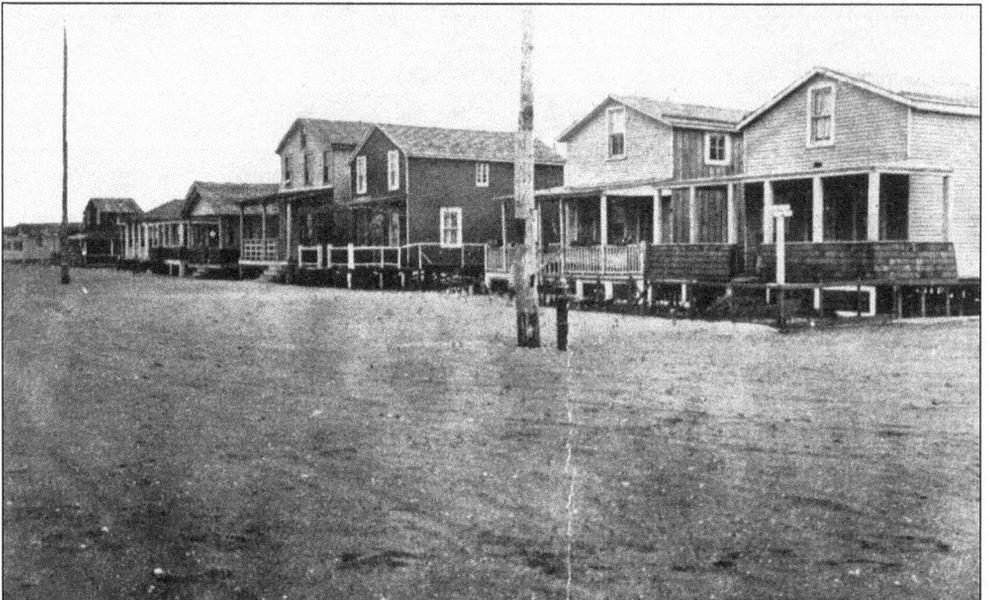

Homes on east side of Cross Bay Boulevard between Seventh and Noel Roads are shown, around 1923. Originally Cross Bay Boulevard was named Rockaway Boulevard, then named Jamaica Bay Boulevard. It runs north-south, roughly bisecting the island community. Cross Bay Boulevard was later paved with cobblestones called Belgian blocks. (Courtesy of Broad Channel Historical Society.)

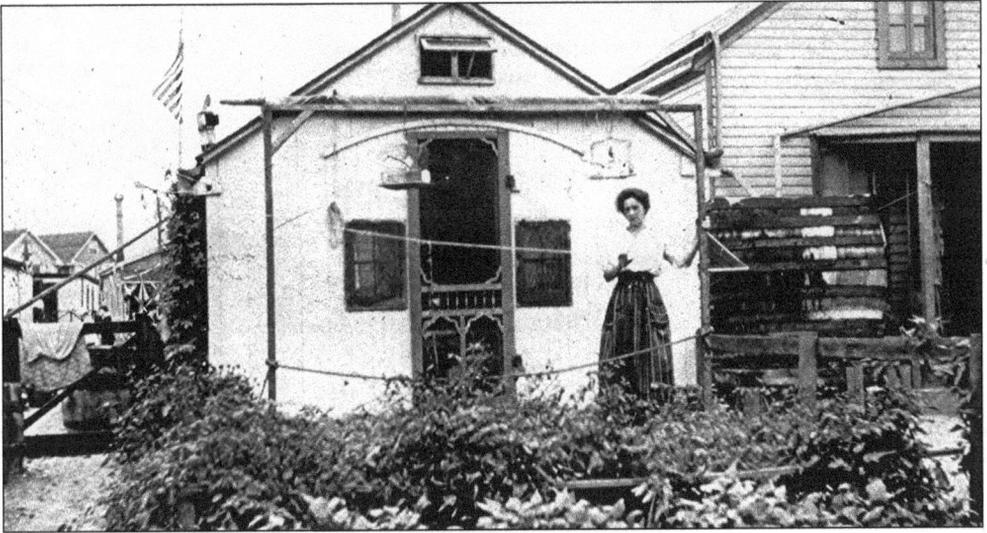

It was not unusual for summer residents to have vegetable and flower gardens like the one in the yard of this traditional bungalow in 1917. Here the lady of the house has her hand on one of the uprights that provides a framework for an awning, which was unrolled. (Courtesy of Stanley Reich and the Broad Channel Historical Society.)

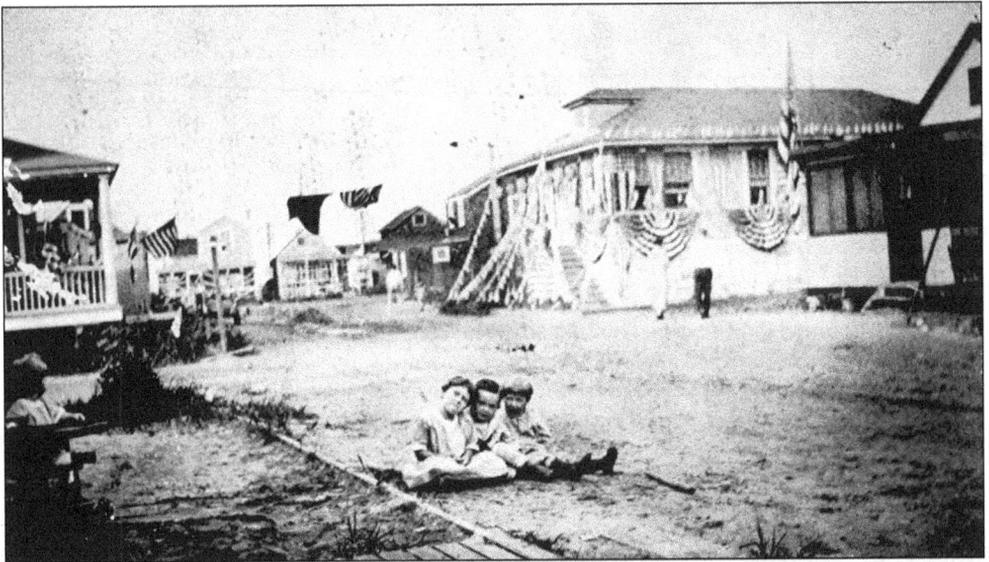

Children sit in the road before it was paved and sidewalks were installed. American flags and patriotic buntings on the house decorated it for the 1918 Mardi Gras. In the foreground, boards placed over bare ground made walking or using a pram or wagon easier, especially if the ground was wet. (Courtesy of the Theis family and the Broad Channel Historical Society.)

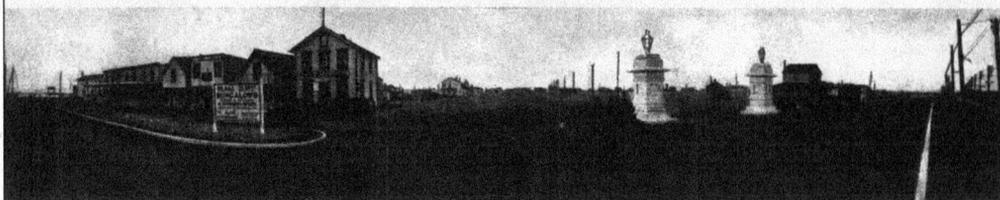

NEW YORK OFFICE
TELEPHONE 744 CORTLANDT

BROAD CHANNEL OFFICE
TELEPHONE 1616 HAMMELS

BROAD CHANNEL CORPORATION
31 NASSAU STREET
NEW YORK

RENTING AGENT

Broad Channel Beach, Station Plaza.

April 30, 1917.

Mr. Chas. A. King
649 Morgan Ave.
Brooklyn, N. Y.

Dear Sir:

Enclosed please find official green
receipt.

Will you kindly send by return mail
the temporary receipt Mr. Noel gave you yesterday,
and oblige

Very truly yours,

The Broad Channel Corporation (BCC) leased the community's land from the city. It issued its first land leases in 1916 at $30 per lot/per year for two years. One year later, it issued new leases at $50 per lot/per year. In this 1917 correspondence, Charles King received his permanent receipt. In a letter dated September 25, 1926, responding to a less than complimentary *New York Times* article, BCC president Pierre Noel writes, "We have spent in the one and a half years of our lease upward of $180,000 on the development and improvement of the place . . . filled in a vast area of white sand beaches, dug canals, laid out streets (and) provided clean water for bathing. We have now installed an electric plant and providing lighting to the streets." Deeming the original article to be "politically" motivated, Noel concludes, "We defy any investigation now to find 'a squalid collection of ancient shanties and sheds.'" (Courtesy of John McCambridge Jr. and the Broad Channel Historical Society.)

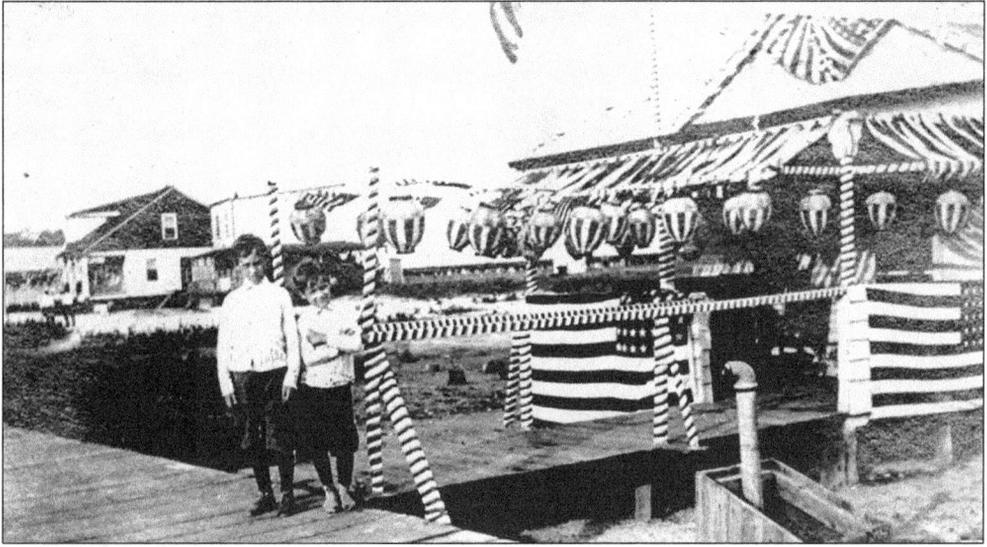

This highly decorated house was done up for the Broad Channel Mardi Gras in 1918. The design carried its handiwork beyond the house to the railings on its wooden boardwalk. (Courtesy of the Theis family and the Broad Channel Historical Society.)

A group of people displayed their finery and decorative jewelry for the camera in 1919. Note the wooden boardwalk, which was over water, beneath the people's feet. (Courtesy of the Theis family and the Broad Channel Historical Society.)

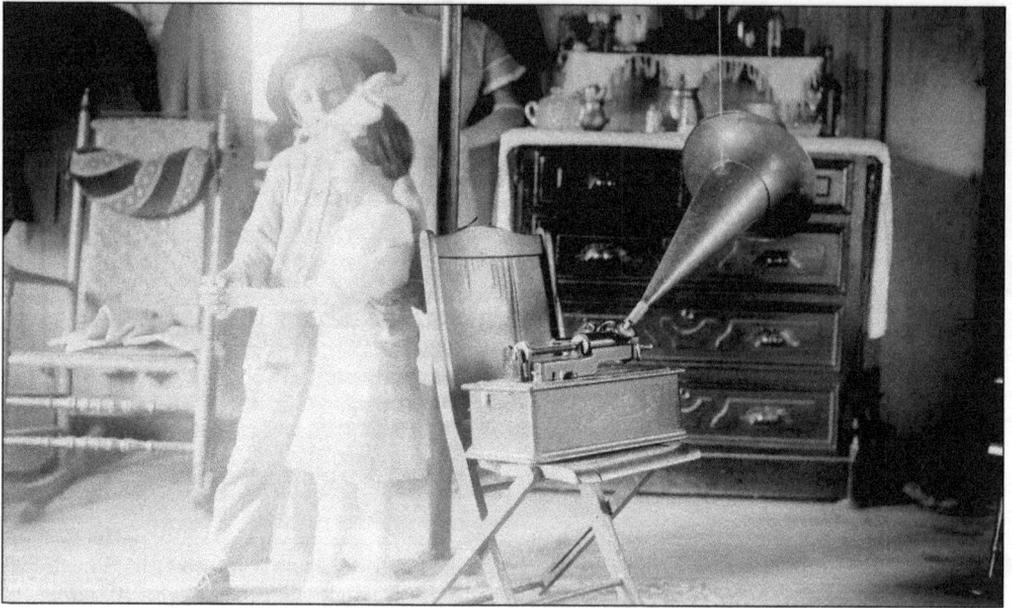

Featured in this photograph, titled "The Dance," is a cylinder player. Invented by Thomas Edison, it was the forerunner of the phonograph. Like the furniture and other amenities, it probably came in by boat. Bridges to the island had not yet been built. Very popular from 1888 to 1915, cylinder players like this one played two to four minutes of music recorded on a wax or hard plastic tube. Some models also allowed for home recording and also offered ear tubes for private listening. (Courtesy of Library of Congress.)

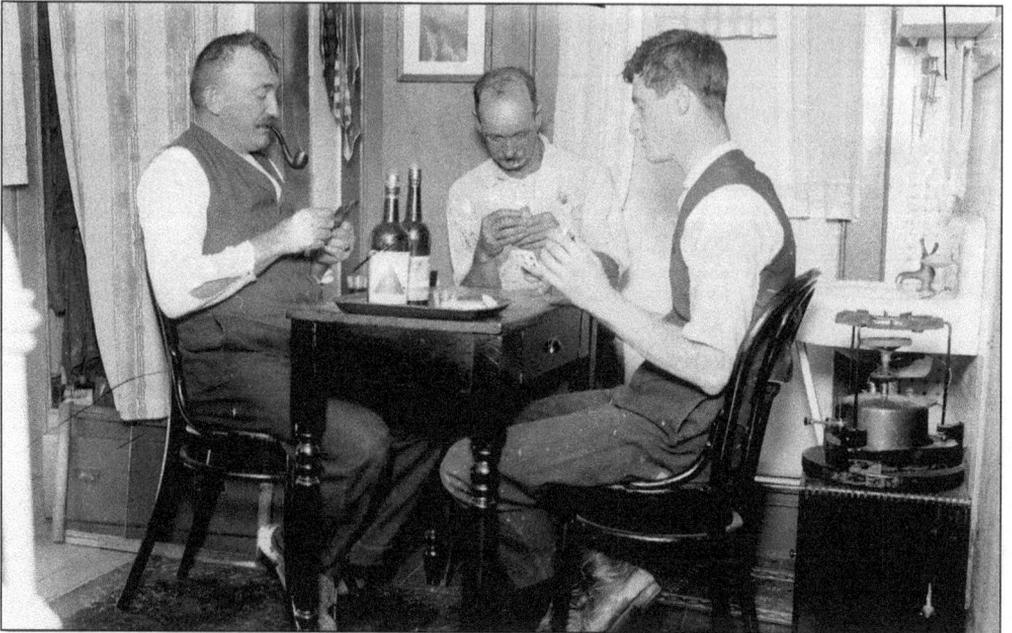

"A Card Game" shows Broad Channel working men enjoying the simple pleasures of a round of cards, a pipe, and liquid refreshment. The sink and shaving mirror in the same room indicate the sparse accommodations. The bottles of alcohol set out on the multipurpose table indicate that Prohibition would not be enacted for another four or five years. (Courtesy of Library of Congress.)

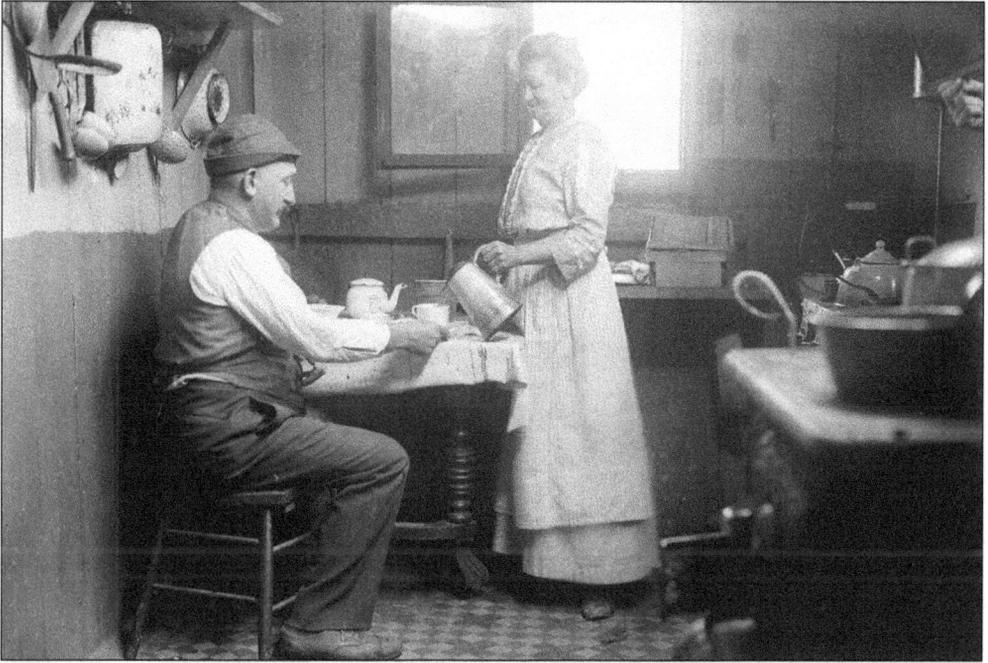

A simple kitchen and dining area is shown with a painted slat board construction. The sturdy stove at right burned wood or locally delivered coal. Today many residents depend on stoves adapted for propane, as Broad Channel has no gas lines running to it. (Courtesy of Library of Congress.)

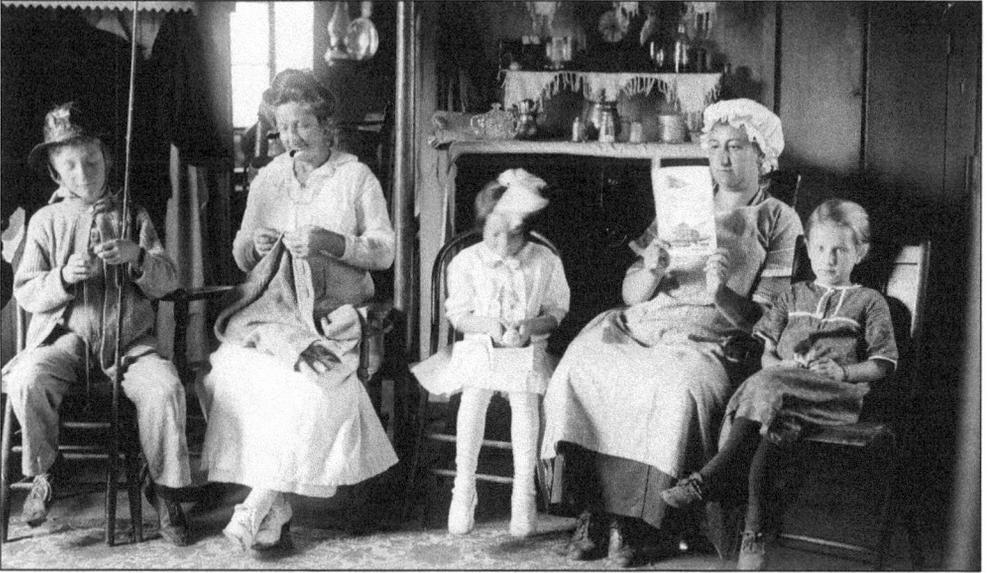

The family engages in everyday activities like reading, sewing, quiet play, and fishhook tying. Though posed, these photographs were taken to show life on the island around 1915. Produced on glass plate negatives, a photographic medium that predates the American Civil War, they are part of the George Grantham Bain Collection, of which the Library of Congress holds 39,744 negatives and additional 1,600 prints from the 1860s to the 1930s. As a founder of one of America's first new picture services, George Bain took and gathered photographs all over the world. (Courtesy of Library of Congress.)

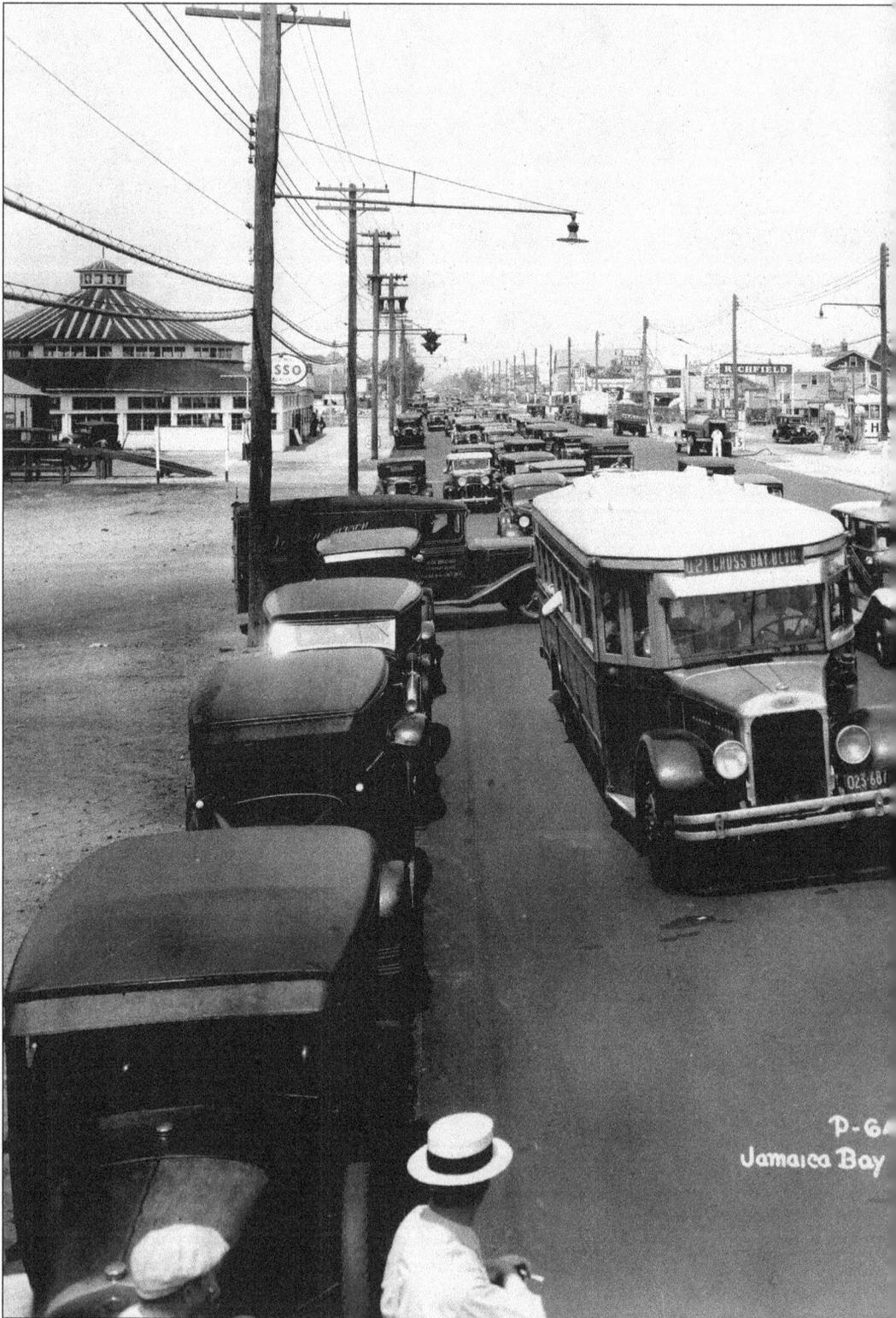

P-6
Jamaica Bay

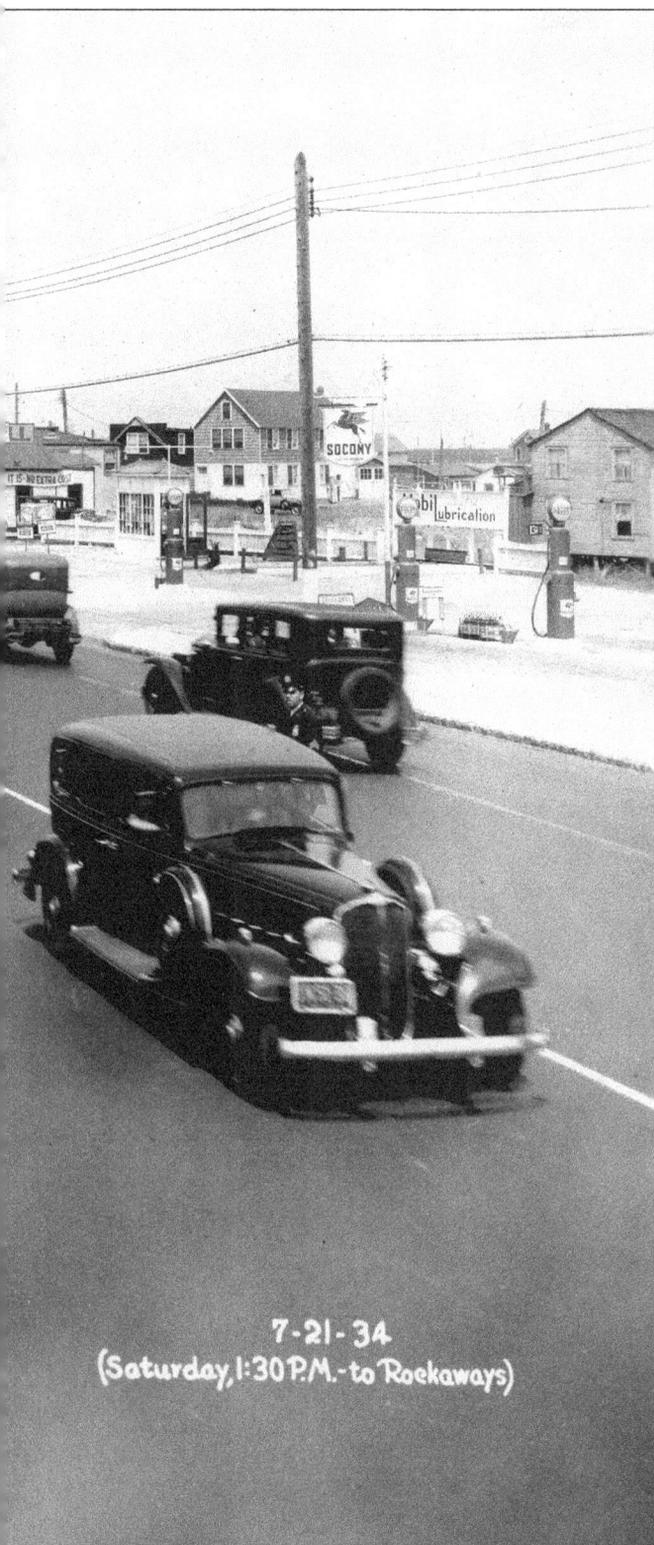

7-21-34
(Saturday, 1:30 P.M.-to Rockaways)

Vehicles drove on Jamaica Bay Boulevard (now called Cross Bay Boulevard), many headed south toward the Cross Bay Bridge and the Rockaway peninsula in 1934. At that time, there were no toll booths and no toll for commuters to pay. As the bridges at both ends of the island were opened and provided access to Rockaway beaches through Broad Channel, beach traffic on the boulevard was very heavy. On the right, a business offered gas for five cents. On the left is Nunley's Carousel and Channel Diner. The bus is the Q21, which is still in service though the Metropolitan Transit Authority (MTA) now administers this route. (Courtesy of MTA Bridges and Tunnels Special Archives.)

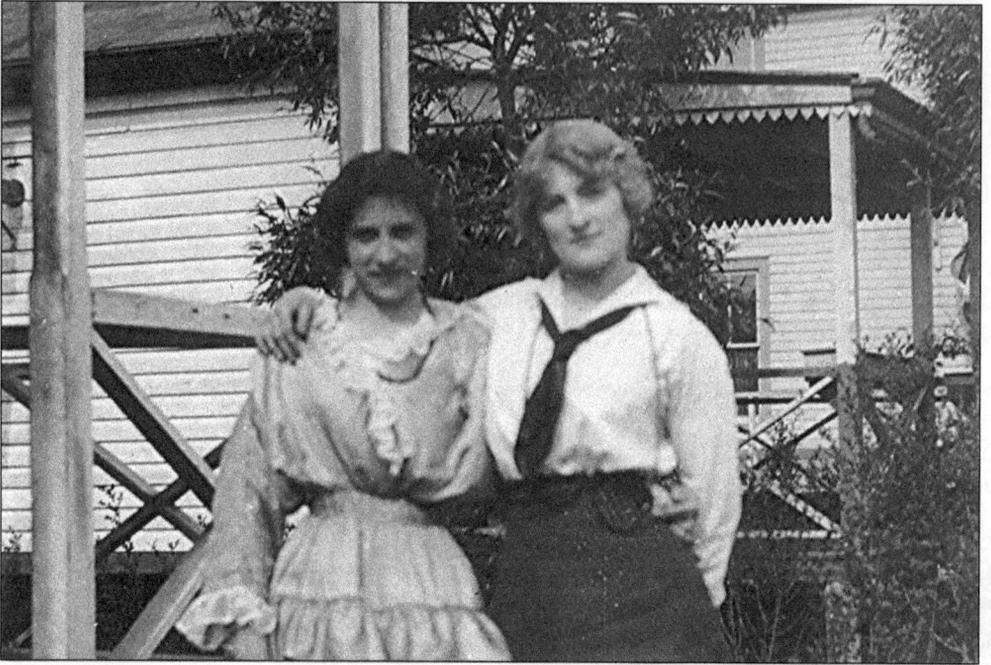

Regardless of the era, it was not difficult to find people wearing the latest fashions in the island community. In 1913, both wearing ankle length fashions, one woman sports a dress, while the other wears more casual attire—a nautically themed skirt, blouse and tie. (Courtesy of Stanley Reich and the Broad Channel Historical Society.)

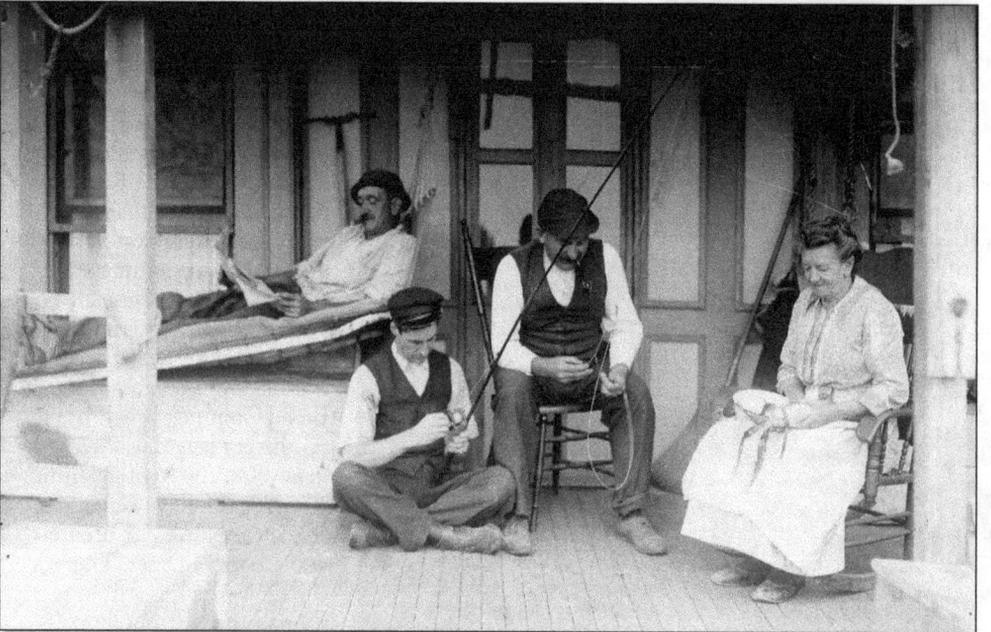

Here is another c. 1915 photograph by George Grantham Bain. Here a family group enjoys the outdoors and the fresh bay breezes, while two men prepare a rod and reel. Fishing is still a popular pastime today. As far back as the 1600s, Dutch settlers harvested fish, oysters, clams, and shrimp from the bay. (Courtesy of Library of Congress.)

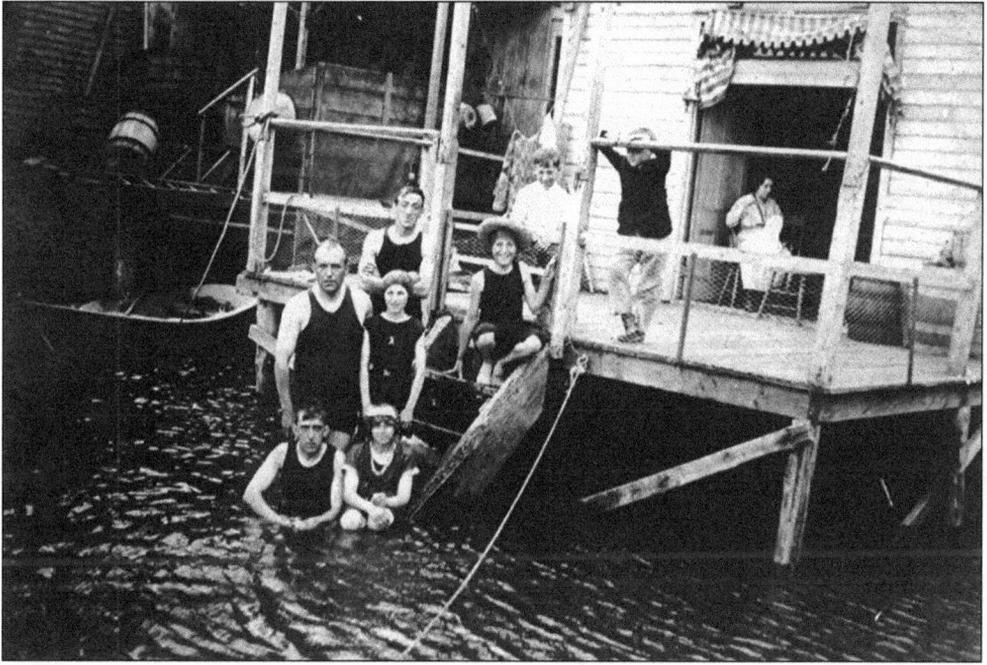

Around the fencing on the back deck of this house, filling half of the space below the railing, ran a mesh screen. Many objects dropped on the deck would have bounced, rolled, or been blown into the close water without the mesh screen securely in place. (Courtesy of the Theis family and the Broad Channel Historical Society.)

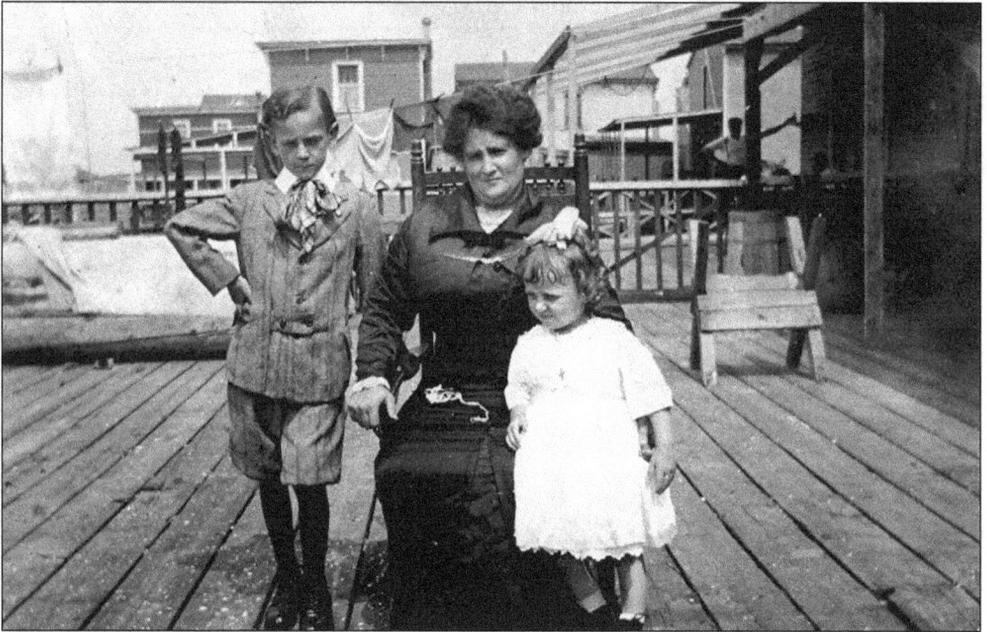

The Ward family poses in their Sunday best for a postcard picture. The child on the right is Veronica Ward, born in 1910. The house at 28 West Ninth Road is now the office of the Northeast Chapter of the American Littoral Society, a coastal conservation organization. (Courtesy of Veronica Ward Quinn and the Broad Channel Historical Society.)

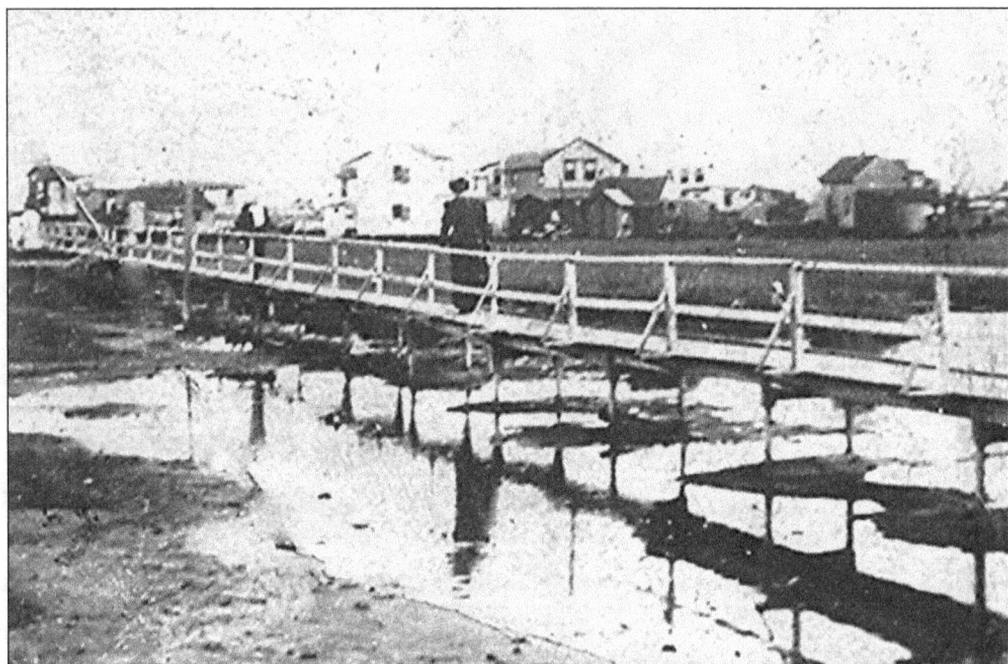

Even at low tide, boardwalks, like the one that extended the length of Sixth Road and beyond, were a necessity. When it was first built, the boardwalk was only three feet wide and had a handrail on one side only; it was later replaced by a wider structure with handrails on both sides. Here is a 1908 example of Broad Channel's boardwalks. (Courtesy of the family of Gertrude McAleese and the Broad Channel Historical Society.)

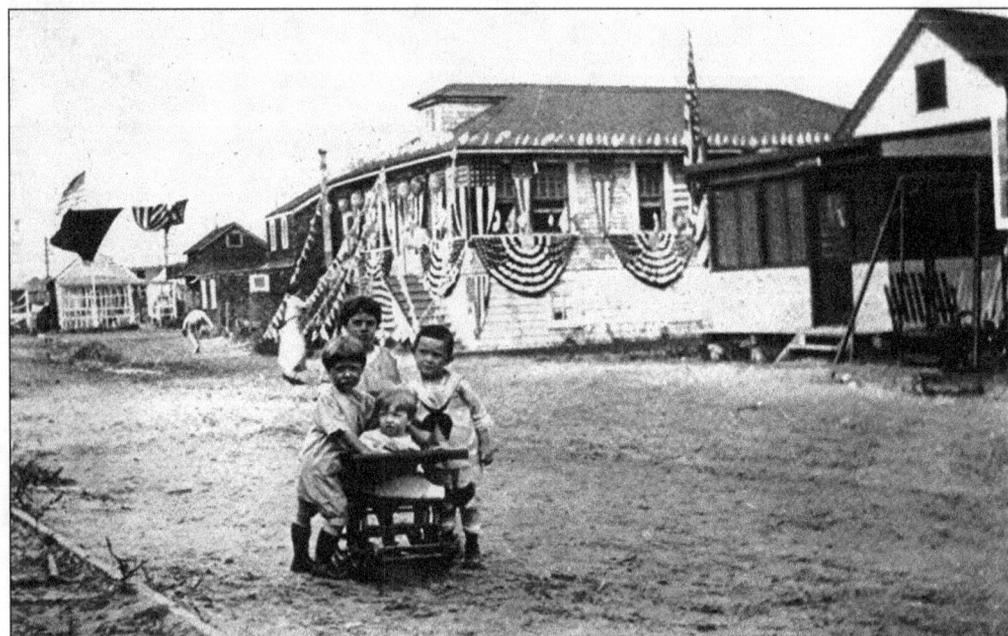

A group of children is wearing typical children's clothing of the period. They surround a child seated in a rocker chair—a piece of furniture familiar to those whose household contained a small child at that time. (Courtesy of the Theis family and the Broad Channel Historical Society.)

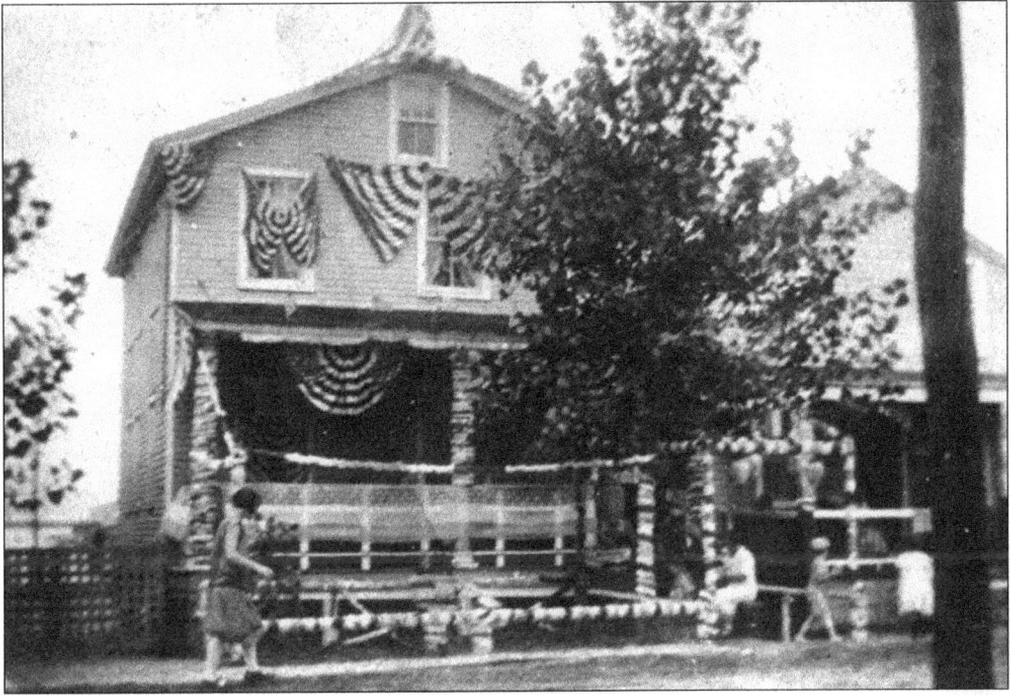

This 1920 photograph above of the front of the house at 10-09 Cross Bay Boulevard in Broad Channel reveals a two-story house, highly decorated with patriotic buntings. The now-winterized house still stands at this location. No paved roads had come to Broad Channel as yet, and the boulevard is just a road of sand mixed with cinders. Residents walked everywhere on the island, as do many residents today. At right is the back of the wooden frame house. Fewer private homes had two stories than one. At that time, most homes were not winterized; they were occupied only during the summer months. The stilts under the house were used to support the rear of the structure. (Courtesy of Mario Cina.)

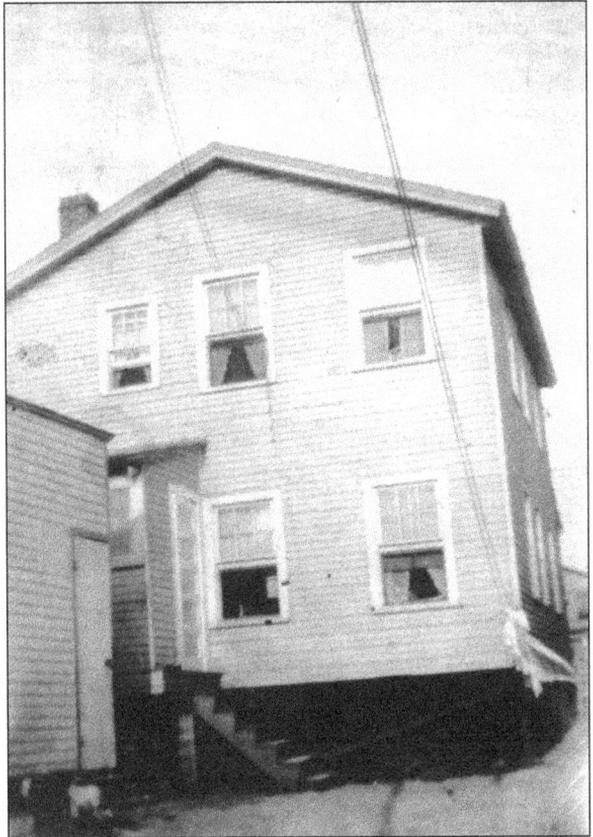

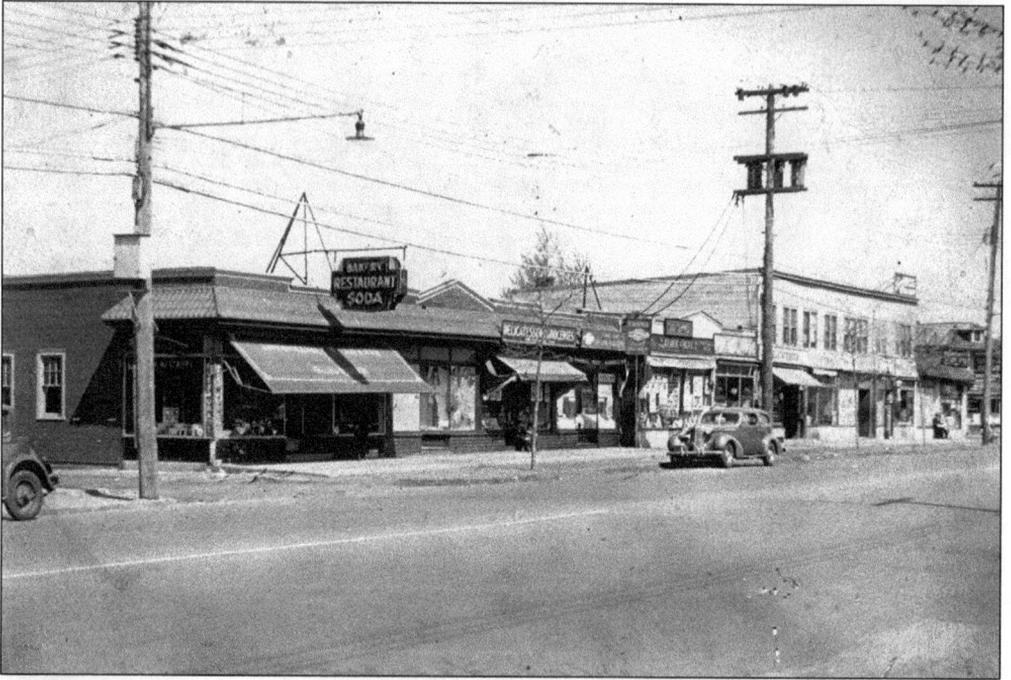

This 1930s photograph shows the southern end of the commercial strip on the west side of the island community between West Ninth and Tenth Roads. A restaurant was on the corner and two delicatessens were there as well, one near the corner and another a few doors away. The road and sidewalks are wide, unlike the narrow walks and central mall the boulevard has today. (Courtesy of Broad Channel Historical Society.)

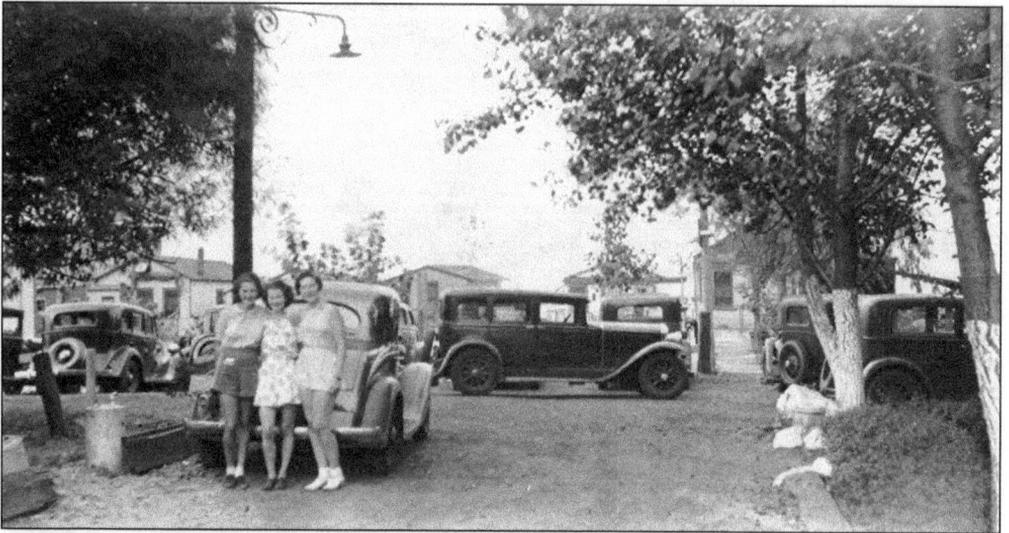

This image captures Demarest and Twenty-second Roads in the summer of 1930. There are many parked cars lining the street; their passengers likely patronizing the marina, which was operating at that time. Although the street is neatly kept and tree-lined, note the white-painted rocks and bark, it is not as yet paved. Note the quaint shape and configuration of the streetlight on the pole behind the women. (Courtesy of Jerry Bourke and the Broad Channel Historical Society.)

This 1940s view of the west side of Cross Bay Boulevard between Ninth and Tenth Roads shows automobiles of the era. Charley's Barber Shop, partially obscured by a tree, is next to the real estate office of town luminary Marcel Peysson. The tailor shop is the one-story building on the left side of the photograph. Charley's Barber Shop today is occupied by Channel Cutters hair salon. (Courtesy of Ed Neuer and the Broad Channel Historical Society.)

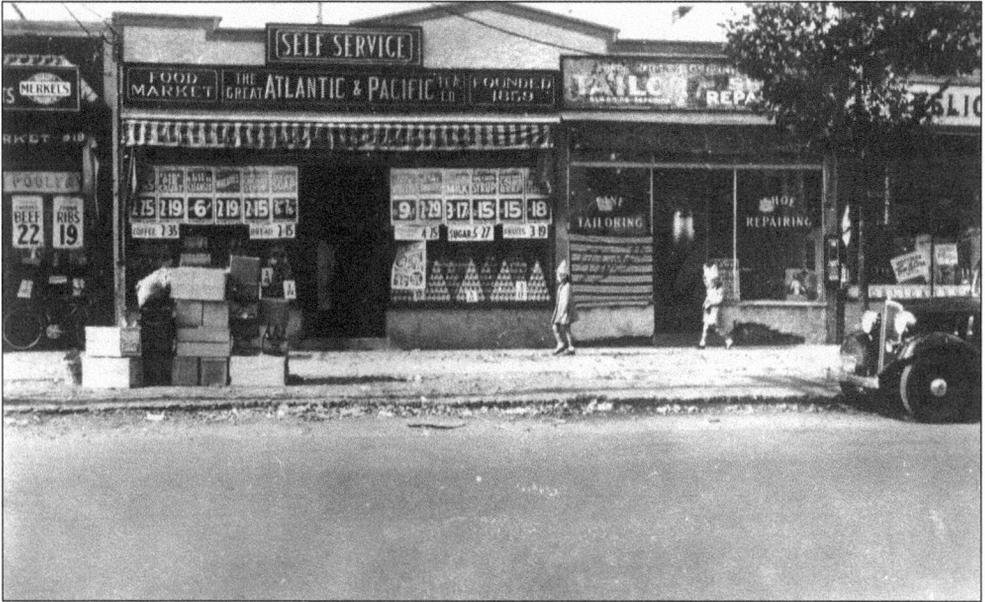

A Great Atlantic and Pacific Tea Company Food Market, which opened in 1932, was located on the west side of Cross Bay Boulevard between Ninth and Tenth Roads. On the window posters, food items for 25¢ or less are advertised. Self-service, a new concept at the time, was listed atop the entrance to the store. A tailor shop run by John Goetke and the shoe repair by Mr. Minei (called Mr. Minnie by locals) offered their services to the growing year-round community. (Courtesy of Ed Neuer and the Broad Channel Historical Society.)

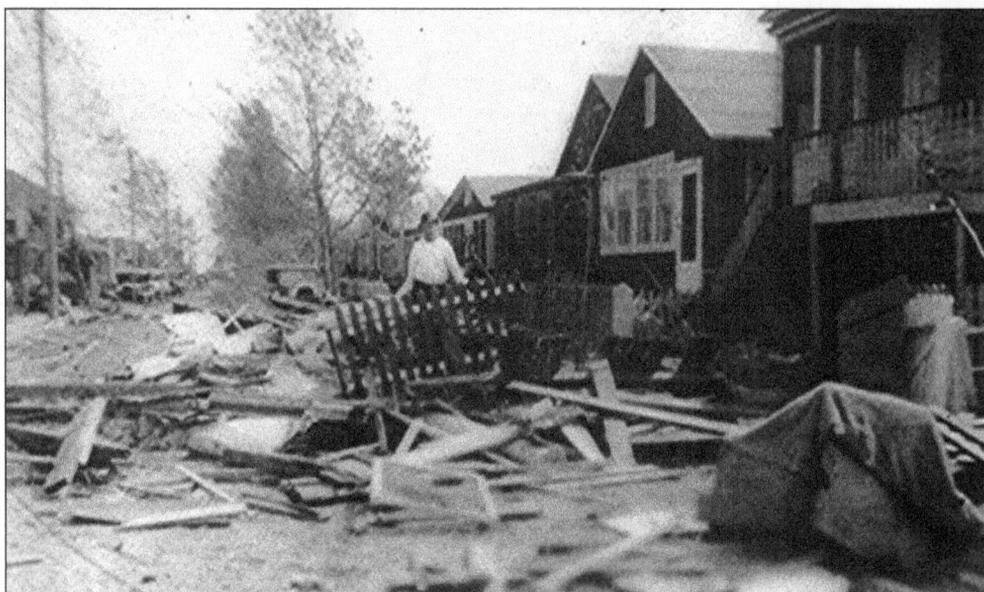

Local streets are piled high with rubble after Broad Channel was lashed by a hurricane in 1938. Very high winds and the accompanying rain wreaked havoc on the island community. A section of fence that once bordered property is held up by a resident. Pieces of wood blown into the street include, railings, screens, pilings, shelves, trellises, tarpaulins and many other items. The photograph below shows the next-door neighbor framed by part of the patio and piles of chairs and other furniture. (Courtesy of John McCambridge Sr. and the Broad Channel Historical Society.)

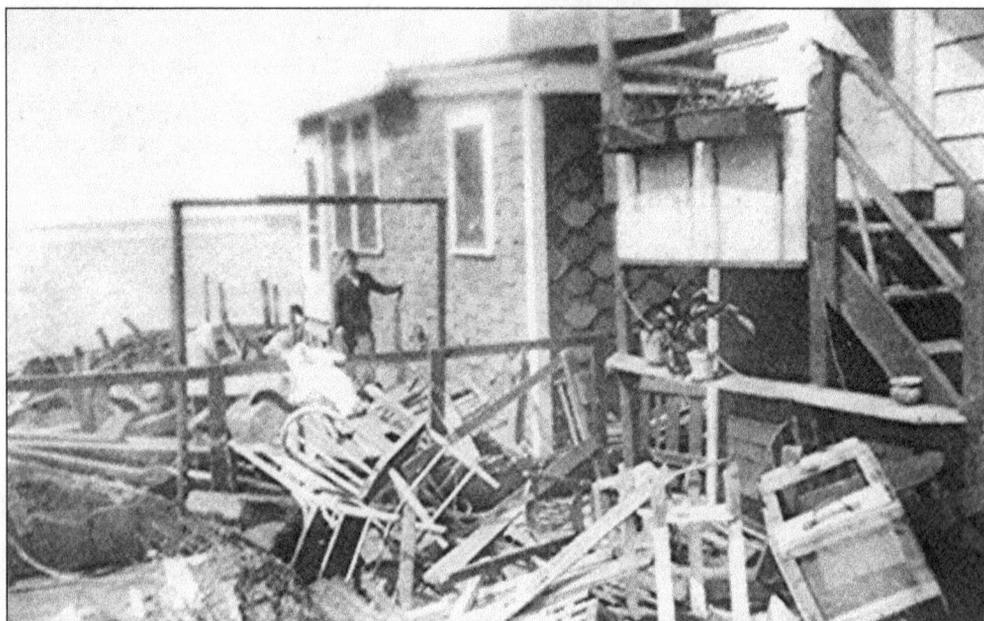

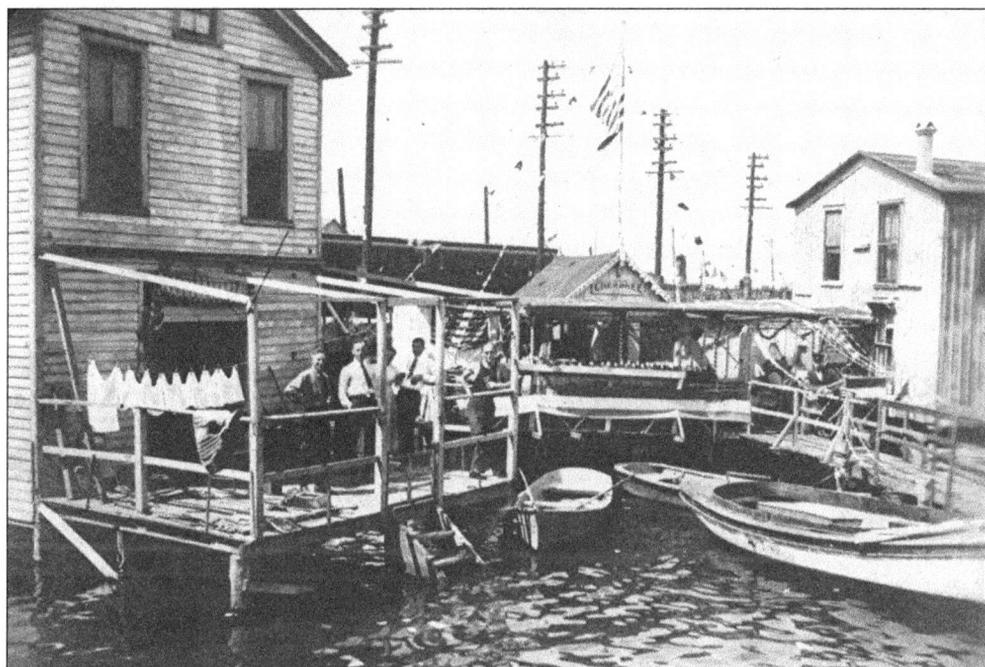

Houses, boardwalks, boats, and steps to the water were in proximity early in the 1900s. Laundry was hung on the clothesline in the back deck of the house on the left as it still is in some yards today. The American flag hangs on a pole near center of photograph. (Courtesy of the Theis family and the Broad Channel Historical Society.)

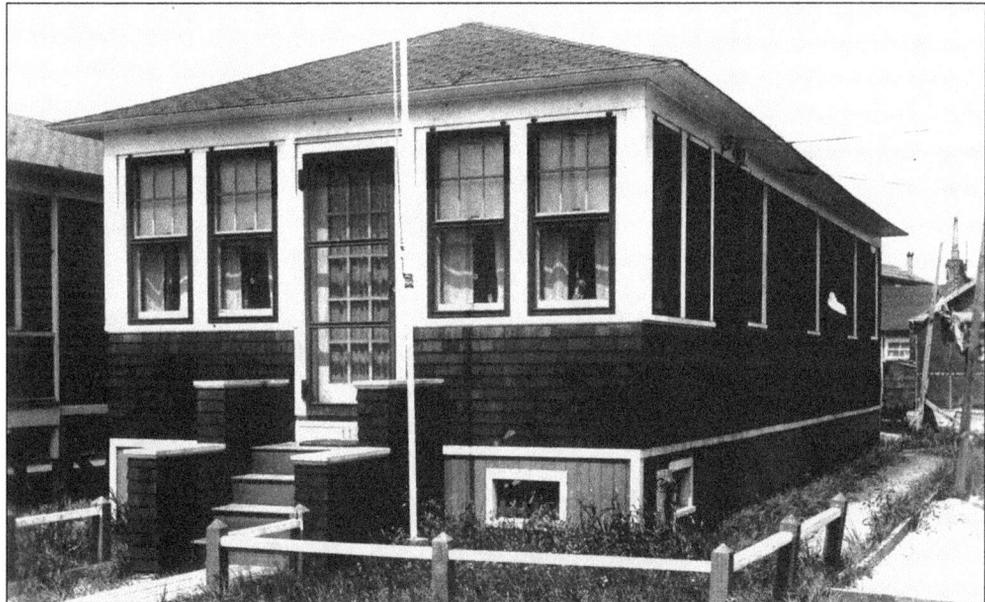

The typical Broad Channel home was a one-story dwelling with a crawl space beneath it. This photograph is of a bungalow on East Seventh Road. A flagpole in the front yard is visible at the right side of the door. A low fence borders the property and the sidewalk looks roughly framed out. A wooden plank leads away from the stoop. (Courtesy of Jean Bohne Ryan and the Broad Channel Historical Society.)

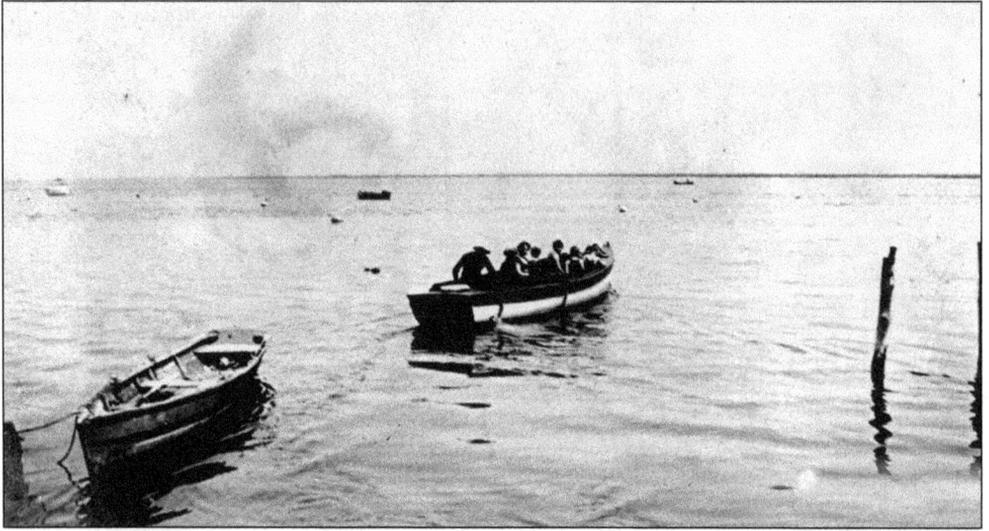

A motorboat with inboard motor and full load of passengers moves across the waters of Jamaica Bay, passing a rowboat on a mooring in the early 1900s. Many residents were drawn to Broad Channel for its nearness to the water and the many recreational water activities it provided. (Courtesy of the Theis family and the Broad Channel Historical Society.)

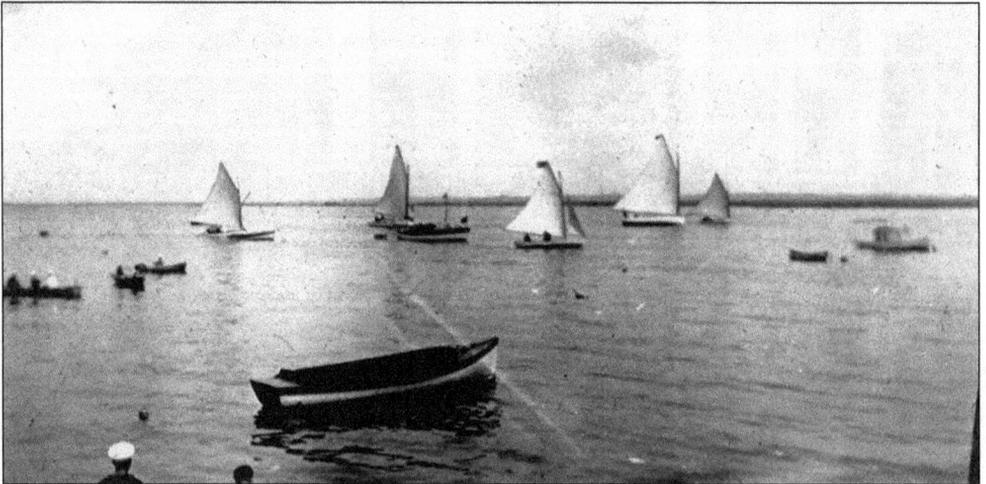

On September 1, 1920, a sailboat race took place as part of the Mardi Gras festivities that were anticipated at summer's unofficial ending of Labor Day weekend every year. Jamaica Bay provided the winds required to propel the winning sailboat past the finish line. (Courtesy of the Theis family and the Broad Channel Historical Society.)

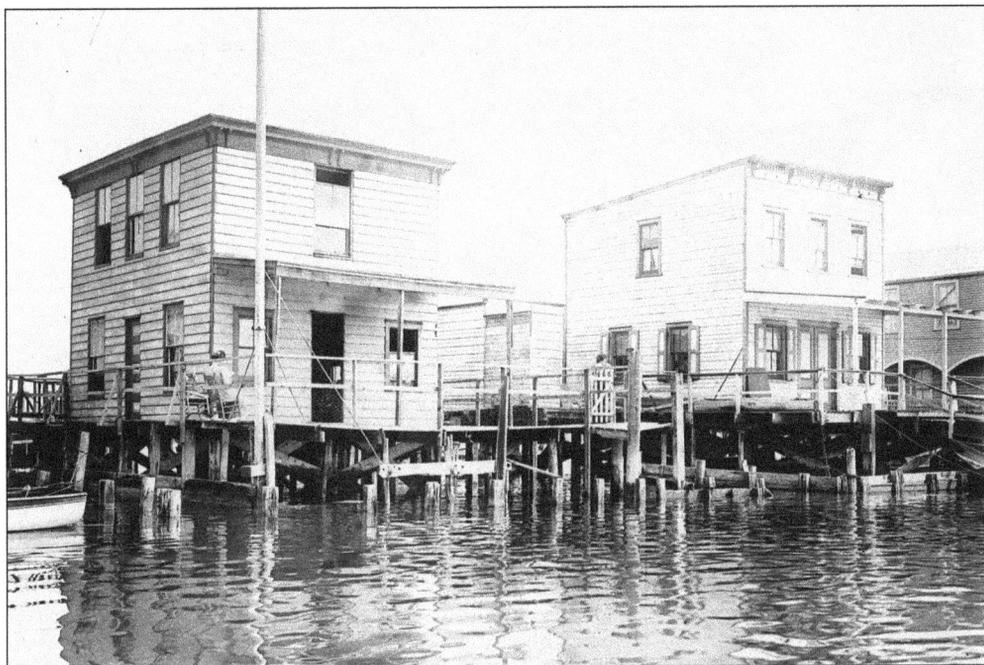

The Raunt was a bay colony located about a mile north of Broad Channel; it also had boardwalks connecting the homes. Unlike their neighbors one mile south, there was no running water in the Raunt. Residents were able to get their own railroad stop, but had to let the engineer know in advance or the train would not stop. In the 1950s, Raunt residents had to relocate when it became New York City parkland and the new subway rail was built. Many residents moved to Broad Channel. Some floated their houses on barges. (Courtesy of Library of Congress.)

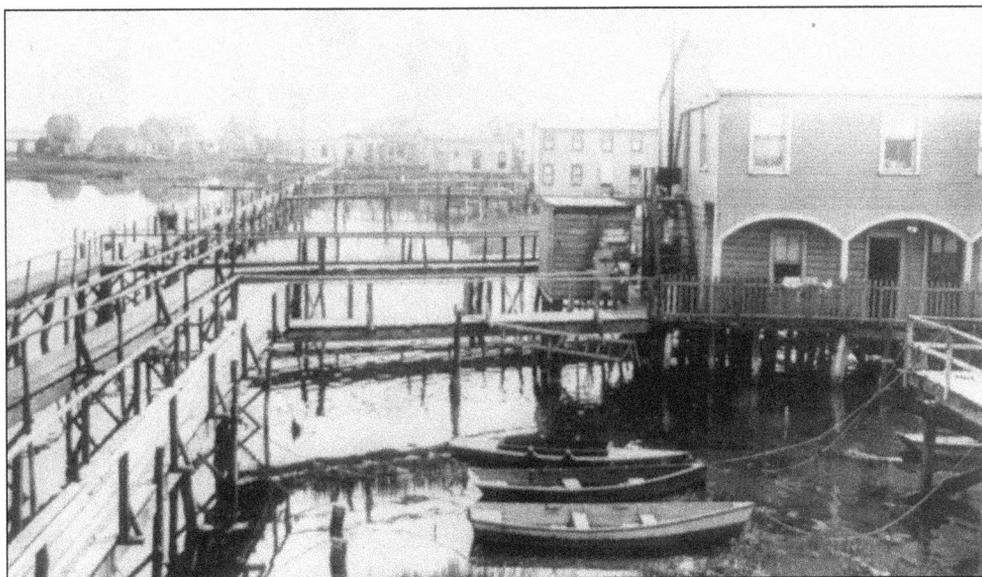

The Raunt area was located a little further north in Jamaica Bay. In this 1915 photograph, there are buildings as far as the eye can see. Each has a wooden walkway leading from its front door. The train station is in the background. Boardwalks were often named after the person who owned the house or establishment from where it originated. (Courtesy of Library of Congress.)

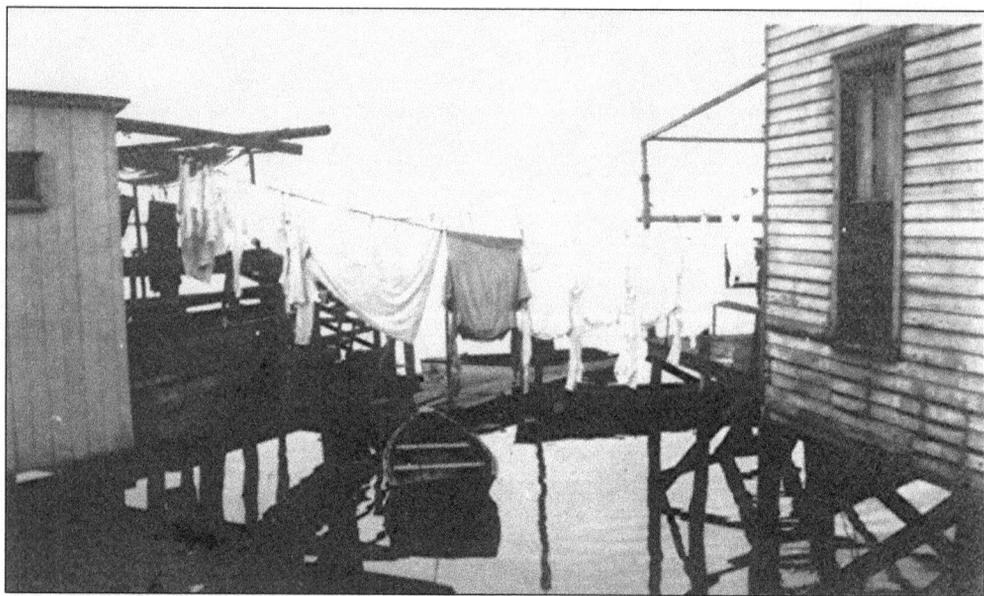

Relationships between next-door neighbors in old Broad Channel were closer than most, partly because of the physical nearness. Here neighbors have each other's clotheslines fastened between their two houses. (Courtesy of the Theis family and the Broad Channel Historical Society.)

The Bohne family lived on Sixth Road near the LIRR seen in the background. Porches were popular and built on many of the homes so residents could enjoy cool breezes blowing off the waters around the island community. A boardwalk that extends the length of the street is on the left side of the photograph. (Courtesy of Jean Bohne Ryan and the Broad Channel Historical Society.)

Two

MARDI GRAS
COMMUNITY CELEBRATION

More than just a colorful September Labor Day parade, Mardi Gras, even to its beginnings, sums up Broad Channel in very many ways. Back in the days when the Channel was largely a summer destination, it was not uncommon to mark the end of the season on that last holiday weekend. Then it was not only a celebration but also a looking back as people left the summer bungalow community behind and went back to their everyday lives.

Sometime before 1908, the fledgling Volunteer Fire Association hit on the idea of raising monies for a new firehouse and equipment by arranging events associated with Mardi Gras. Not only were festive gatherings such as dances in evidence, but also other entertainments began to stretch the idea into a summer-long social celebration. For instance, not only were boating races organized, but entire boat parades were held. The idea of having a king and queen of the Mardi Gras, as well as other attendants in full regalia, also came into being.

In time, civic groups and others began to join in. Among many over the years have been the Ladies Welfare Association, the Broad Channel Sea Scouts, the American Legion, the VFW, the Prince-Wynn Colonials Fife and Drum Corps, and the North Channel Yacht Club. Other fire brigades, like the West Hamilton Beach Volunteer Fire Department, and neighboring organizations, such as the Rockaway Artists Alliance, have been invited and marched along with Broad Channel's own.

Always with a strong homemade element, it is not unusual to hear hammers and saws all over the town as neighbors fashion their own floats along all types of themes. Mounted on trailers or kiddie wagons, some complete with music and pulled by small trucks, cars, or even Mom, adults and children alike ride along as these plywood and paint creations parade up one side of Cross Bay Boulevard, then turn around and march down the other. Parade-goers dutifully pull their folding chairs across the road to enjoy the floats and marchers once again.

Mardi Gras went into hiatus during the Depression and for the duration during World War II. But it came back each time and remains a strong Broad Channel tradition. Today it is alternately sponsored by the Broad Channel Athletic Club and the Board Channel Volunteer Fire Department (BCVFD) and still raises funds for community causes. Its celebration of summer still continues.

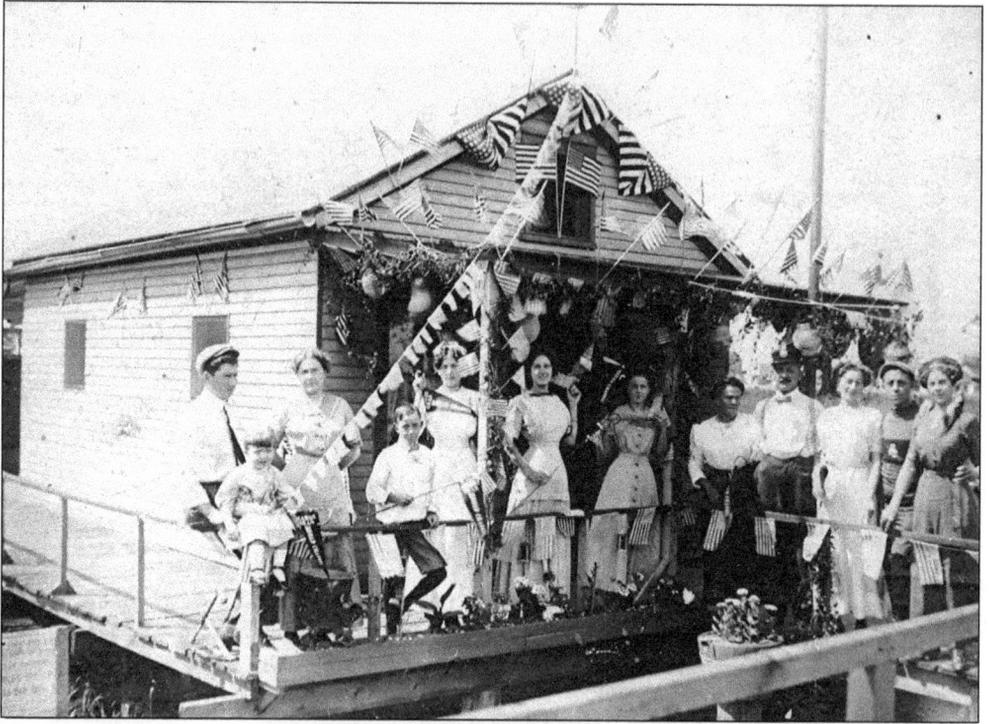

This bungalow shows patriotic decorations for Mardi Gras, early in the 20th century. A look at the ground shows dry land to the east side of the house. Prior to the building of sidewalks and roads, people walked on boardwalks, which were necessary to visit a building built over the water or in tidal areas. (Courtesy of Jean Bohne Ryan and the Broad Channel Historical Society.)

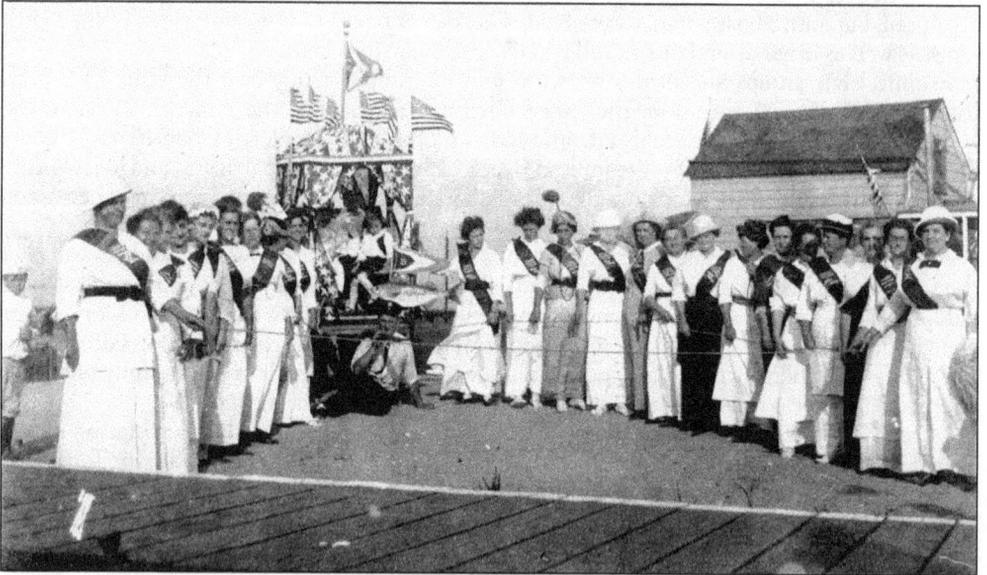

In 1913, the then Ladies Auxiliary of the Fire Association marched together in the Mardi Gras parade. Mardi Gras and the parade have been a community staple for about 100 years. The Ladies Auxiliary of the Fire Association would later become the Ladies Welfare Association. (Courtesy of the family of Gertrude McAleese and the Broad Channel Historical Society.)

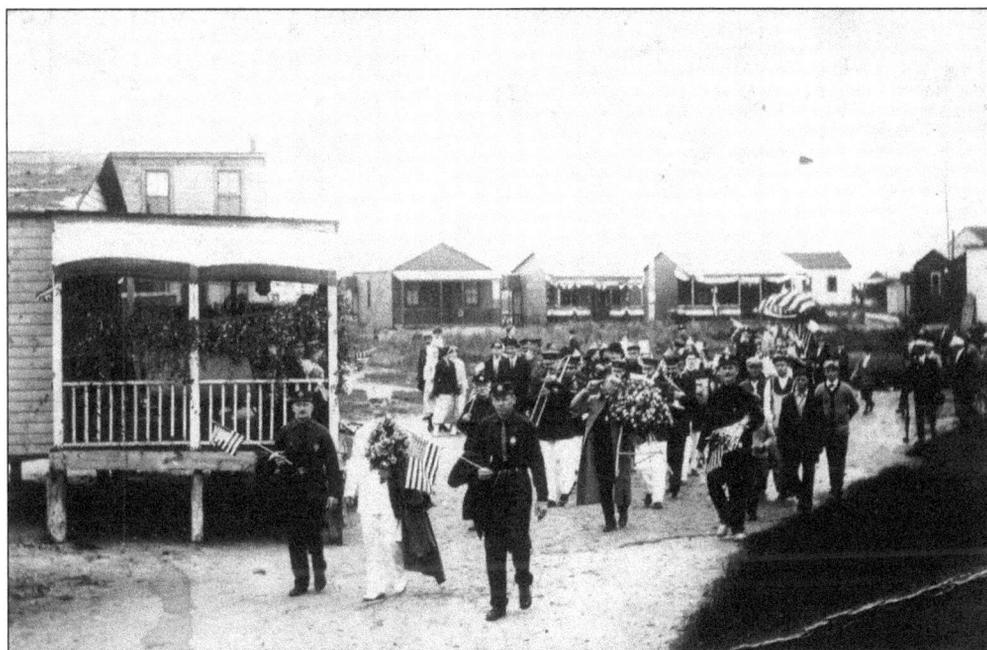

Broad Channel volunteer fire department members in full uniforms tread over sand during the Mardi Gras parade. Note the brass band toward center of photograph. The fire chief is all in white at the center of the photograph. The facial hair sported by firemen indicates that this is one of the early Mardi Gras parades. (Courtesy of Broad Channel Historical Society.)

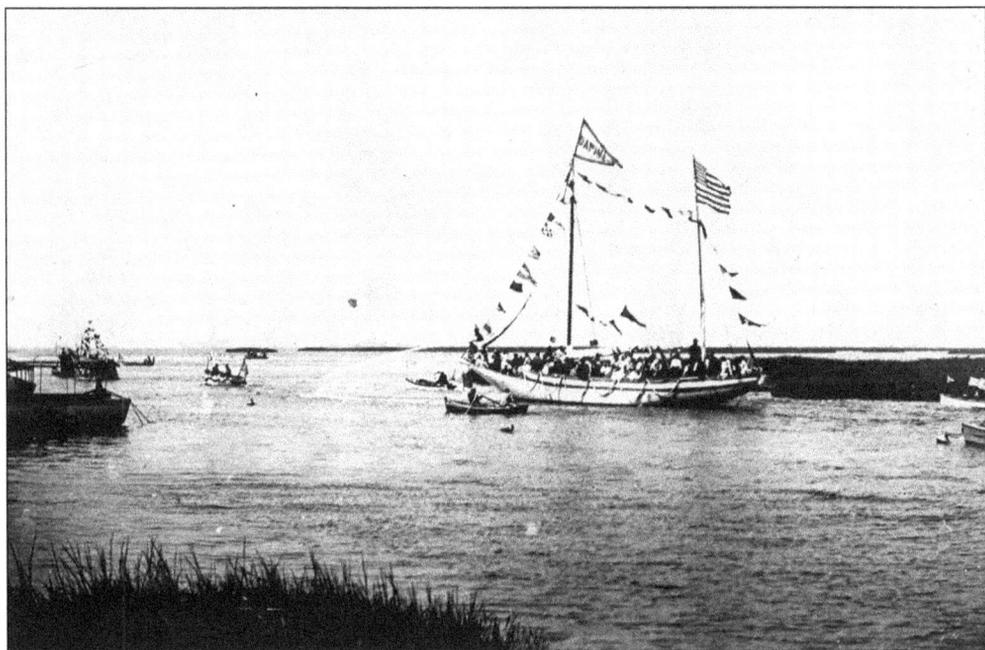

Navigating its way around the salt marshes, this highly decorated sailboat and Mardi Gras race winner headed for more open water accompanied by other types of craft and some ducks which bobbed on the surface of the bay. (Courtesy of Stanley Reich and the Broad Channel Historical Society.)

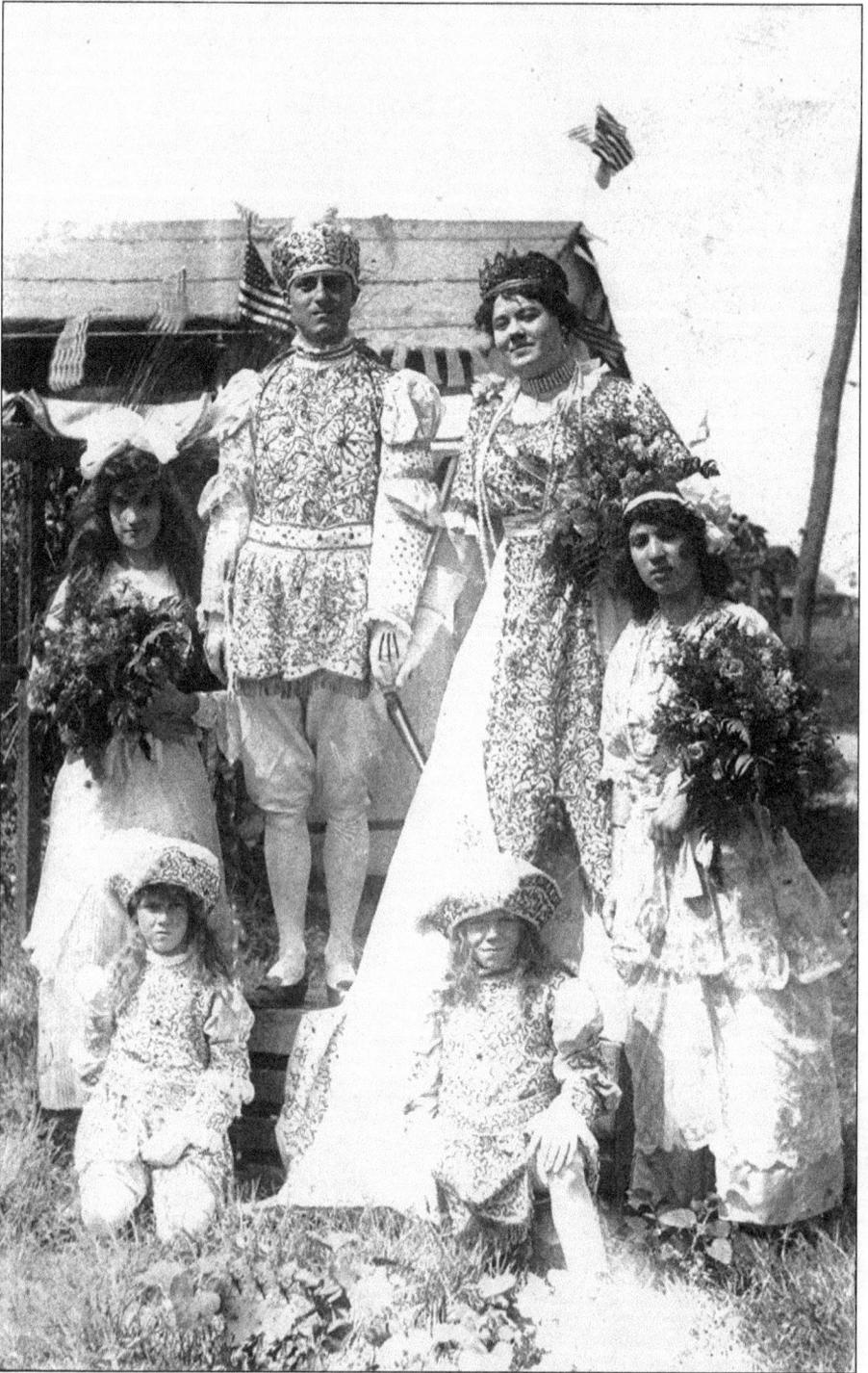

Mardi Gras costumes could be very elaborate early in the early 1900s as this photograph shows. They were probably very warm as well, with long sleeves and layers of clothing for both the king and queen. Their attendants, each carrying flowers, and their pages are equally well costumed. (Courtesy of Jean Bohne Ryan and the Broad Channel Historical Society.)

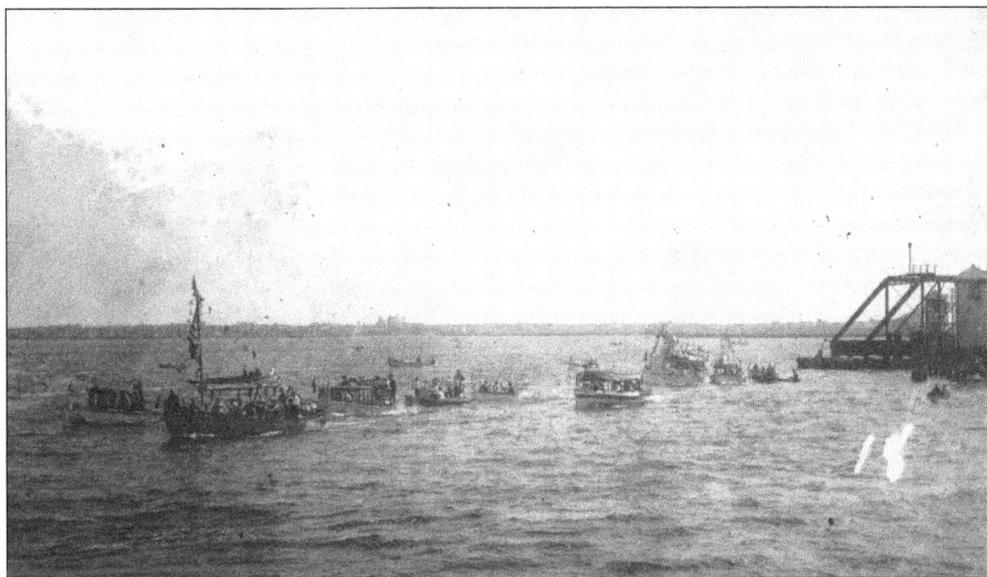

Boats are lined up in a Mardi Gras water parade of the Broad Channel Volunteer Fire Association. The lead boat *Pioneer* belonged to prominent resident Edward Severin. The parade marked the end of Mardi Gras fun and the unofficial end of summer. Note the swing bridge at right of picture. (Courtesy of the family of Gertrude McAleese and the Broad Channel Historical Society.)

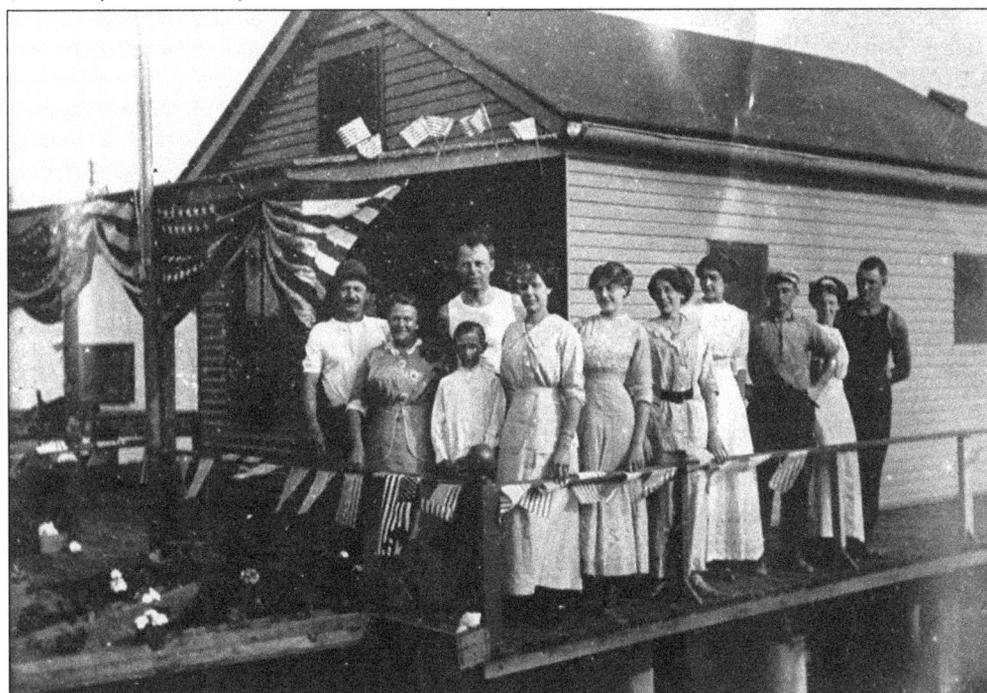

This bungalow on Sixth Road displayed patriotic decorations for Mardi Gras, early in the 20th century. This photograph clearly shows an angle-roofed front porch, a walkway on the west side of the house, many support pilings underneath it and heavy beams to the front of it to support its connection with the Sixth Road boardwalk, called Sporck's Boardwalk. (Courtesy of Jean Bohne Ryan and the Broad Channel Historical Society.)

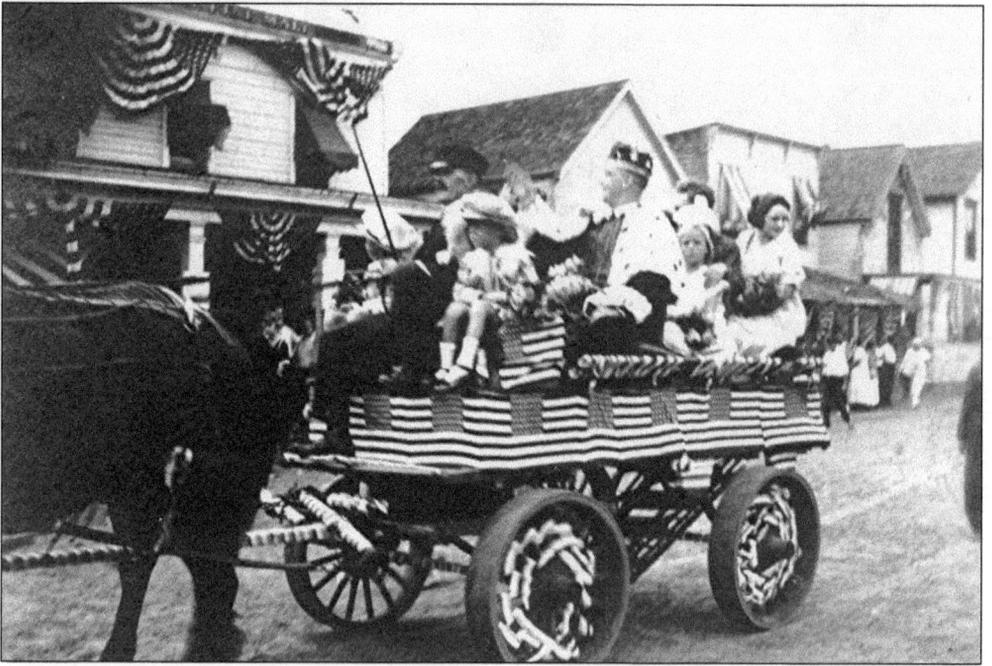

A horse pulls a patriotically-decorated cart down the unpaved street for the Mardi Gras parade during Labor Day weekend festivities. King, queen, pages, and courtly entourage, decked out as their roles required, occupied the cart. (Courtesy of the Theis family and the Broad Channel Historical Society.)

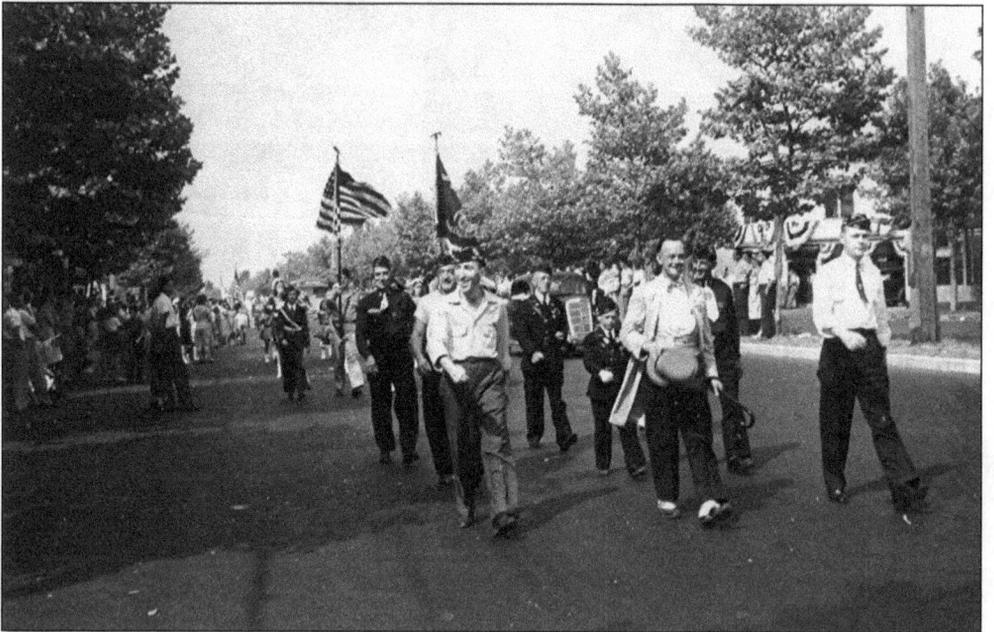

Led by the Mardi Gras mayor, veterans promenade down Cross Bay Boulevard. The VFW and the American Legion both have active, involved members and their own buildings for their meetings. Both do fund-raising for their charitable efforts. Each organization has a very visible ladies auxiliary, especially vital in fund-raising. (Courtesy of Broad Channel Historical Society.)

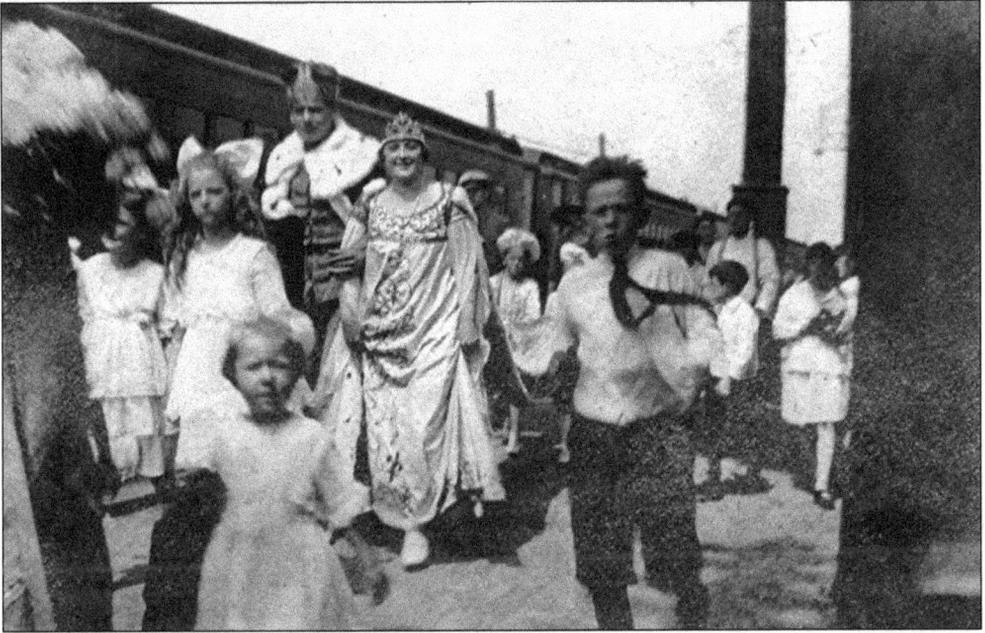

The 1919 royal family arrives in style. Here the king and queen of the Mardi Gras, with costumed pages carrying her train and entourage, and revelers in attendance, parade along the Rail Road platform. Note the over-the-knee socks, knickers, and tie on the boy running past the camera. (Courtesy of Broad Channel Historical Society.)

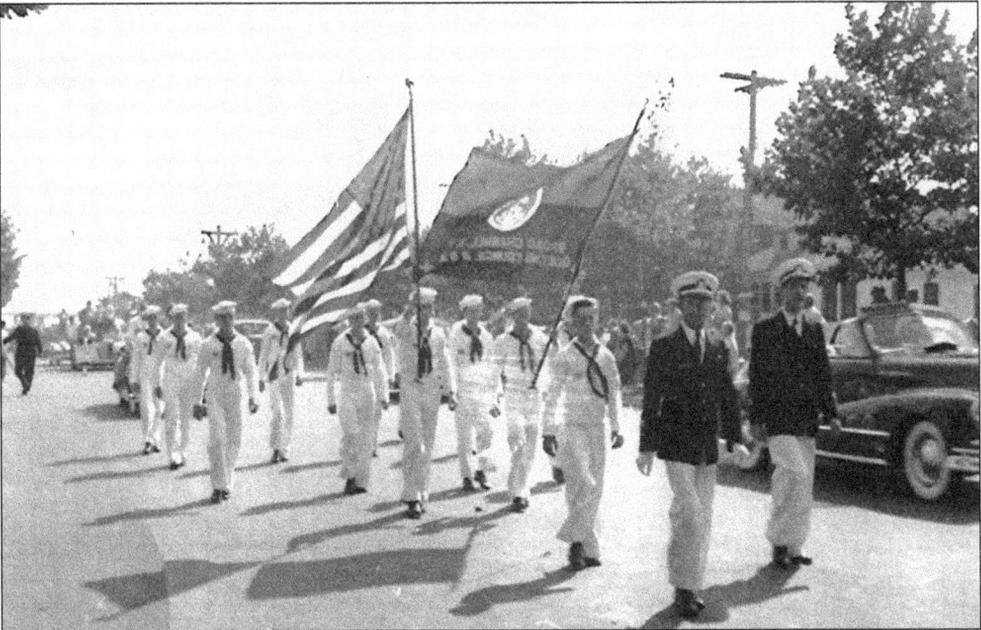

Parading down Cross Bay Boulevard in 1949 were the Sea Scouts. Earlier that year St. Virgilius Church had received a charter for the Sea Scouts from the Boy Scouts of America. It lists "character building" and "citizenship training" as part of its mission and bears the "signatures" of honorary scout president Harry Truman and honorary vice president Herbert Hoover. (Courtesy of John McCambridge Sr. and the Broad Channel Historical Society.)

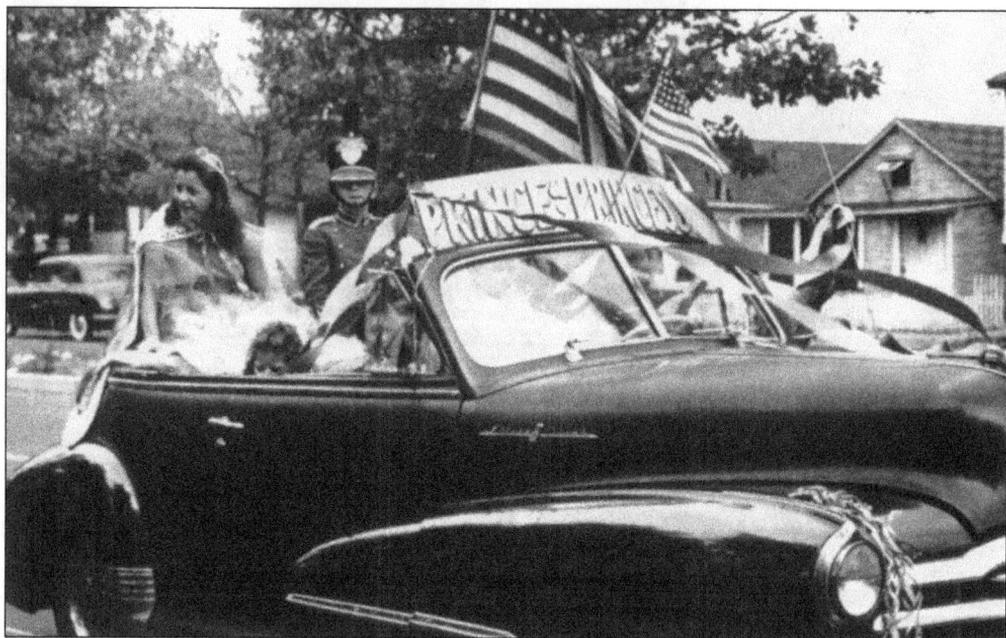

Mardi Gras prince "Butch" Neuer and princess Tina Moynihan (noted as "Monahan" in a later *New York Daily News* article) ride in style in 1953. She wears the traditional tiara and cape while he sports the plumed, shield-embossed cap and gray tunic similar to the dress uniform of a West Point cadet. In 1949, there were at least four candidates each for prince and princess as well as three kings, three queens, and five mayors. Competition for votes was keen. (Courtesy of Broad Channel Historical Society.)

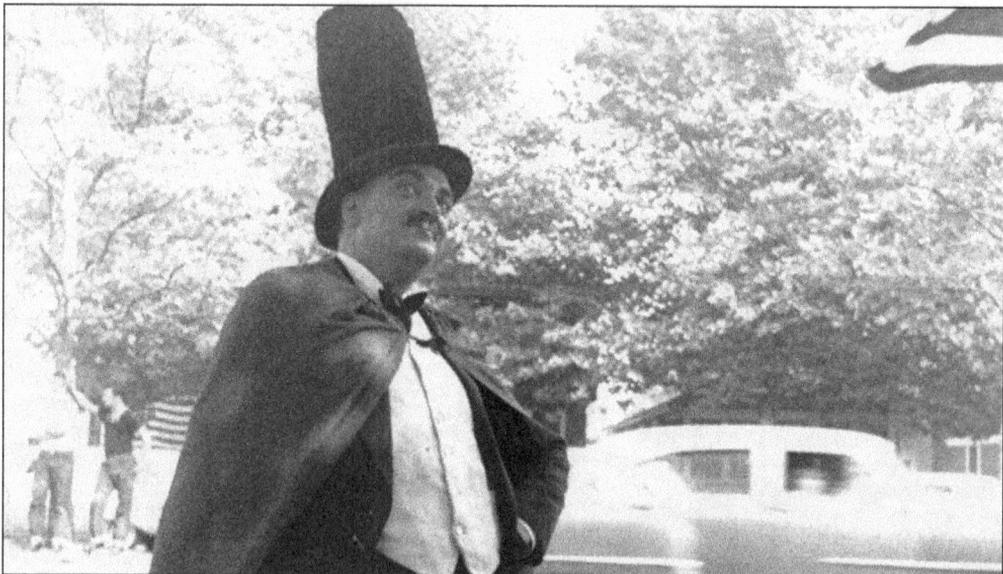

In the early 1900s, Mardi Gras costumes were more traditional and conventional. As time passed, however, costumes became more experimental and more daring in a move toward standing out and being different. Here a man stood head and hat above the crowd in an old-fashioned concept of a suitable costume for a mayor; he led the parade. (Courtesy of Broad Channel Historical Society.)

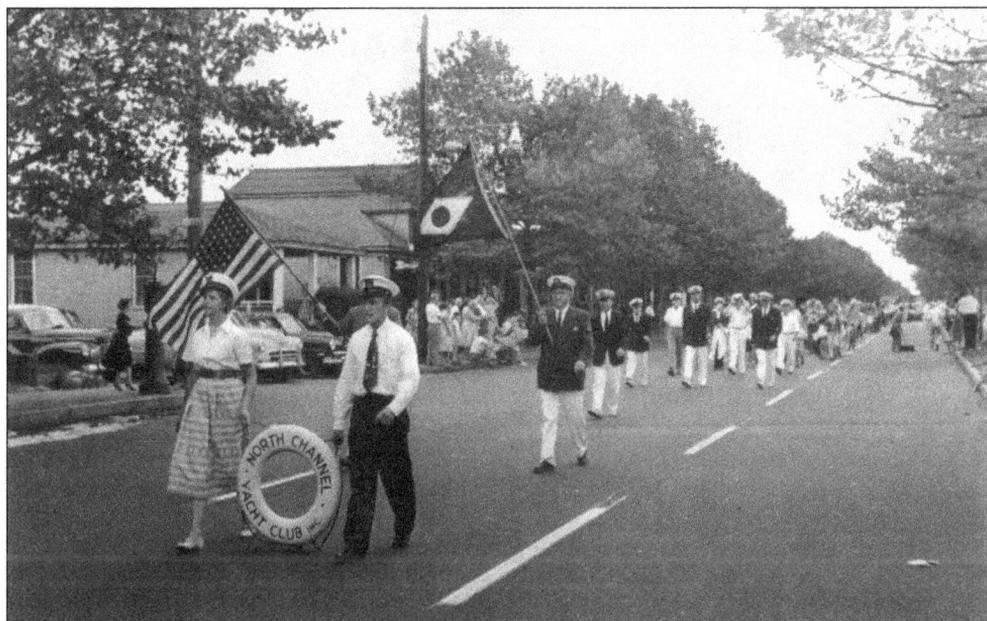

During Mardi Gras in the 1960s, members of the North Channel Yacht Club parade down Cross Bay Boulevard. With two members carrying a life preserver inscribed with the club name as their banner, the rest of the marchers sport the traditional yachtsman's white pants, navy blue blazer, and white yachting cap. (Courtesy of Mildred and Hal Flanagan and the Broad Channel Historical Society.)

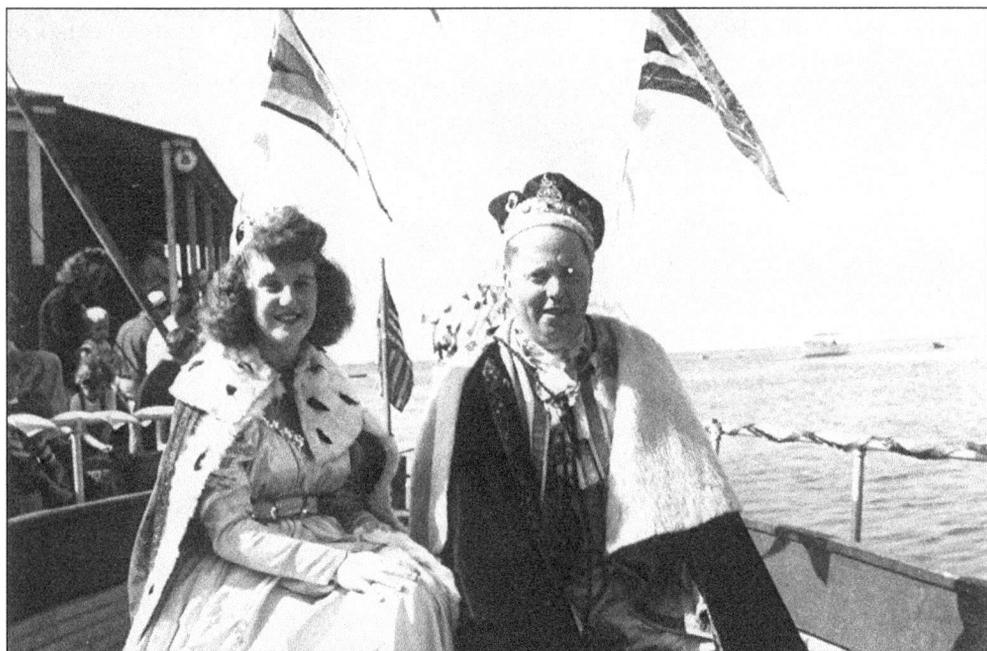

The king and queen of Mardi Gras in the 1940s rode in style on the prow of a gaily decorated boat. Since its beginnings, the king and queen of the Mardi Gras have walked, ridden in a horse-drawn wagon, and in the 1950s, would ride in the parade in a convertible automobile. (Courtesy of Broad Channel Historical Society.)

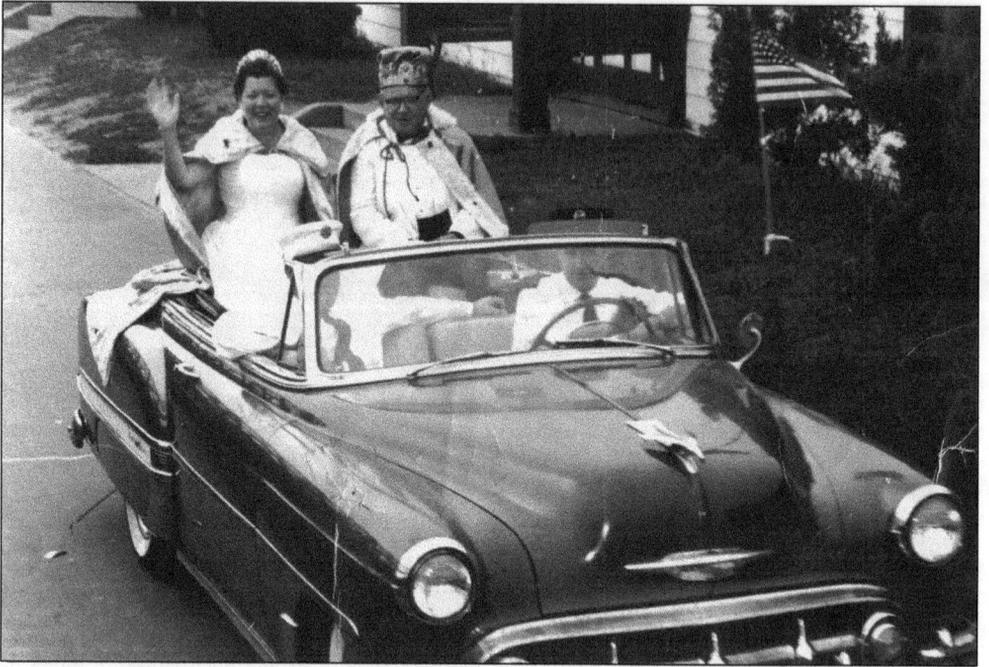

Mardi Gras winners assumed the titles and costumes of a royal family—the king and queen in this 1950s photograph, Jack Hartel and Lil Kass, ride in style on the back of the convertible, a 1949 Chevrolet. Mardi Gras began as a way to raise money for non-profits in the community, with winners being chosen by the amount of money candidates raised through various fund-raising efforts for the recipient organization over the summer months. (Courtesy of Marilyn Kass Stewart and the Broad Channel Historical Society.)

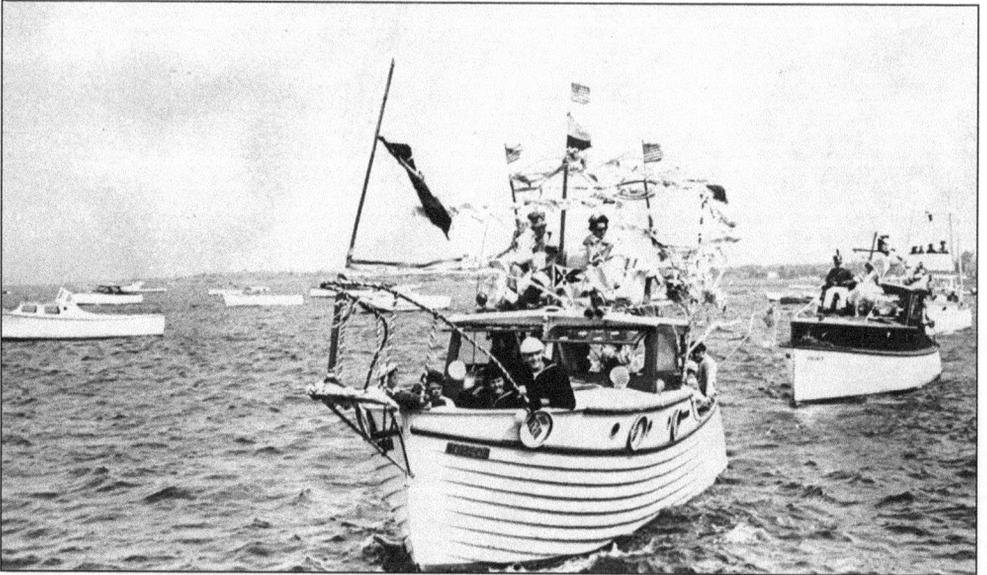

In 1963, a gaily decorated boat led the boat parade, followed closely by other parade entrants. Boat races and boat parades, which had been an integral part of Mardi Gras from its start, continued on through the 1980s, when they were discontinued out of concern for the bay. (Courtesy of Mildred and Hal Flanagan, Gerry O'Brien, and the Broad Channel Historical Society.)

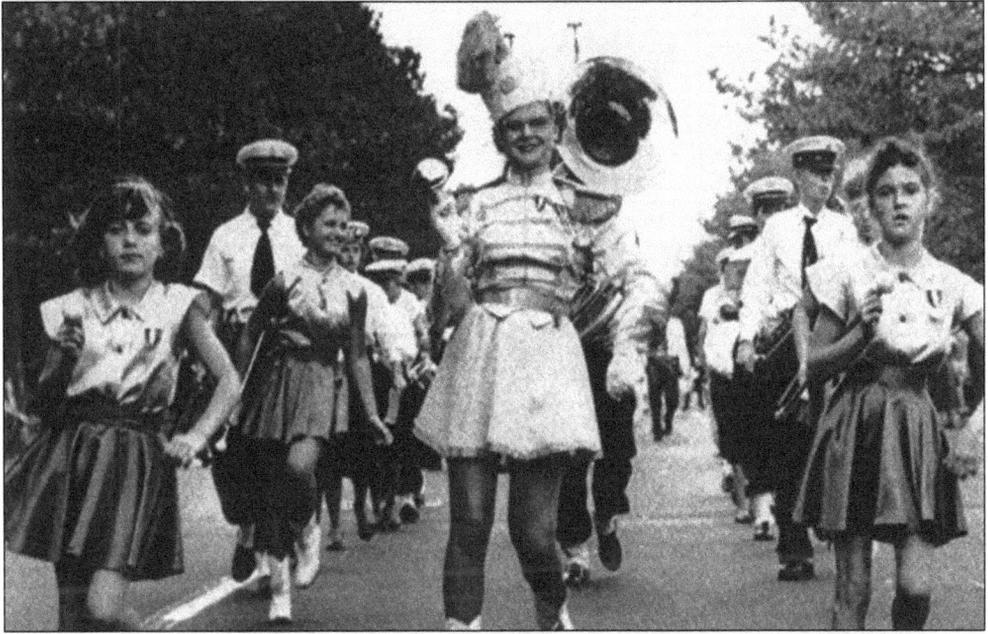

Over the decades as Broad Channel acquired roadways and bridges to allow freer access to it, Mardi Gras acquired the ability to become more mechanized. Handmade floats entered the parade and were either built on trailers and pulled by cars or were built all around cars, making them self-propelled. As always, however, the parade sported a phalanx of uniformed steppers and baton twirlers heading up columns of brassy marching bands. (Courtesy of John McCambridge Sr. and the Broad Channel Historical Society.)

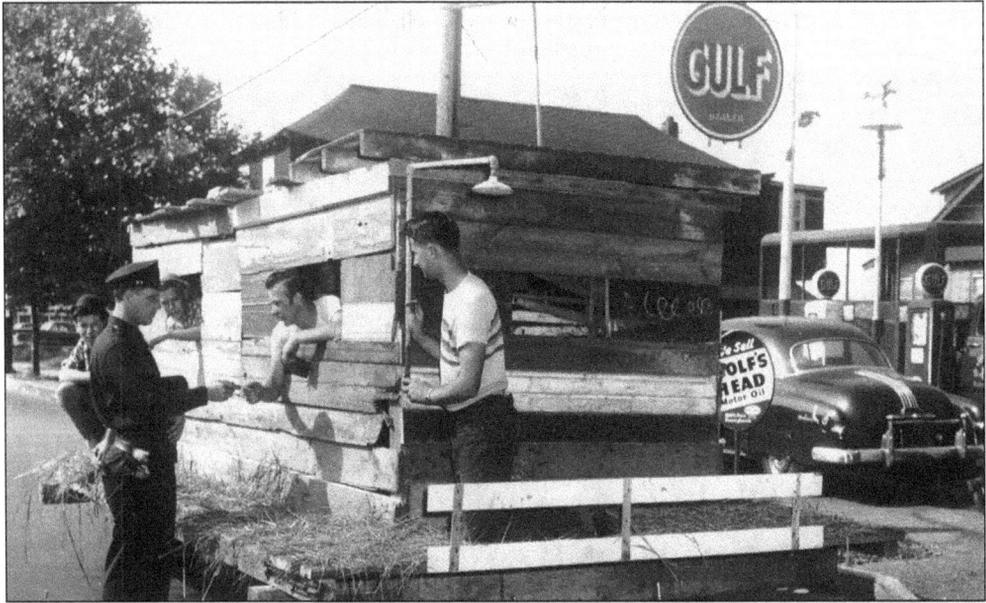

Called "This Old House," this float in the 1952 parade is built over a car and is self-propelling. A police officer stops the float, jokingly giving it citations for building without a permit and being an unregistered vehicle. A speaker played "This Old House," sung by Rosemary Clooney, a popular song at the time. (Courtesy of the family of Ed Clarity and the Broad Channel Historical Society.)

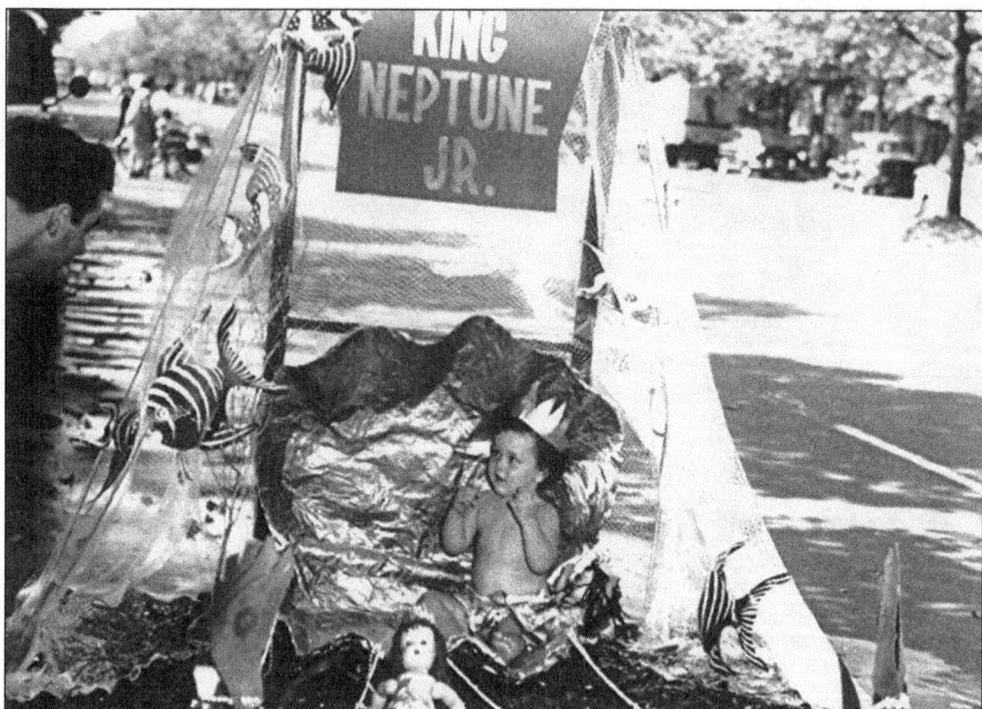

Children often developed float ideas once the presence of paved roads and motorized vehicles made them a common item in Mardi Gras "baby" parades. These photographs from the 1950s show creativity in developing themes for floats. In the image below, a little girl in leopard skin is Miss Tarzan on this jungle float, while two older boys stand on either side of her. Seen above, King Neptune Jr. holds court nestled in a seashell, a mermaid nearby. (Courtesy of John McCambridge Sr. and the Broad Channel Historical Society.)

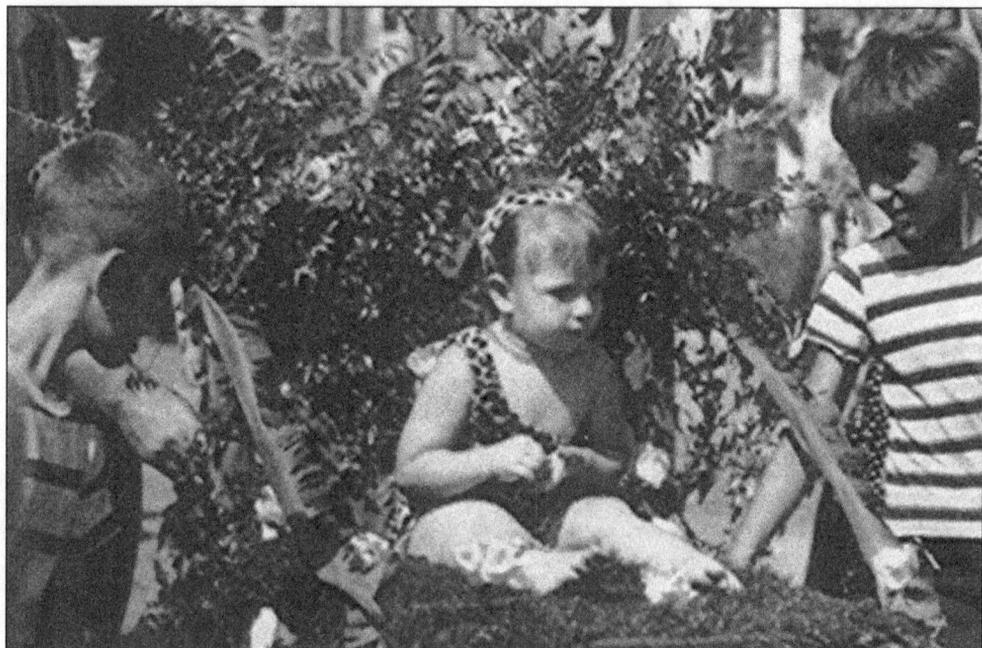

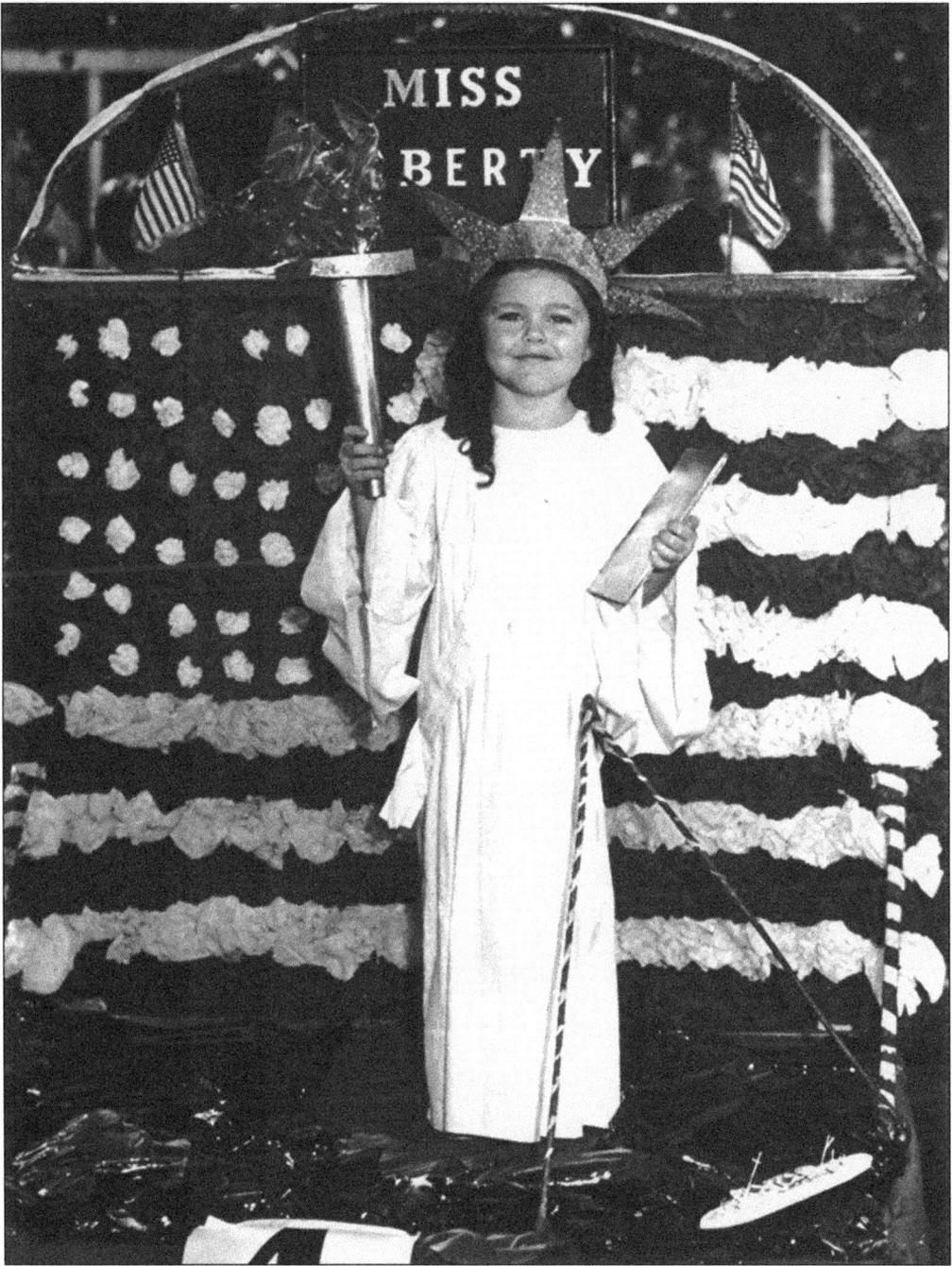

A float shows a replica of Miss Liberty as portrayed by Roberta DeMott. The waters of New York harbor in miniature, complete with ship, stand at her feet. Her torch and the flag recreation at her back are carefully and imaginatively done. Patriotic themes enjoyed great popularity then, as they do now. Note that the child is secured to the float frame. (Courtesy of John McCambridge Sr. and the Broad Channel Historical Society.)

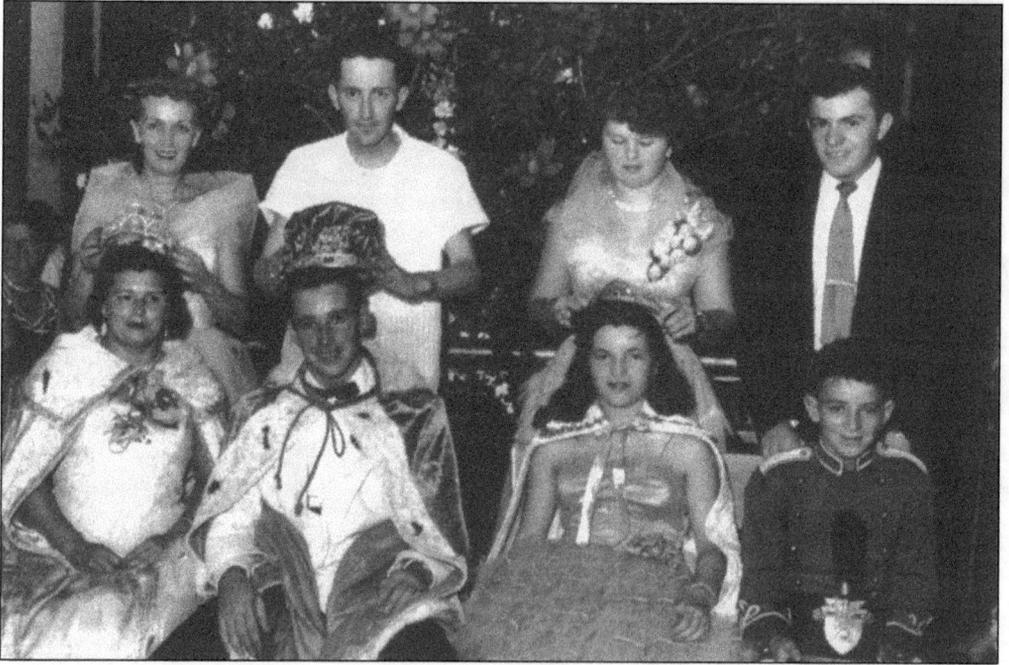

Crowning of the "royals" was done by those who held the reigning positions the previous summer. In this photograph from the 1950s, the queen, king, princess, and prince (seated left to right) received their crowns from their predecessors (standing left to right). This portion of the Mardi Gras fun typically has always taken place on Friday night. (Courtesy of John McCambridge and the Broad Channel Historical Society.)

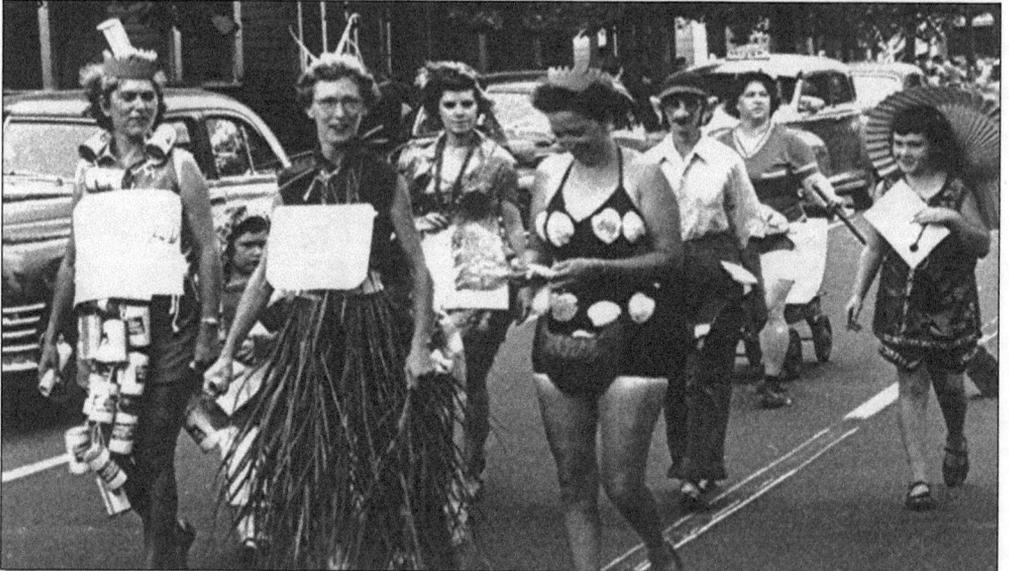

Mardi Gras has often been a "bring your imagination" affair. During the 1950s, boat parades and races continued to be part of the Mardi Gras tradition. One newspaper article from the mid-1950s reported one year that prizes would be presented by bandleader Guy Lombardo. He was also known to have raced his own speedboat, the aptly named *Tempo*, in competition at Broad Channel in 1948. (Courtesy of Broad Channel Historical Society.)

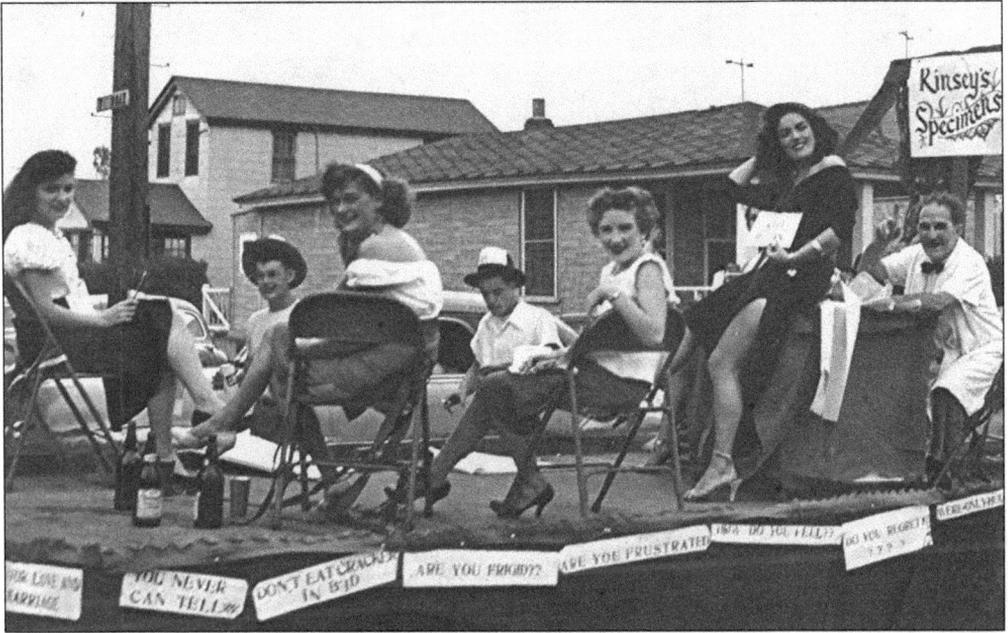

This is the lighter, more humorous, and satirical side of the residents in the parade—a float that took a good-natured poke at Alfred Kinsey, the sex researcher, and his recently published works. (Courtesy of John McCambridge Sr. and the Broad Channel Historical Society.)

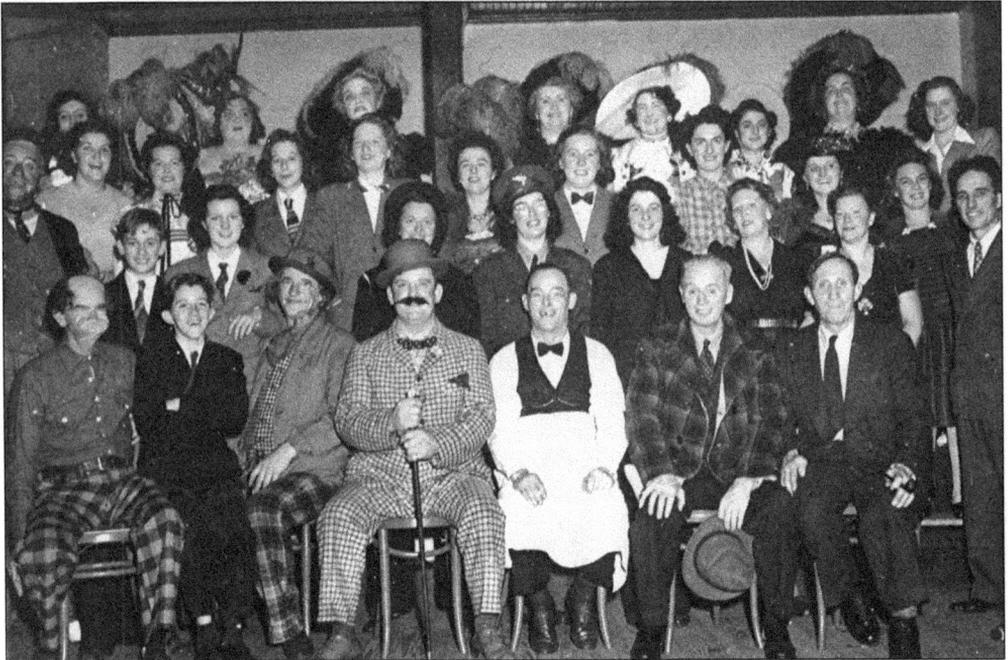

The cast assembles in full costume for a successful "Irish Night" song and dance revue. Characters and clothes here range from 1890s vaudeville to large-hatted society ladies to military uniforms and women in suits and ties. The first Irish Night was held on March 12, 1932, at Moran's Hotel and organized by the Holy Name Society of St. Virgilius. (Courtesy of Broad Channel Historical Society.)

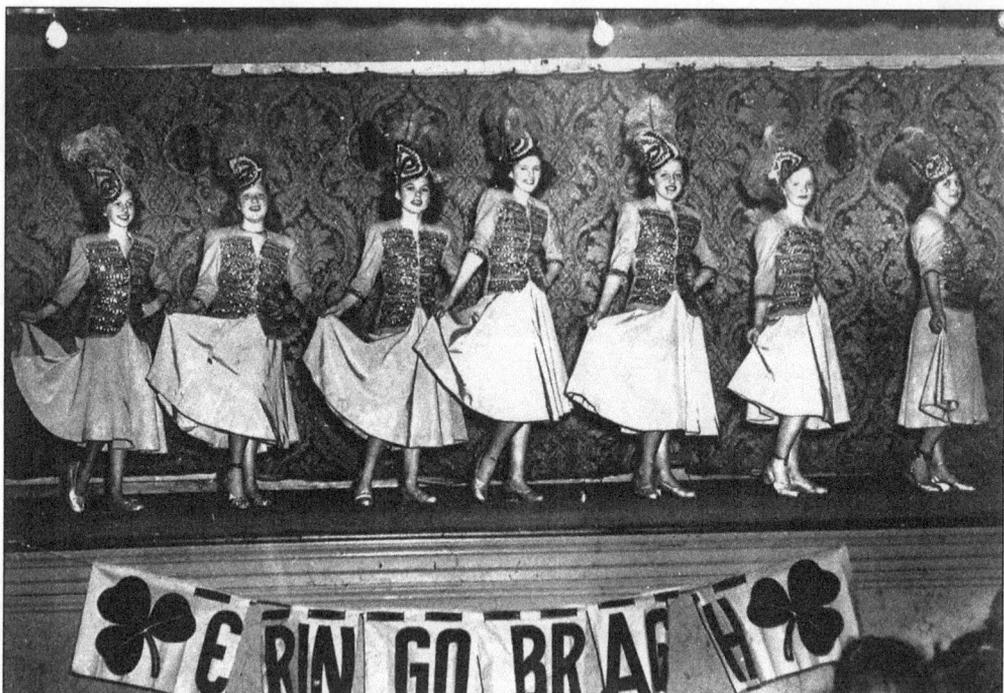

St. Patrick's Day has always been very important in the lives of Broad Channel residents. In the 1940s, approximately half of the island's population was of Irish heritage; most of the remainder were of German lineage. Above elaborately costumed young women performed in a show in honor of the special day. In the image below, costumed girls performed, also on the stage of the St. Virgilius Parish Hall. (Courtesy of Marilyn Siebermen and the Broad Channel Historical Society.)

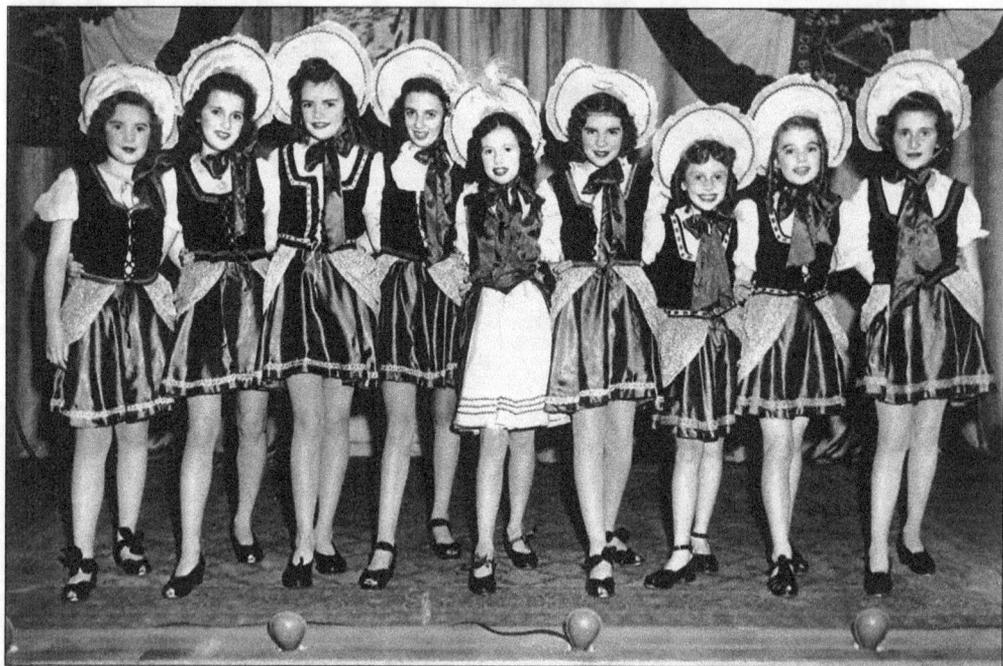

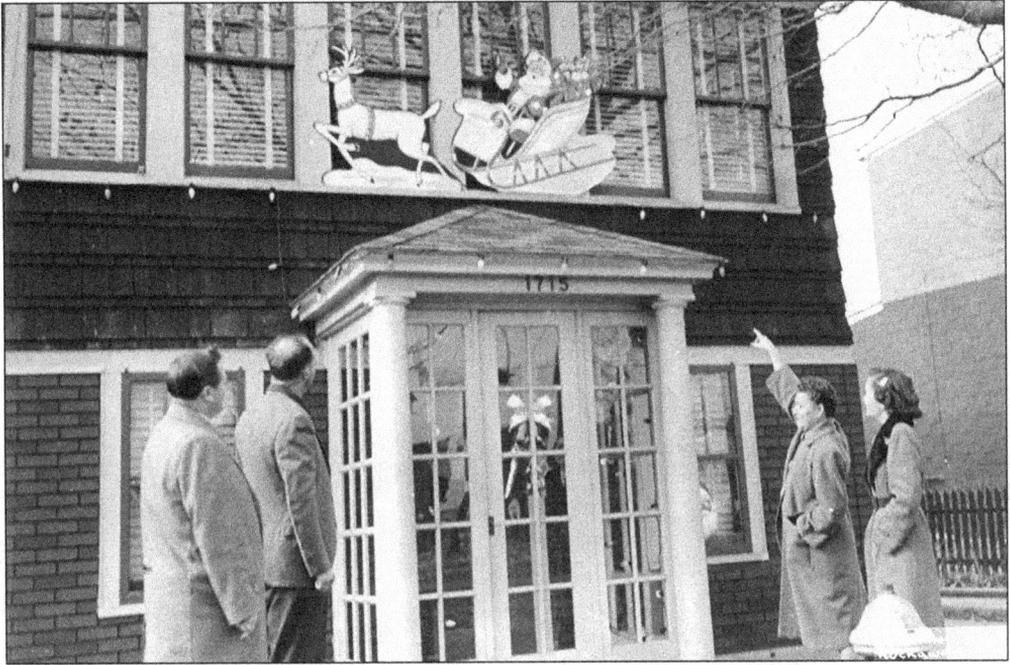

A long-standing tradition in Broad Channel is the Christmas House Decorating Contest, where people festoon their homes according to their chosen theme. A panel of judges picks the winning houses in each of various categories. In this photograph, from the early 1950s, decorations at 17–15 Cross Bay Boulevard are being examined by the judges. (Courtesy of Marilyn Kass Stewart and the Broad Channel Historical Society.)

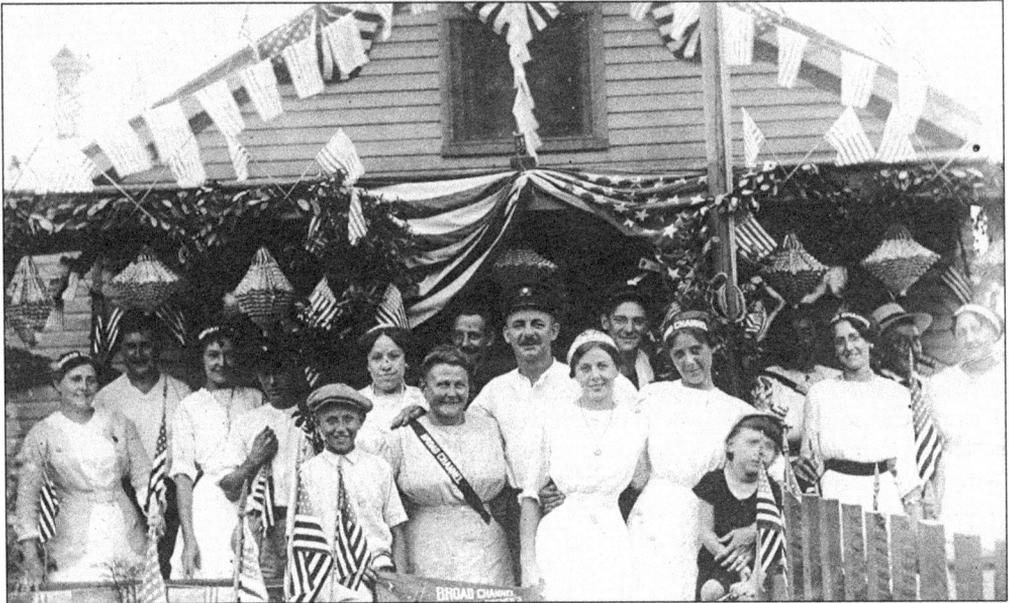

This early 1900s photograph shows that its own brand of Mardi Gras has long been a summertime practice in Broad Channel; part of the festivities was a patriotic display. At bottom center there is a pennant, which reads "Broad Channel Volunteer Fire Association." This highly decorated house was on Sixth Road. (Courtesy of Jean Bohne Ryan and the Broad Channel Historical Society.)

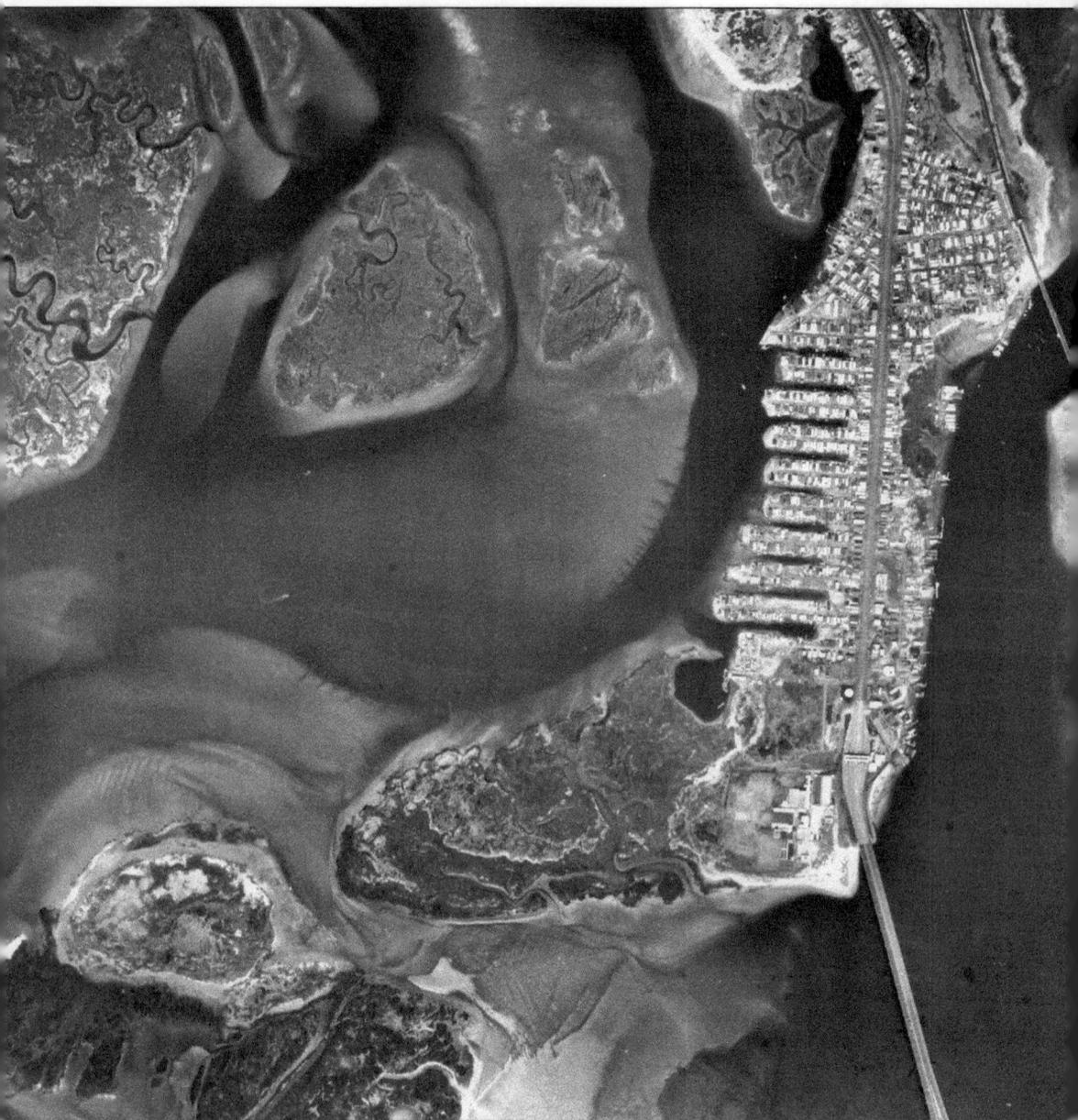

This aerial view of Broad Channel shows the size and shape of the island on which the community is located. It also shows the subway line to the east, the bridge to Rockaway in the south, the canals on the west side of town, and the surrounding marshes of Jamaica Bay. The tiny white circle near the southern end of town is the carousel, which is now gone. The landmass at the bottom of the photograph to the left was the location of the Broad Channel baths. In its current configuration, the island is comprised of fill and other landmasses. The residential community occupies the lower third of the island, while the upper two-thirds are federal land known as the Jamaica Bay Wildlife Refuge. (Courtesy of Aero Graphics Corporation.)

Three

SURROUNDED BY WATER
BROAD CHANNEL AND JAMAICA BAY

The now defunct *Daily Brooklyn Eagle* (1841–1955) noted, probably sometime between the 1880s and 1900s, "Broad Channel boasts a fairly good hotel and caters chiefly to fisherman . . . (with) boats and bait. The Broad Channelers are all shrimp fisherman who get 75 cents a bucket." Since 1609, when Henry Hudson sailed into Jamaica Bay to reckon his best course to China, and probably when the Canarsie and Jameco Indian tribes fished and hunted in the area, its rippling waves have had a special hold on people, especially newcomers.

It is not surprising that Broad Channel, which nearly literally rose up from the bay, has water at its roots.

Prior to the 1880s, those who lived on these isolated islands made their living fishing, shrimping, or harvesting clams and oysters for the seafood trade. After the railroad came bringing regular access to Broad Channel, hotels and restaurants were built out and over the water. Fishing, boating, and bathing beaches became major attractions. Boat yards, rentals, marine services, and dry docks still dot the area, and it is not unusual to see boats on trailers parallel parked between cars along the streets.

The orange-hulled boats of Smitty's Boat Rental are often visible in great number on the blue waters between the Rockaway Peninsula and the Broad Channel shore.

Since it is an island, one can never go too far in any direction in Broad Channel without reaching Jamaica Bay. From almost any elevated vantage point in town, one can see the water. Many people made their homes right up against the tide line. Others, especially along the west side canals, have the bay right in their backyards. Then as now, Broad Channelers are never far away from the water.

This group gamely passes the time between low and high tide by discussing the daily newspaper. The gentleman at rear is strumming a short-necked banjo. The boat is "safely" moored by a rope tied to the bow. (Courtesy of the Theis family and the Broad Channel Historical Society.)

In 1918, Broad Channel boating was a popular pastime on Jamaica Bay. Here a boy cools his feet in the water, and a woman protects herself from the sun with a large hat. (Courtesy of the Theis family and the Broad Channel Historical Society.)

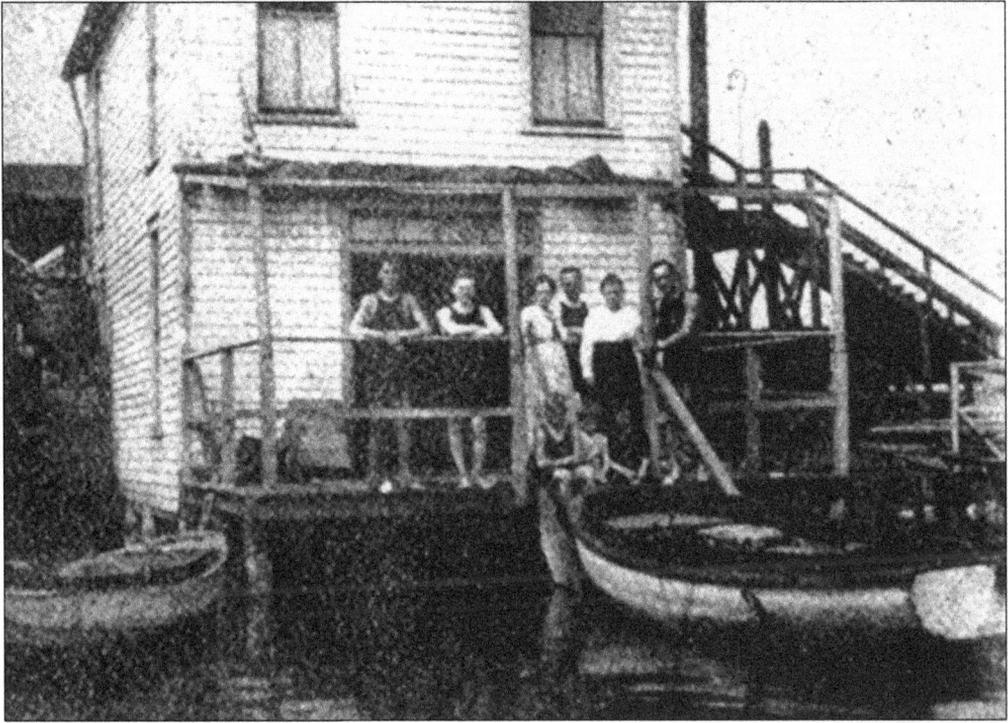

A typical Broad Channel house on the water is seen in 1918. At the right, there is an overpass to cross tracks of the LIRR. A boat is docked close at hand at steps leading to the water. Unlike most houses that had ladders leading straight down to the water, this house's ladder was built like stairs. (Courtesy of the Theis family and the Broad Channel Historical Society.)

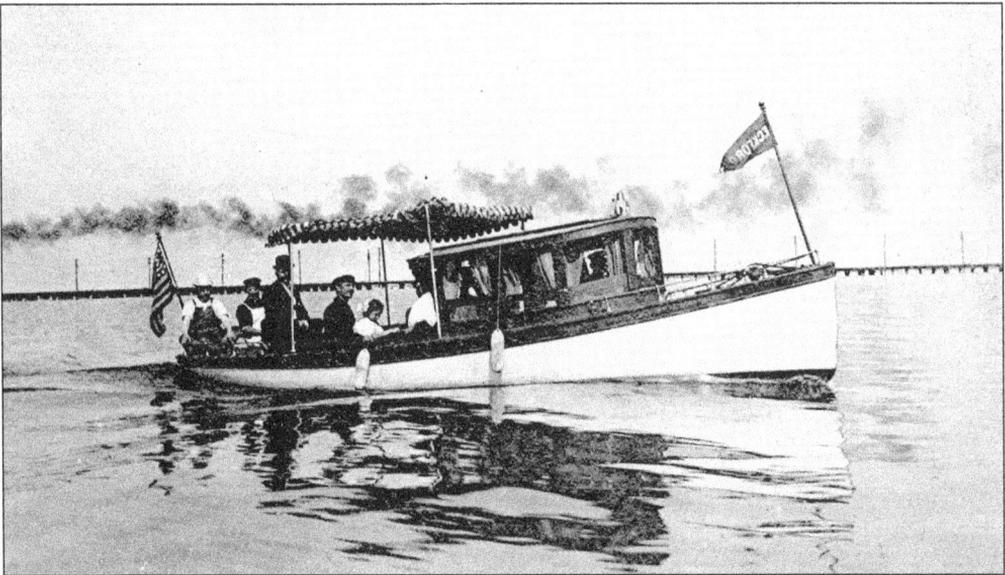

A coal-burning boat steams on Jamaica Bay just north of Broad Channel. Note the railroad tracks extending across the bay in background. Bags called "fenders" or "bumpers" were hung over the side of the boat to protect it from damage when it rubbed against the pilings while docking. (Courtesy of Stanley Reich and the Broad Channel Historical Society.)

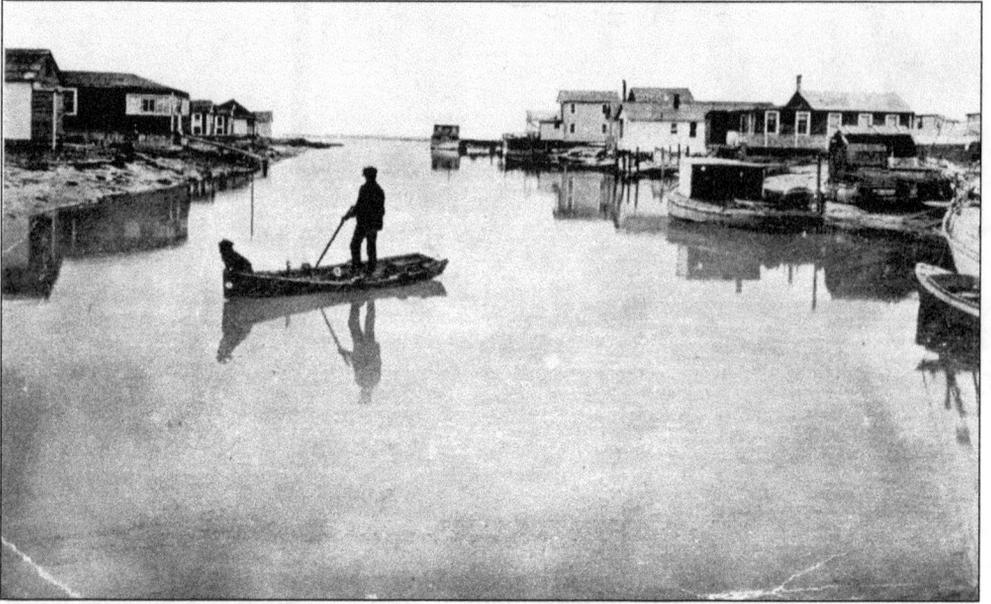

Broad Channel's first canal lies between Tenth and Eleventh Roads. The water-filled spaces between streets on the west side of the island allow people to secure their boats outside their homes' back doors and fish from their dock or deck. (Courtesy of Alvina and Jack Reis and the Broad Channel Historical Society.)

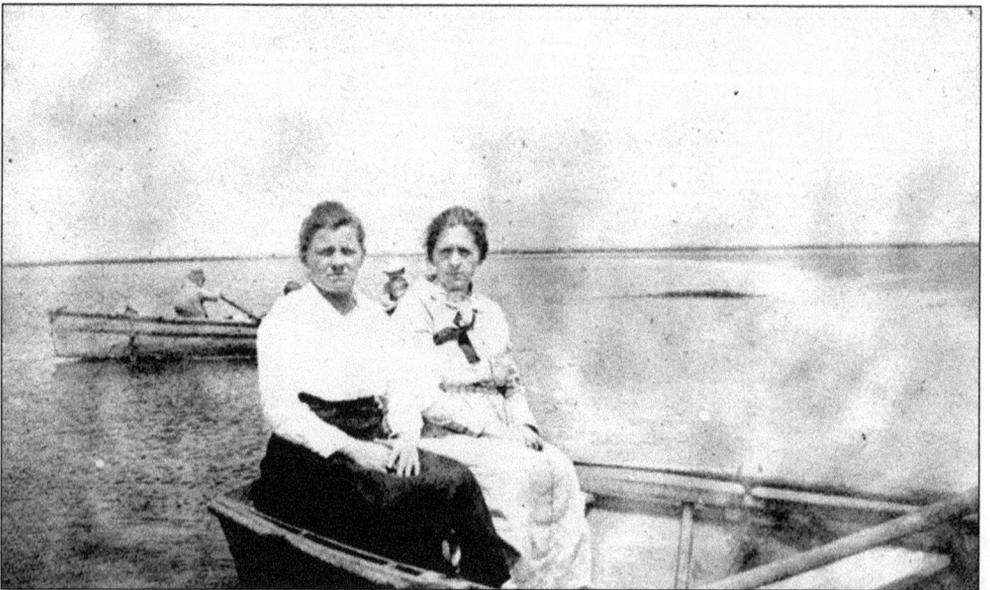

Two women appeared uncomfortable posing in the stern of the rowboat in which they were riding on the waters of Jamaica Bay. Summertime often brings calmer waters to the bay; at times, the water's surface looked like glass. (Courtesy of the Theis family and the Broad Channel Historical Society.)

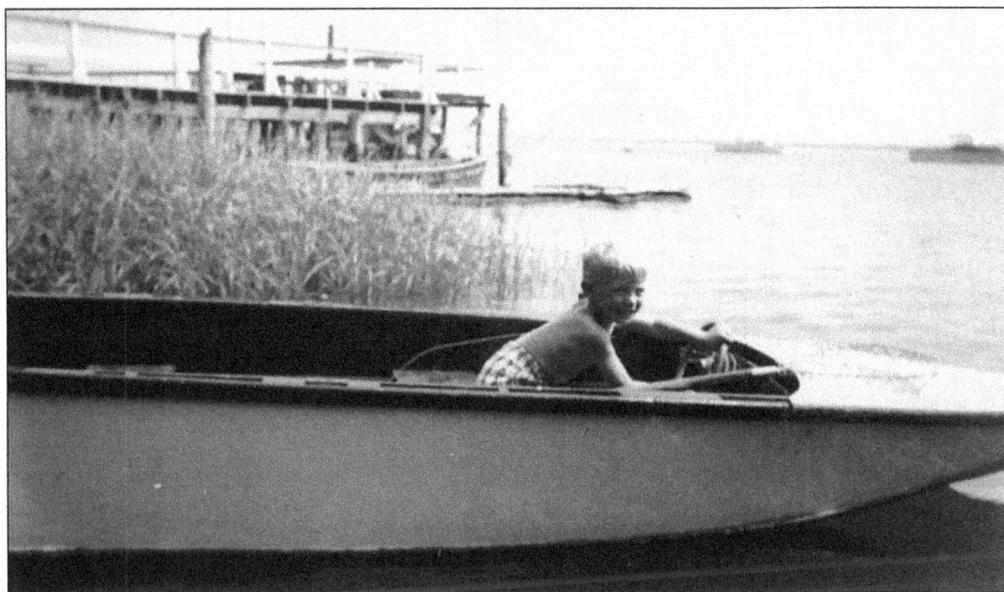

Greg Henkel poses in a boat made by his father in the 1950s. Immediately in back of the boat are salt marsh grasses, plants that often grow where the land abuts the saltwater source of Jamaica Bay. At the rear is the North Channel Yacht Club, an organization still in existence and quite active. (Courtesy of Dr. Gregory Henkel.)

In 1919, these Broad Channel residents were "cooling their heels" and laughing at the splashing they made in the Jamaica Bay waters surrounding the island; the bay was literally in the backyards of some of the houses. (Courtesy of the Theis family and the Broad Channel Historical Society.)

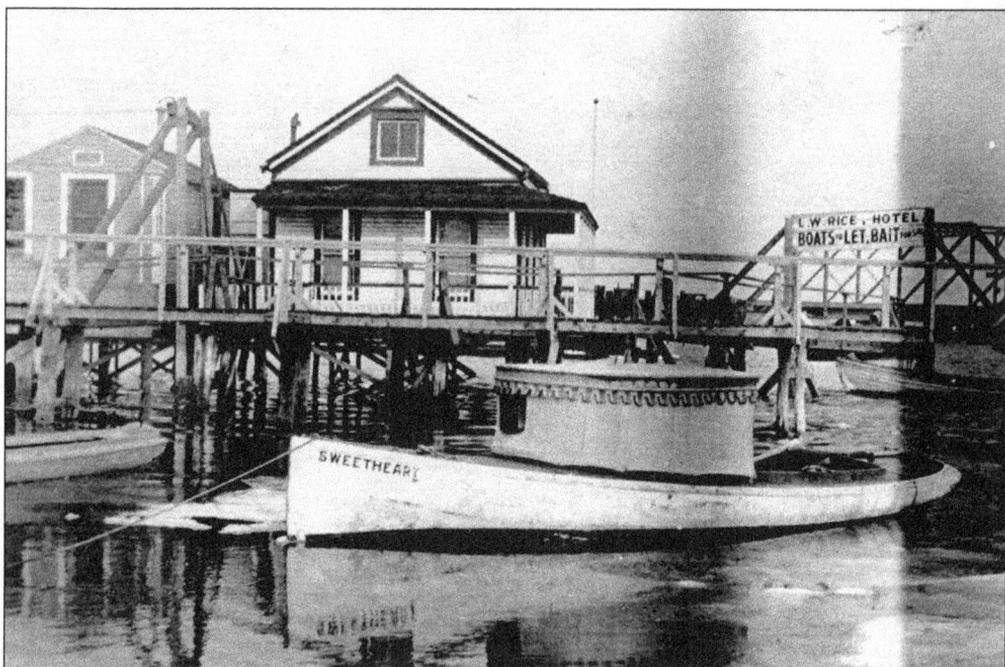

In the early 1900s, a sign indicates L. W. Rice Hotel. It offered boats for renting and bait for sale for guests who enjoyed angling. This boat with an unusual windscreen/overhead is named *Sweetheart*. Note the train trestle in the background. (Courtesy of the Theis family and the Broad Channel Historical Society.)

Men relaxed in their swimwear in 1918 Broad Channel, posing on a ramp. The purpose of these ramps was to connect the back deck of the house to a floating dock, which moved up and down with the rise and fall of the tides. (Courtesy of the Theis family and the Broad Channel Historical Society.)

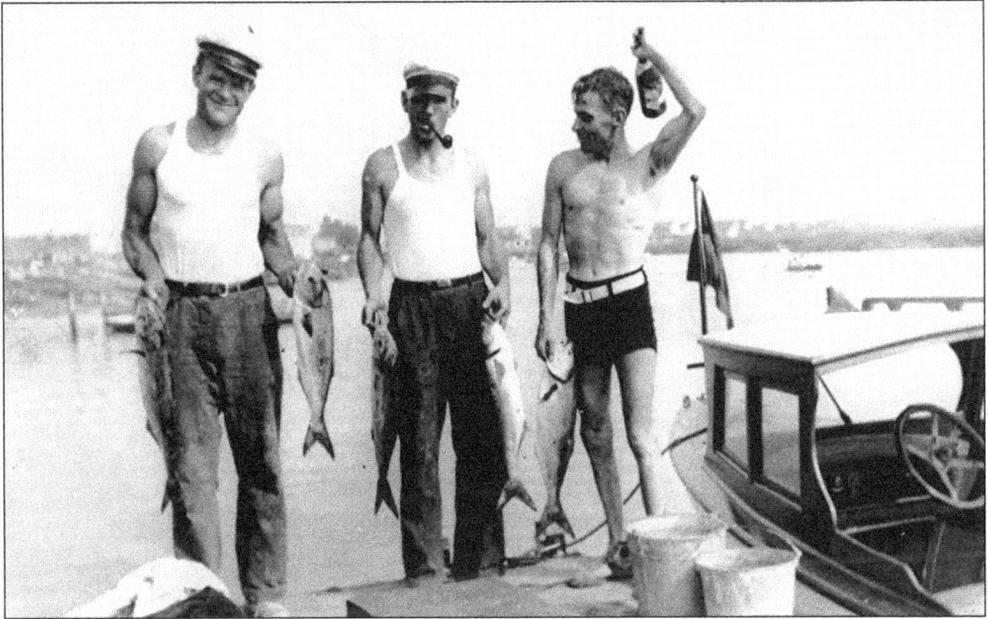

This 1936 photograph showed the dock at the Egg Harbor Yacht Club. The Egg Harbor Yacht Club was actually founded by people who did not live in Broad Channel. After they vacated the building, it was made over into a single family home. Due to its grand size, it was considered by the local people to be "pretentious." (Courtesy of Victor and Marion Durchalter and the Broad Channel Historical Society)

The waters of Jamaica Bay teemed with edible life. Crabs of all types inhabited the waters, as did many varieties of fish, seaweed, mussels, oysters, and clams. During the Prohibition era, there were several speakeasies located on the island. They served clam chowder to lure patrons to drink liquor in their facilities. (Courtesy of Broad Channel Historical Society.)

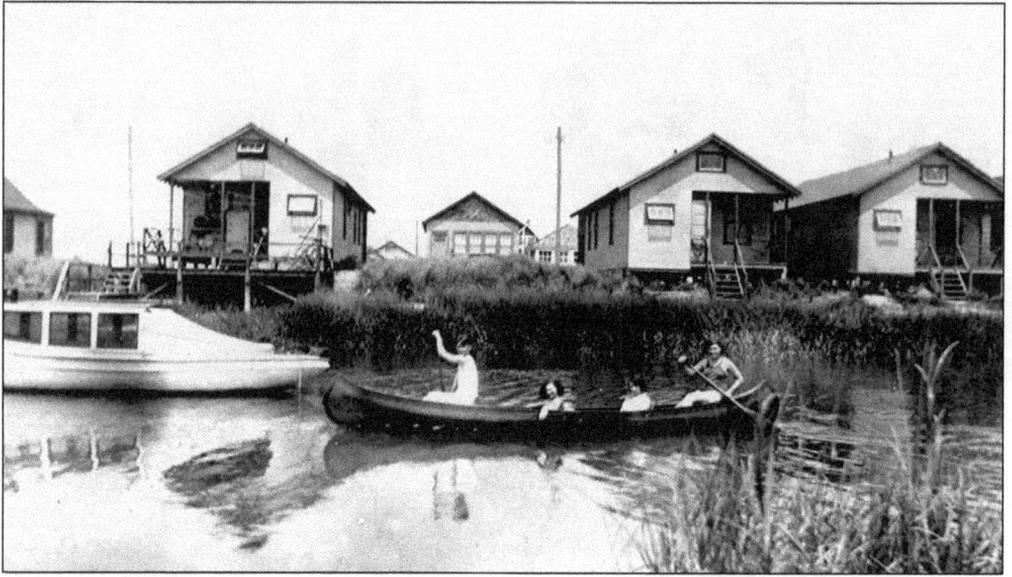

Young women paddled a canoe on one of the canals, taking their passengers to and fro in a pastime that required synchronous movements. Homes perched above the banks while good-sized clumps of marsh grasses grew in the calm waters of the canals. (Courtesy of Hazel Chamberlain and the Broad Channel Historical Society.)

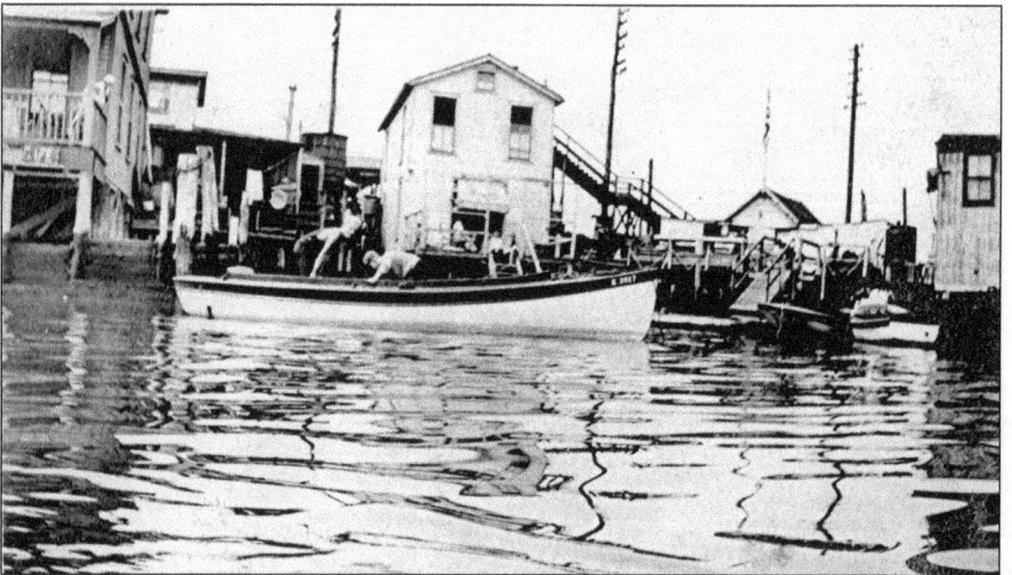

Here two men prepare a boat on a typical day in 1918. The ramp at right leads to a floating dock and other boats that are moored nearby. The high stairway at center right does not lead to the second floor of the house as it appears. It is part of the railroad crossover. (Courtesy of the Theis family and the Broad Channel Historical Society.)

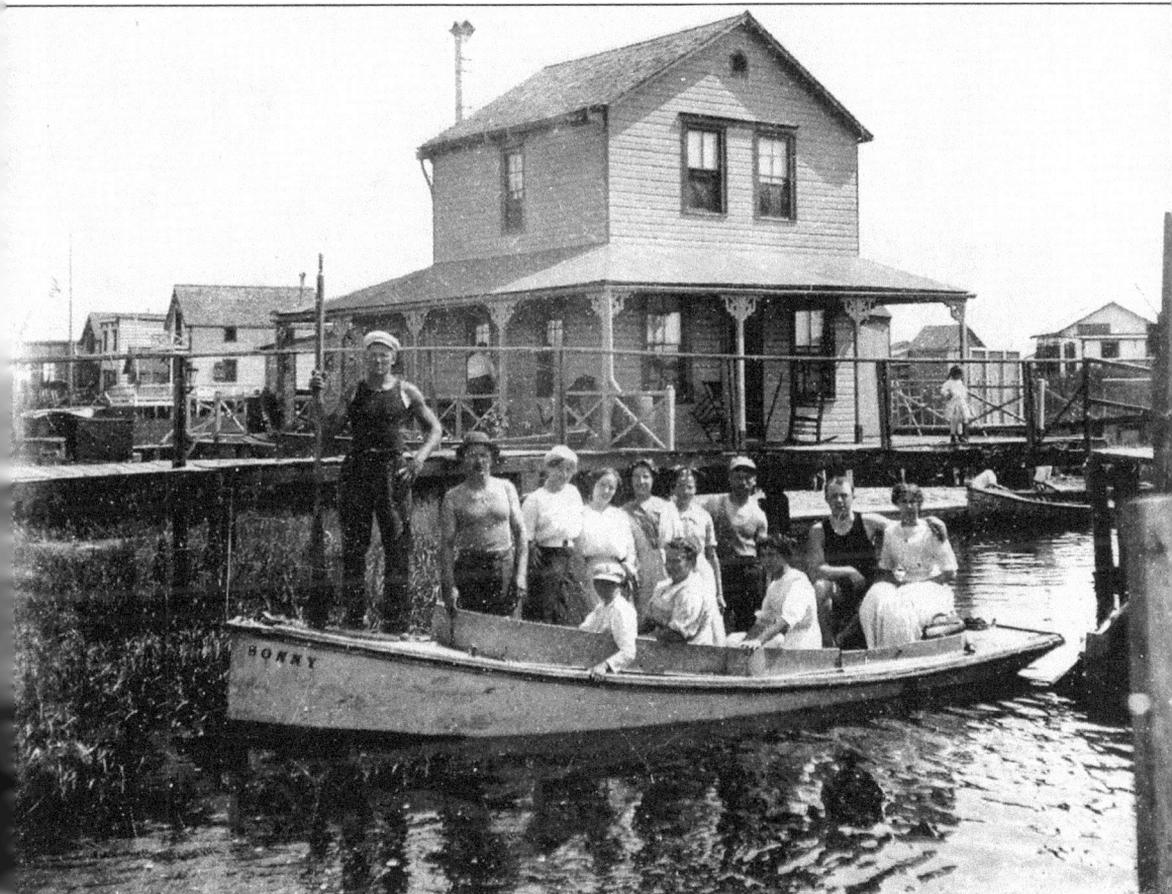

Broad Channel of the early 1900s boasted many structures, all connected to each other by boardwalks. People were cooled by the effect of the surrounding waters on summer breezes. Being on the island was almost like living in Venice as this photograph shows the system of wooden walkways, the houses perched on stilts over the water, good use of the closeness of the water, and access to a boat. The boat is named *Sonny*. (Courtesy of Jean Bohne Ryan and the Broad Channel Historical Society.)

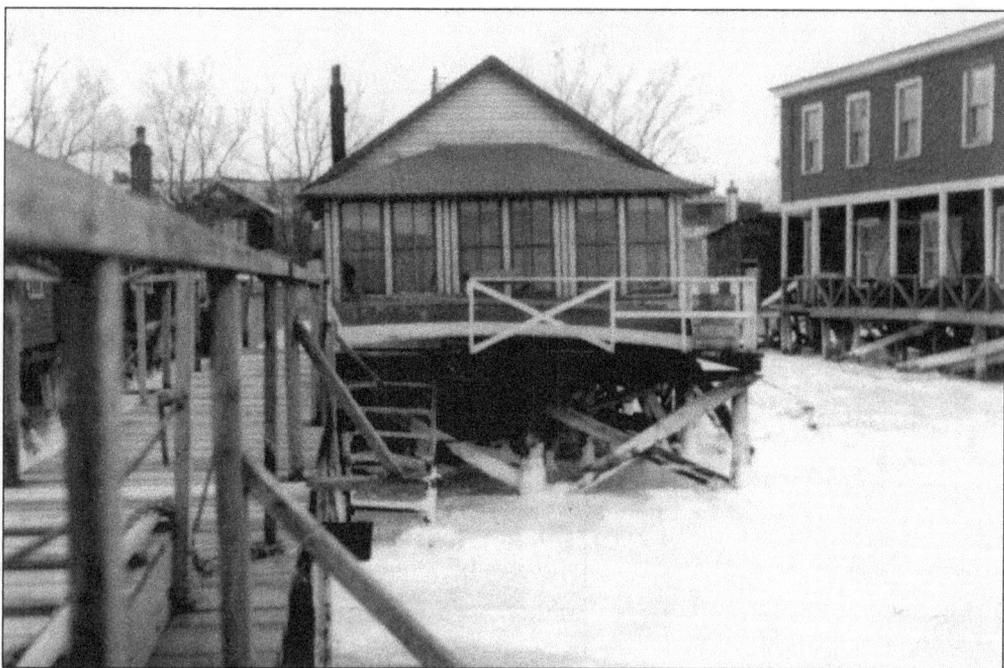

Broad Channel houses weathered a 1950s deep freeze. Low tide gives a good view of the stilts under the one-story house. Pipes under the houses are carefully covered with insulation to prevent freezing. On the right is a house that was moved from the Raunt, a northern bay colony, by barge to its new location on the southeastern side of Broad Channel. (Courtesy of Dr. Gregory Henkel.)

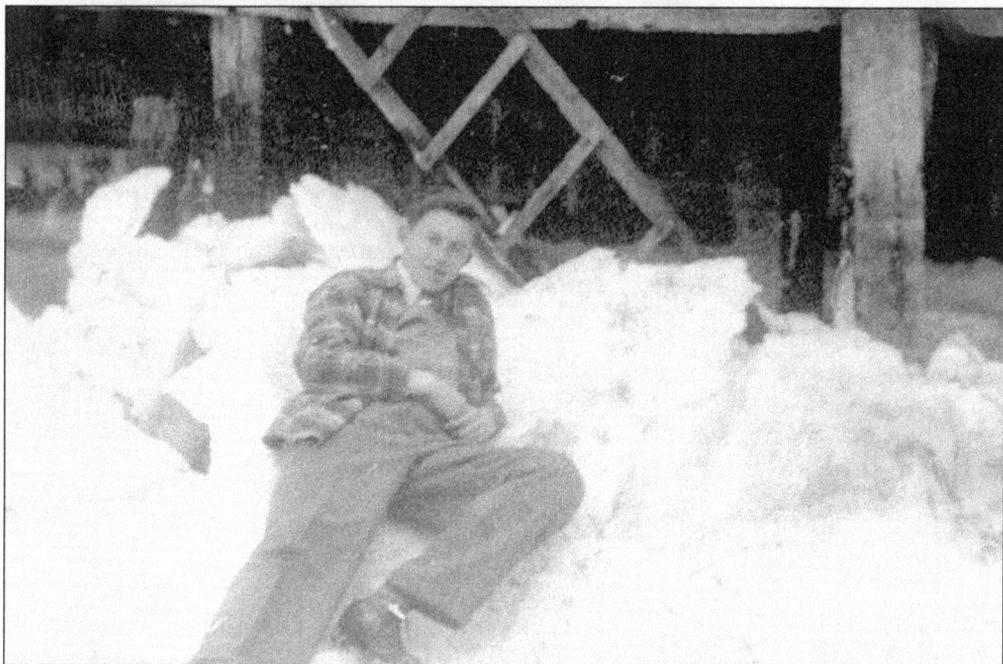

A teenaged Larry Sweet is perched on the canal at the rear of his home in 1941. Snow and ice piled up to almost cover the stilts under the home. Just as the lapping waves provided enjoyment in summer, many made the frozen bay a playground in winter. (Courtesy of the Sweet family.)

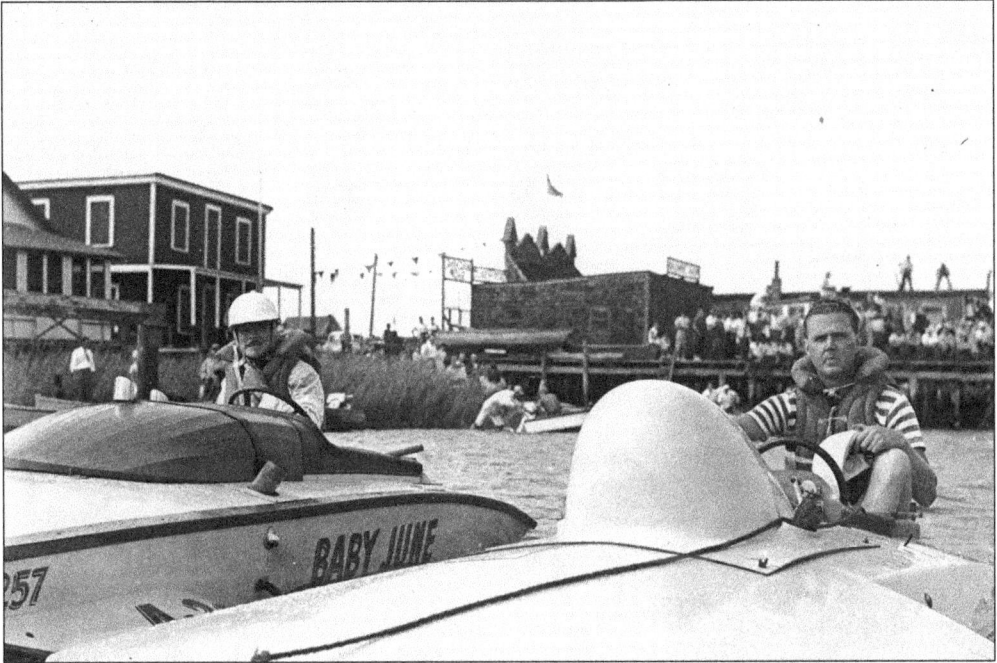

As the decades of Mardi Gras passed, the speed of the contest entrants increased. From locomotion by foot through gasoline engines, Mardi Gras contests could involve more and more speed. In this 1950s Mardi Gras photograph, men wait for the signal in a speedboat race. (Courtesy of Carol and George Boyle Sr. and the Broad Channel Historical Society.)

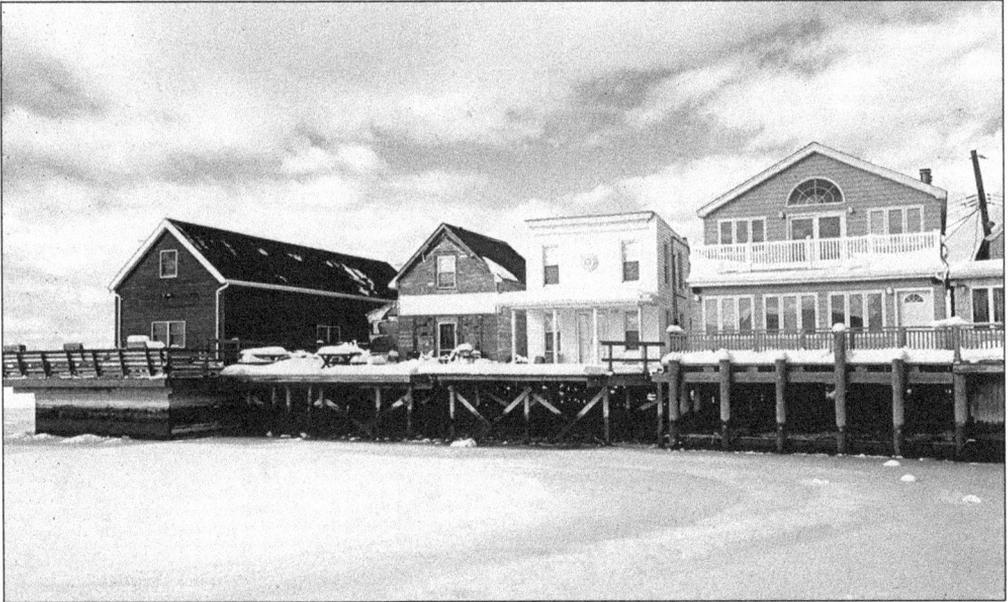

Houses on stilts are becoming rare in the 21st century. This 2007 photograph pictures examples of the homes on stilts in Broad Channel today. Often described as a working class neighborhood, Broad Channel finds lawyers, engineers, teachers, writers, artists, and other professionals among its population of resident police officers, firefighters, and other government employees. This scene is by the sluice on the west side of the island community. (Courtesy of Don Riepe.)

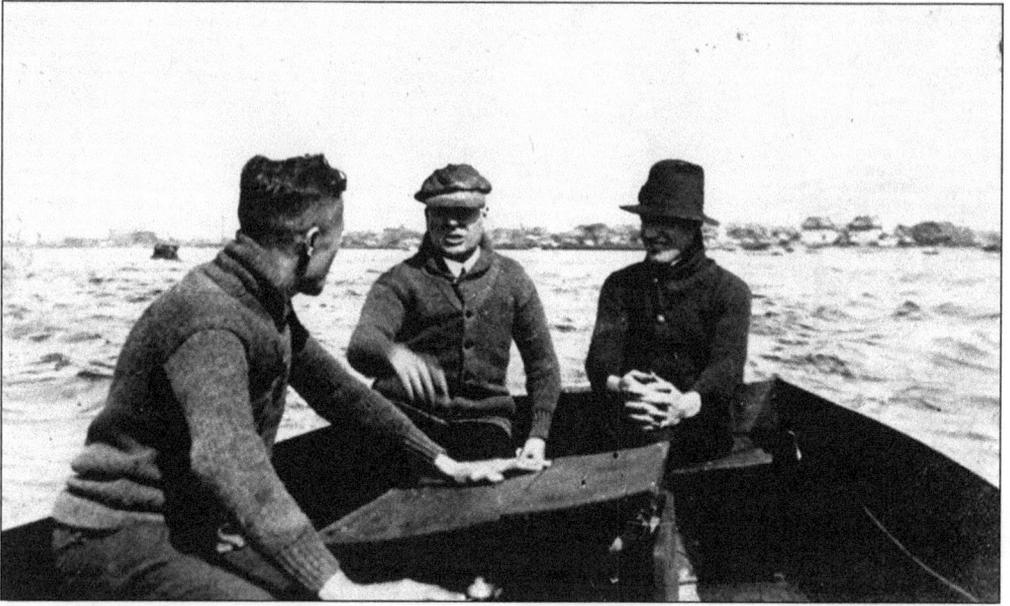

This picture from around 1918 is part of a group that records a boating excursion out onto Jamaica Bay. Then as now, even a small boat could reach the Rockaways, Howard Beach, Jamaica, parts of Nassau County Long Island, and also Brooklyn. (Courtesy of the Theis family and the Broad Channel Historical Society.)

This c. 1918 photograph illustrates some of what made Broad Channel a popular summer destination. The house itself would offer simple but comfortable accommodations, with the deck being a perfect place to enjoy the fresh air and a commanding view of Jamaica Bay with mesmerizing sunrises on the east side of the island and spectacular sunsets on the west. (Courtesy of the Theis family and the Broad Channel Historical Society.)

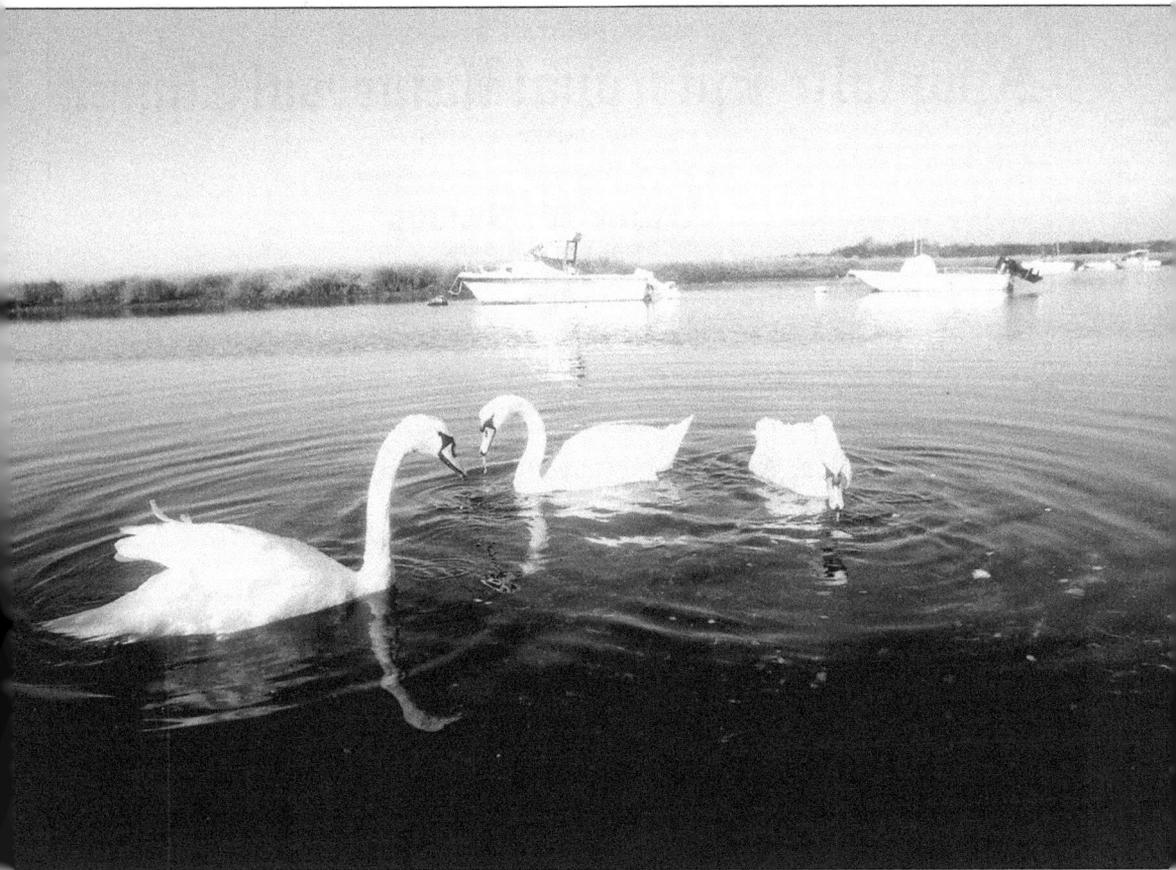

Mute swans swim in the calm waters close to the shores of the island community. These animals are native to Europe and Asia, but were successfully introduced into the United States. With white feathers, they have orange bills whose tip and base are black; they also have sturdy legs and webbed feet that are black. In the wild, they live about 19 years. Adults range in weight from 19 to 28 pounds; when they are fully extended, they measure 56–62 inches tall. The swans have been seen leaving the water and walking around the community, padding along the sidewalk. One resident, who lives near the water, had a swan's nest in her yard for many years. On rare occasions, they bring their families on their forays into the neighborhood and are very protective of their young. (Courtesy of Don Riepe.)

METROPOLITAN SYNOD

Apostolic-Episcopal Universal Church

IN THE UNITED STATES

By the Ecclesiastical Administrator

Arthur W. Brooks
Titular Bishop of Sardis

✠

In the Name of the Father and of the Son and of the Holy Ghost, Amen.

To all the faithful in Christ Jesus, throughout the world, Greetings:

Be it known by these Presents, that acting in accordance with the Canons and Ordinances of this Jurisdiction of the

One, Holy, Universal and Apostolic Church

on the date herein written

We, Arthur W. Brooks, the Ecclesiastical Administrator of

Metropolitan Synod

Conferring the **Sacramental Rite of Confirmation** *by the laying on of Hands after the example of the* **Holy Apostles** *did administer to*

John Reich

this **Apostolic Chrismation,** *wherein were conveyed the* **Seven-Fold Gifts of the Holy Spirit,** *which administration was at* **Divine Worship** *in* *Christ's Church by-the-Sea, Broad Channel N.*

being presented by *Rev Harold Jarvis*

In Testimony Whereof, *we have affixed hereunto our signature and seal this* *9th*
day of *April (Palm Sunday),* 19*33* *A. D. at* *Broad Channel N.Y.*

✠

Attest *D. B. Lunday*

+ Arthur W Brooks
Titular Bishop of Sardis
Ecclesiastical Administrator

ECCLESIASTICAL LETTERS

RECORDED NO. *C632*

A confirmation certificate from the Protestant church showed its name at that time to be Christ's Church by-the-Sea and indicates it was issued before the congregation voted to become Presbyterian. The certificate, dated (Palm Sunday) April 9, 1933, was issued to James Reich. (Courtesy of Broad Channel Historical Society.)

Four

IN THE HANDS OF FAITH
COMMUNITY AND CHURCH

From early on, faith has been an important part of the fiber of residents of Broad Channel. For decades it has been served by two neighboring churches, St. Virgilius Roman Catholic Church and Christ Presbyterian Church By The Sea.

Catholic services were first held in people's homes in 1905 by a priest visiting relatives on weekends. They became a more permanent feature when a Rockaway pastor arranged to send a priest every Sunday for morning mass. First started in the dining room of Hoob's Pavilion, advanced attendance moved services into the larger dance pavilion. Later, the firehouse was pressed into service. The first church building was dedicated on July 4, 1914.

The Protestant church in Broad Channel started as a Sunday school which was organized by several neighborhood women and which held classes in the open-air moviedrome. Soon interest grew and a church was built in 1920. It was served by a number of fine pastors. Starting as a Union Church, it included all Protestant denominations. The congregation voted to make it a Presbyterian church in the 1950s.

Both churches sponsor community events and fund-raisers and engage in good works that go far beyond the community. In the true spirit of neighbors, they have worked together right from the beginning.

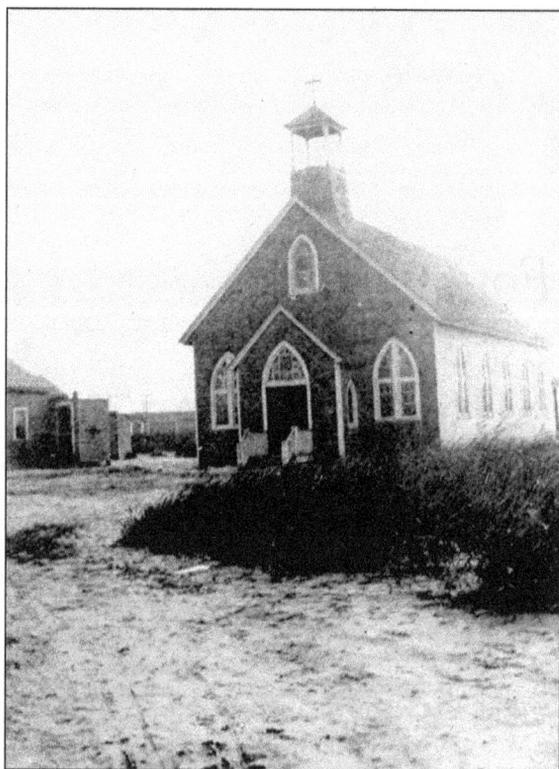

St. Virgilius Roman Catholic Church in the 1920s sat behind a generous sized clump of vegetation. Originally facing onto Church Road as shown here, the church was later turned to face Noel Road. At the time of this photograph, the St. Virgilius School had not yet been built. (Courtesy of the Theis family and the Broad Channel Historical Society.)

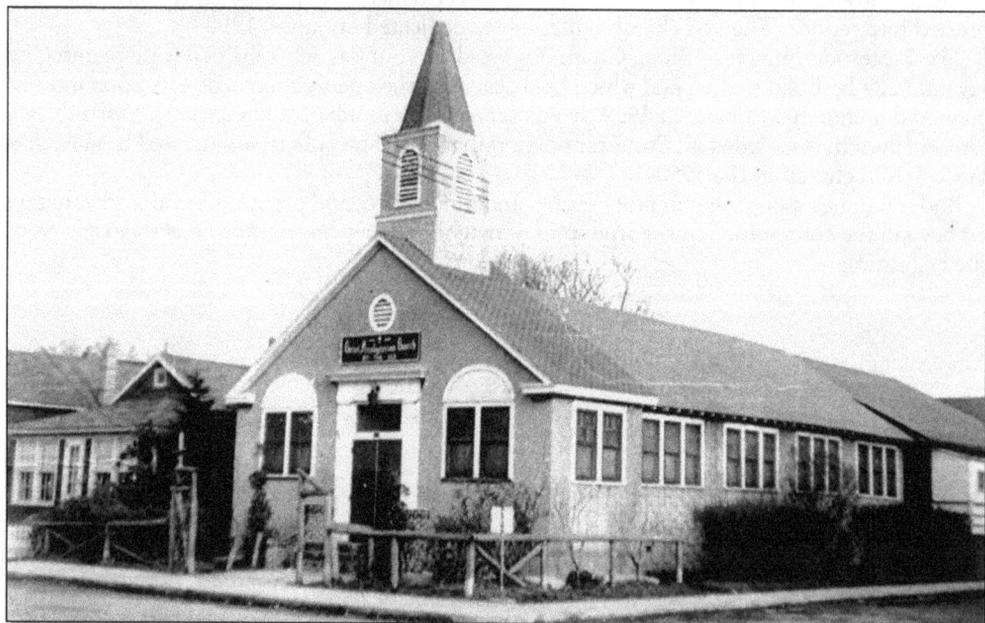

The congregation of Christ Church by-the-Sea had already cast their vote to become a Presbyterian church when this photograph was taken. The hall was later joined to the church and became one building, with a single roof. The hall houses fund-raising efforts for needy causes as far away as Asia and as close as a Rockaway nursing home. (Courtesy of Zoe Verruso and the Broad Channel Historical Society.)

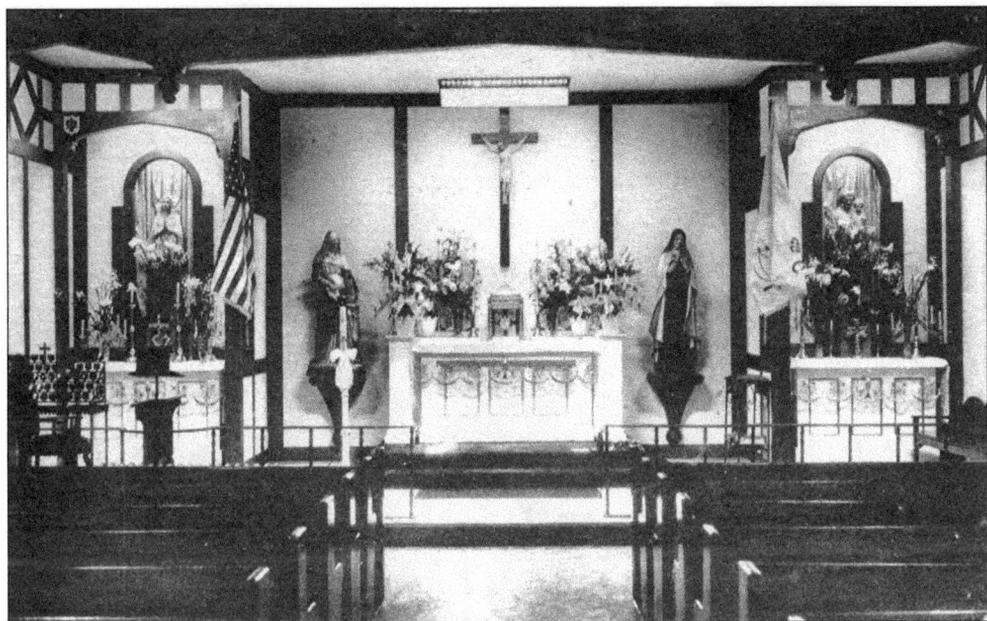

Broad Channel today still has two churches with active, involved congregations that raise considerable amounts of money for local causes or far away events like Hurricane Katrina in 2005. Pictured is the interior of St. Virgilius Roman Catholic Church in the 1950s from a postcard made from an Ed Clarity photograph. Clarity, a resident, was a nationally known news photographer. (Courtesy of Irene Peters Whelan and the Broad Channel Historical Society.)

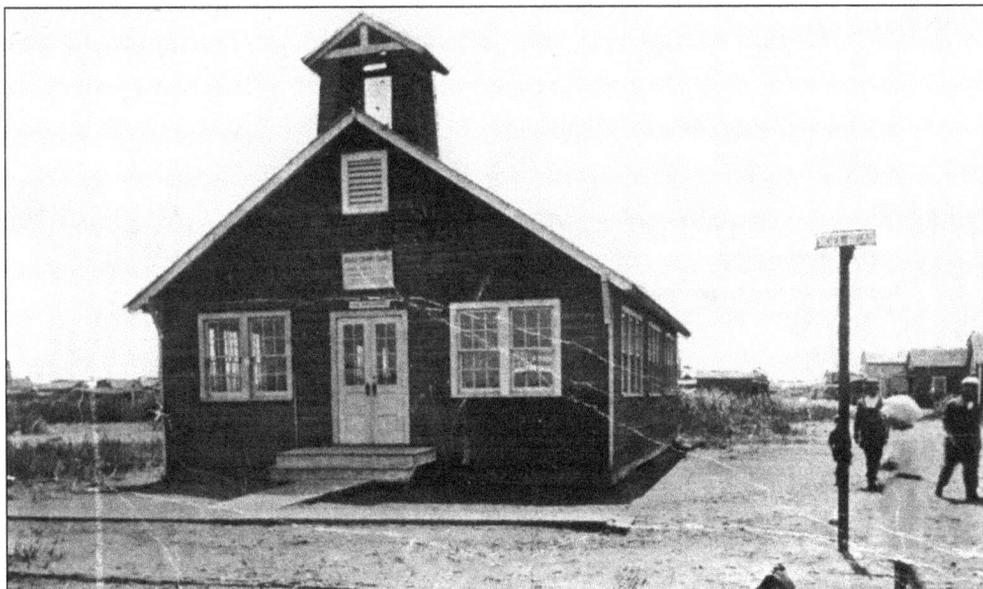

At the corner of Noel and Church Roads stands Christ Presbyterian Church by-the-Sea. Shown is the original church built in 1920 as a multi-denominational Protestant church. Under the leadership of Bishop Wolfert Brooks (1927–1948), the parish changed to Episcopal standing. After 1950, the church affiliated with the Presbytery of Brooklyn-Nassau. Here the church is seen surrounded by empty land, but today is surrounded by houses. (Courtesy of Broad Channel Historical Society.)

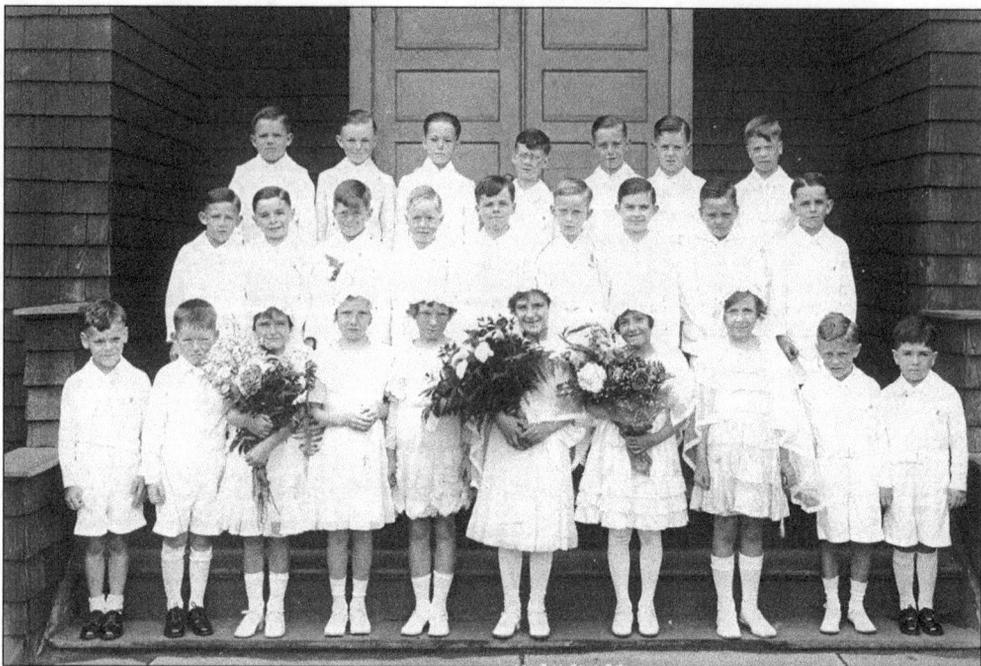

The 1935 First Communion class of St. Virgilius Roman Catholic Church poses on wooden steps for their photograph. There were 20 boys and only 6 girls. All of the boys appear to be wearing identical white outfits popular for Communions at that time. While the girls are wearing different dresses, their head covering appears to be identical. (Courtesy of Broad Channel Historical Society.)

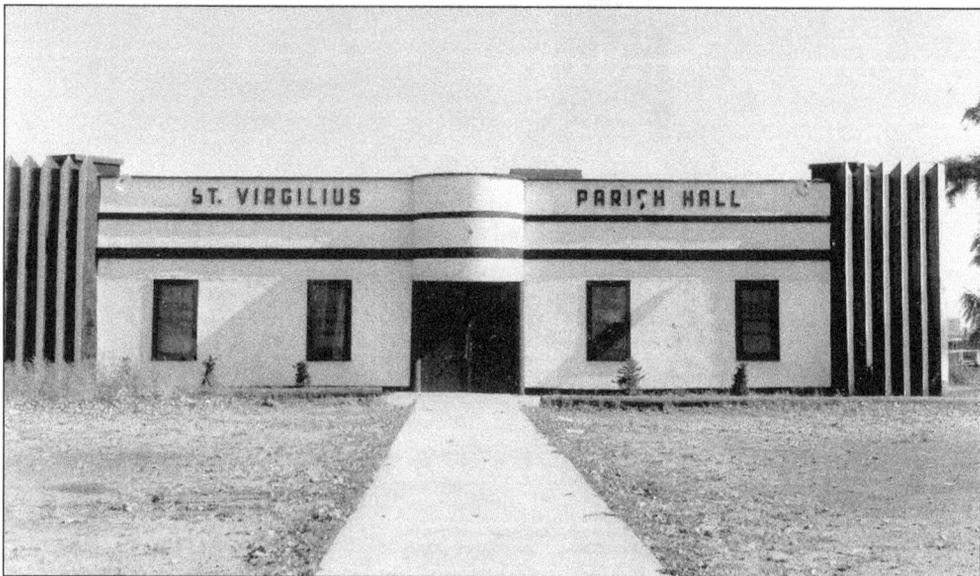

St. Virgilius Parish Hall is shown here in the 1950s. Originally a night club, it had an "art moderne" facade, and was located at Cross Bay Boulevard and Twentieth Road, set far back from the boulevard. Many entertainment productions were performed in the hall. The land it had occupied was sold, and it was taken down in recent years; new homes were built on the site. (Courtesy of John McCambridge and the Broad Channel Historical Society.)

This 1940s image shows Noel Road on the left from this corner at Cross Bay Boulevard. On the right is a roster of Broad Channel servicemen serving in World War II. The Catholic and Protestant churches stand side by side. St. Virgilius Roman Catholic Church originally faced Church Road. In the 1920s, it was placed on large rollers and turned around by a horse pulled winch. (Courtesy of Broad Channel Historical Society.)

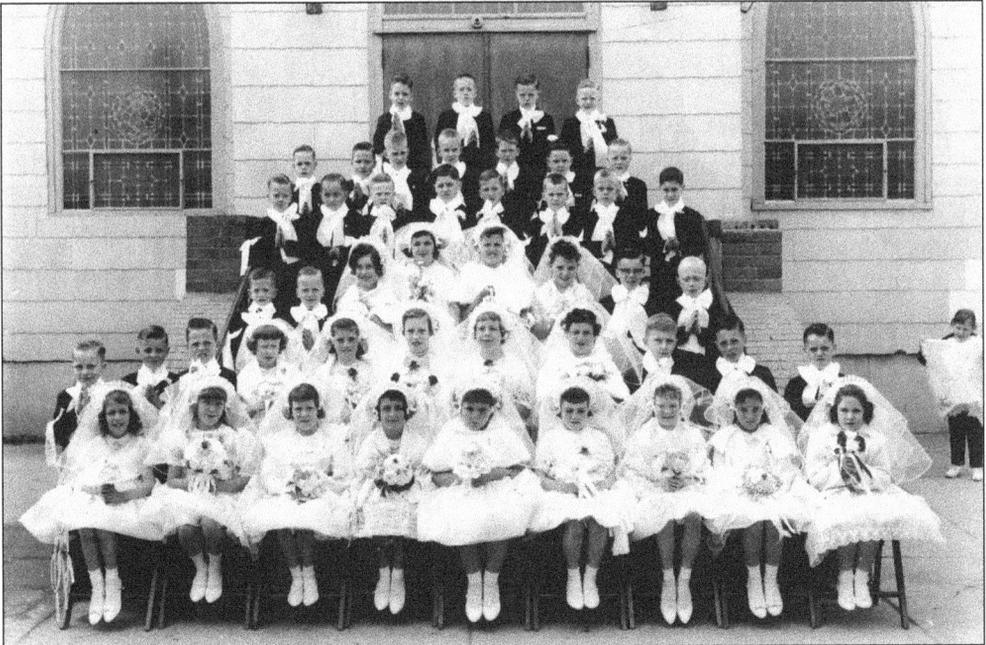

The steps and sidewalk in front of St. Virgilius Roman Catholic Church overflow with the first communion class of 1962. With 57 children (29 boys and 18 girls) in the photograph, it is more than twice the size of the 1935 class. The class size signals a visible increase in the overall population of Broad Channel over the previous three decades. (Courtesy of Edith Kinnaird and the Broad Channel Historical Society.)

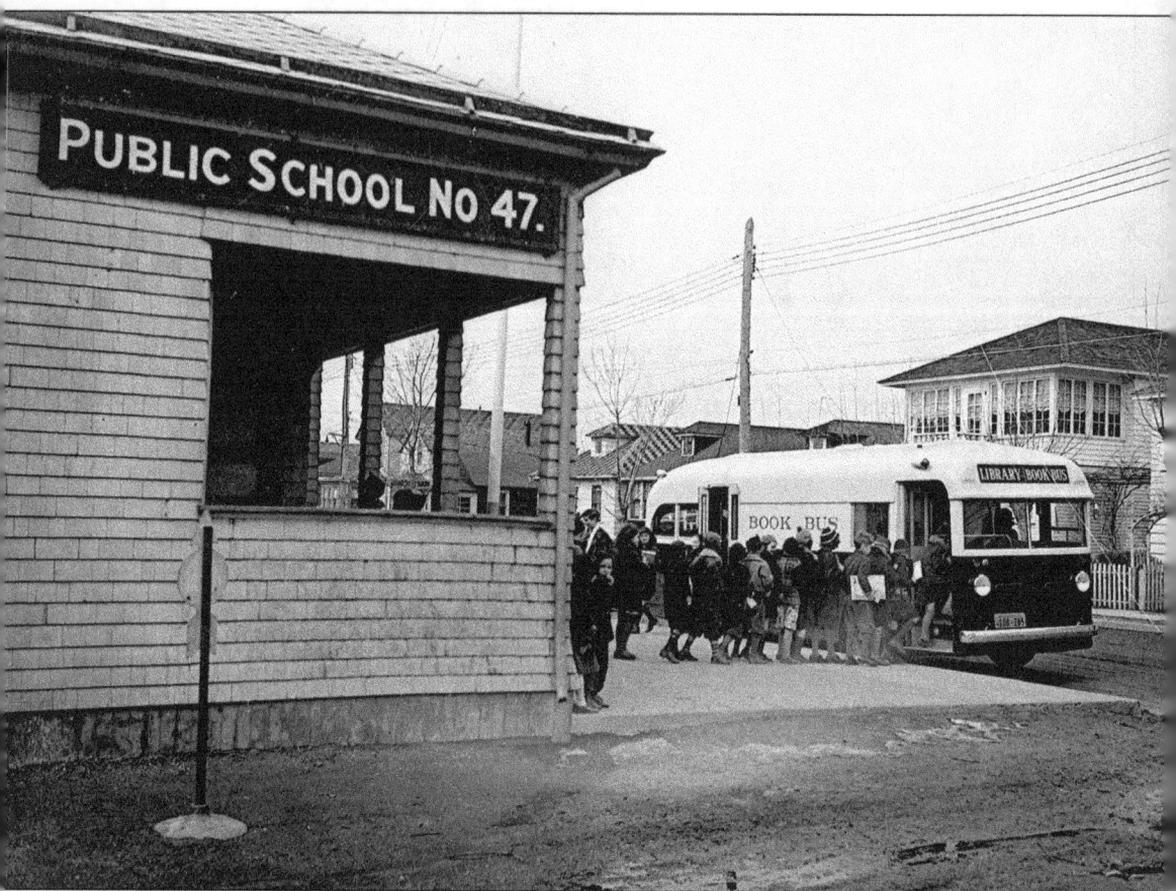

The library system's bookmobile visited Public School 47 on March 15, 1939. Parked outside the school on Noel Road, the Book Bus allowed the students to take out and return books from the library's collection during school hours without traveling, because Broad Channel had no library. The community did not get its own library branch for over 50 years after this photograph was taken. The new library, a compact yet open modern design features clear Plexiglas walls on all sides and a skylight. A prefab structure, it was brought in sections and assembled here. It maintains a high rate of usage. Note the different era of the mobile library bus in this picture and the photograph on page 74. (Courtesy of Queens Borough Public Library, Long Island Division, Queens Borough Public Library Records.)

Five

SCHOOL DAYS
BUILDINGS, BOOKS,
AND BLACKBOARDS

Just as summer turns to September, it seemed inevitable that Broad Channel would turn from being a vacation oasis to becoming a full-time year round community. In the early 20th century, the surest sign of this arrived. Schools were opened.

According to one account, during the 1920s a dance hall in neighboring Goose Creek broke loose during a hurricane and floated to Sixth Road in Broad Channel. A group of enterprising neighborhood men moved the structure to Noel Road and fashioned it into a one-room schoolhouse. Another recollection states that the dance hall and the closed Windsor House hotel it belonged to were purchased and brought over by barge in 1918. No doubt children were delighted either way.

Then as now, to attend higher grades students had to trek to the Rockaways. In the early days, however, if one missed the early train, one would end up traveling to school by boat.

Although the old building is gone, replaced by a sturdy and more modern construction in a new location, the original designation of Public School 47 still carries on.

Parochial school education came to Broad Channel by more conventional means. In 1926, newly appointed Pastor Joseph C. Curran set about establishing a St. Virgilius School. The first classrooms were fashioned out of the first floor of the parish's new recreation hall. Shortly thereafter, the Sisters of St. Francis took over from the original lay teachers who were hired.

St. Virgilius School saw its first graduating class in June 1927. In June 2006, it saw its last. Despite heavy community involvement, the school was closed for good that year due to declining enrollment.

Whether public or parochial, each school holds a strong place in people's memories. Wherever in the world those once smiling schoolchildren have gone, they have taken the lessons Broad Channel has taught with them.

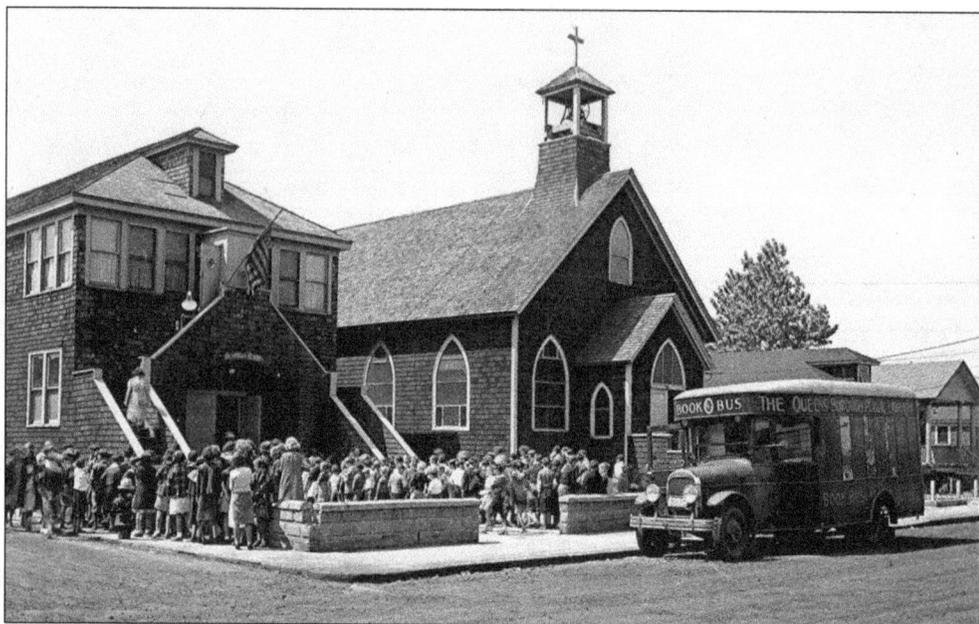

On May 18, 1937, the Book Bus of the Queens Borough Public Library prepared to leave the stop in front of St. Virgilius School on Noel Road. Years after this photograph was taken, the outside of the school was remodeled to remove the external stairway on the left. The one on the right was kept, and both church and school were subsequently re-sided. (Courtesy of Queens Borough Public Library, Long Island Division, Queens Borough Public Library Records.)

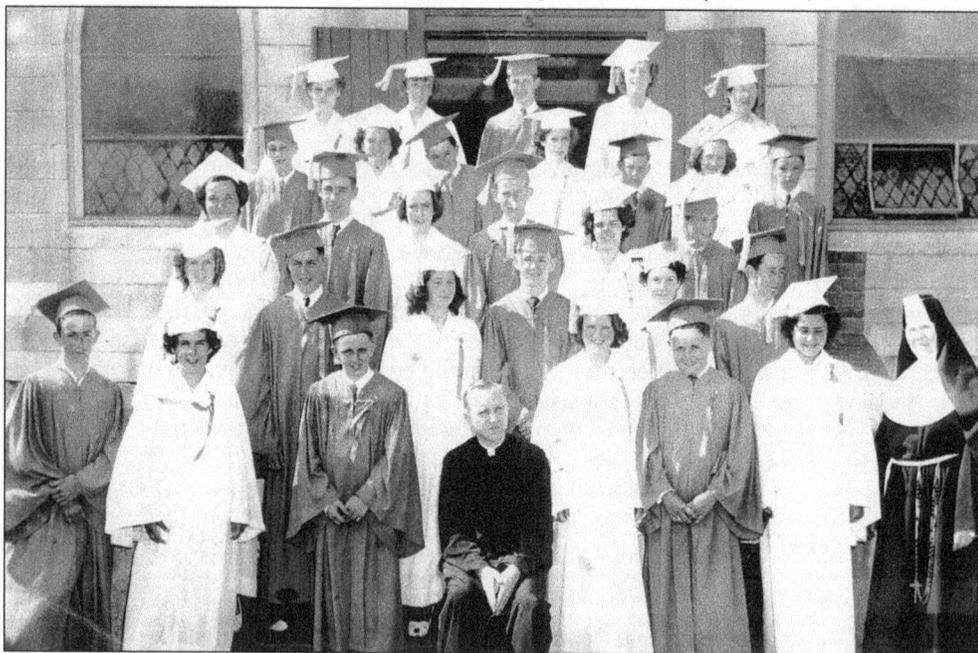

On the steps of St. Virgilius Roman Catholic Church pose the eighth grade graduating class of 1950. Made up of 16 girls and 14 boys, the class was large. Even non-Catholic people of that era were accustomed to seeing a priest wearing a cassock and a religious sister wearing a habit. (Courtesy of Broad Channel Historical Society.)

This image shows the 1940 eighth grade graduating class at St. Virgilius School. A class of this size was, for many years, the average for the Catholic elementary school. Declining enrollment and the resultant effect of requiring high subsidies from the Diocese of Brooklyn led the diocese to close St. Virgilius School in June 2006. (Courtesy of Elaine Maloney Zoffer and the Broad Channel Historical Society.)

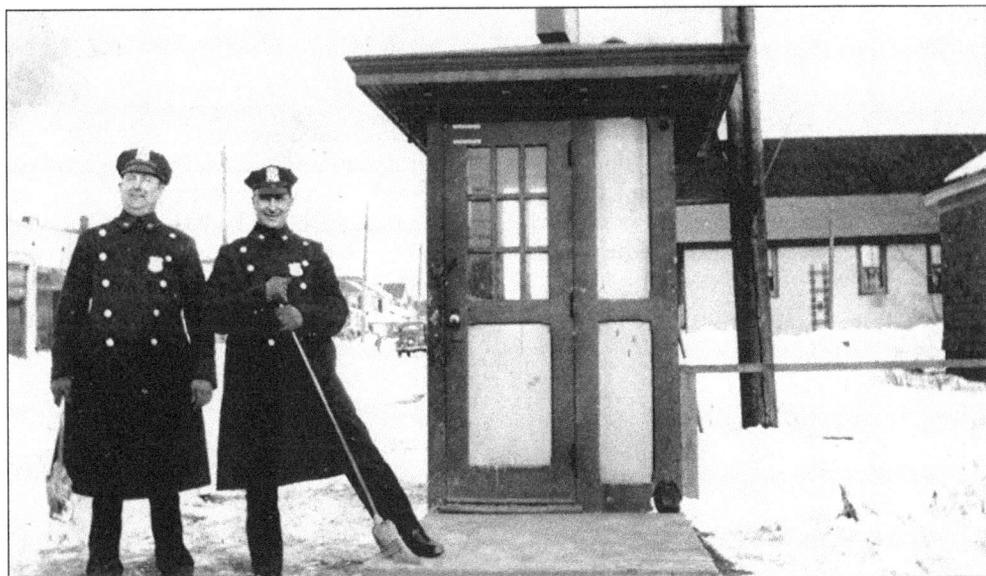

Clearing the snow from the sidewalk along Noel Road in 1932, these two officers of the New York City Police Department stop to have their picture taken. Note the long, button-fronted uniform coats. This police booth was located at the corner of Noel Road and Cross Bay Boulevard. These policemen escorted schoolchildren going to Public School 47 and St. Virgilius School safely through this heavily trafficked intersection. (Courtesy of Broad Channel Historical Society.)

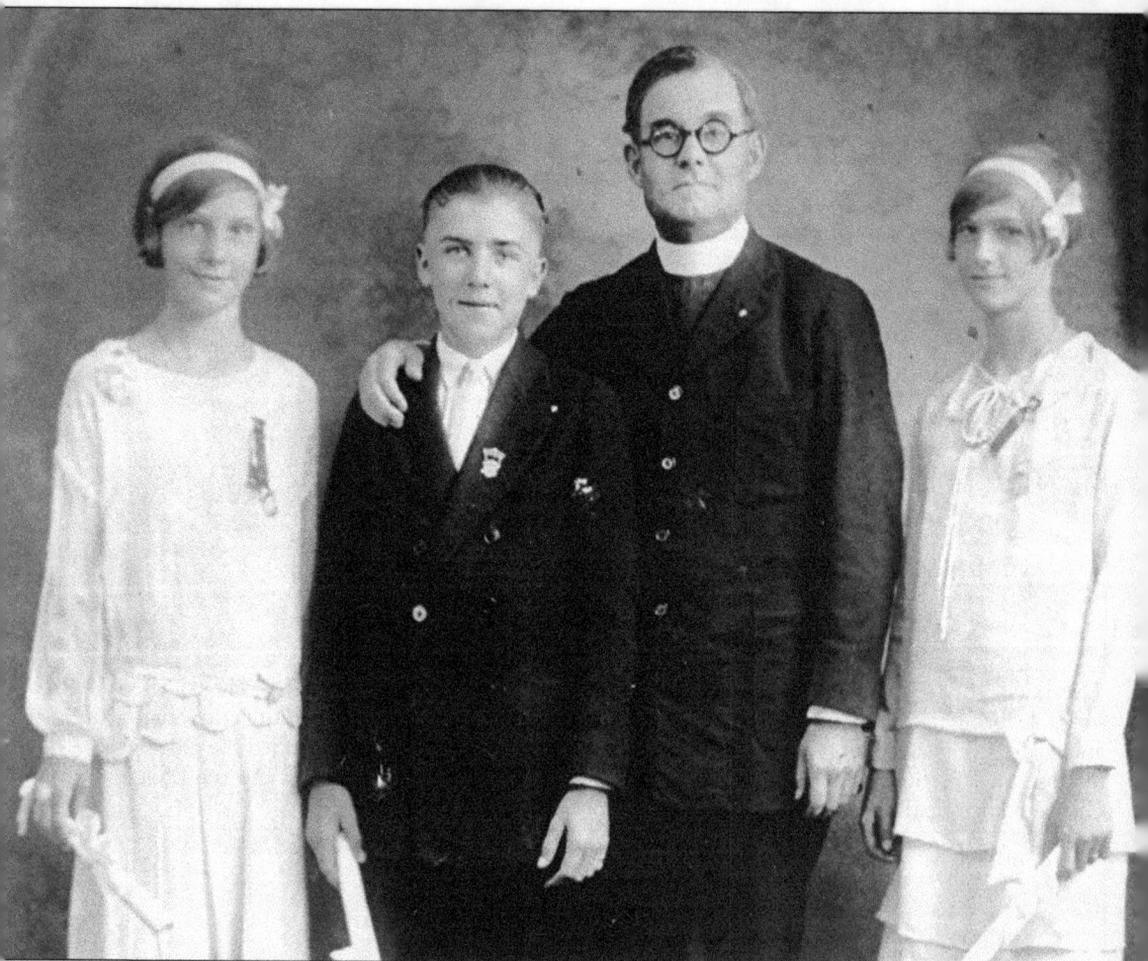

The first graduating class of St. Virgilius School consisted of just three students in 1927. Henrietta Buchheit Harnisher, James Hudson, and Evelyn Goemans Rossi posed with Fr. Joseph Curran. Hudson later became a Catholic priest and, 10 years later, said his first mass in St. Virgilius Roman Catholic Church. Each of the young people can be seen holding a diploma. (Courtesy of Broad Channel Historical Society.)

Six

FAMOUS PLACES
RESTAURANTS, HOTELS, AND BEACHES

Today, there is the John F. Kennedy International Airport across the bay. The road, Cross Bay Boulevard, and the bridges, the Joseph P. Addabbo and Cross Bay Veterans Memorial Bridge (the one with the toll), take thousands to Rockaway's beaches each year. Jamaica Bay Wildlife Refuge attracts tourists and bird watchers from all over the world and is part of the Gateway National Recreation Area which spans three boroughs and New Jersey.

But before any of these famous places, Broad Channel was a famous place in itself. Long before the thoroughfare first known as Jamaica Bay Boulevard was built, the Delevan House Hotel boasted summer rooms for rent, a parlor for guests, excellent meals, a large dining room, and a pavilion named the Palm Garden, which was large enough for dances and socials. There was the Grassy Point Hotel that sported a bar, two pool tables, and two bowling alleys and later advertised two floor shows nightly.

Weiss' restaurant was on many an out-of-towner's list of things to see in New York City. It was so well-known that people who had never heard of Broad Channel had heard about Weiss'.

During Prohibition, Broad Channel was also known for its speakeasies. Because it was remote and surrounded by water, it was a prime location to bring bootleg liquor into and out of. Sometimes it was locally brewed. There were also places like the Hermit Café that hosted entertainers like Mae West and Jimmy Durante whose careers spanned vaudeville, radio, stage, movies, and recorded music.

The moviedrome was opened by Marcel Peysson around 1916. An open-air cinema with wooden benches, it featured silent movies three nights a week, accompanied by a piano player, and held talent contests at which prizes were given.

Also known to many in the 1920s and 1930s, the Broad Channel Bathing Park had two gigantic swimming pools, 16 handball courts, a ball field, and a beautiful carousel. The area later became a day camp.

Famous places great and small? Not only is Broad Channel surrounded by them today, but it was a famous place on its own, years before the rest.

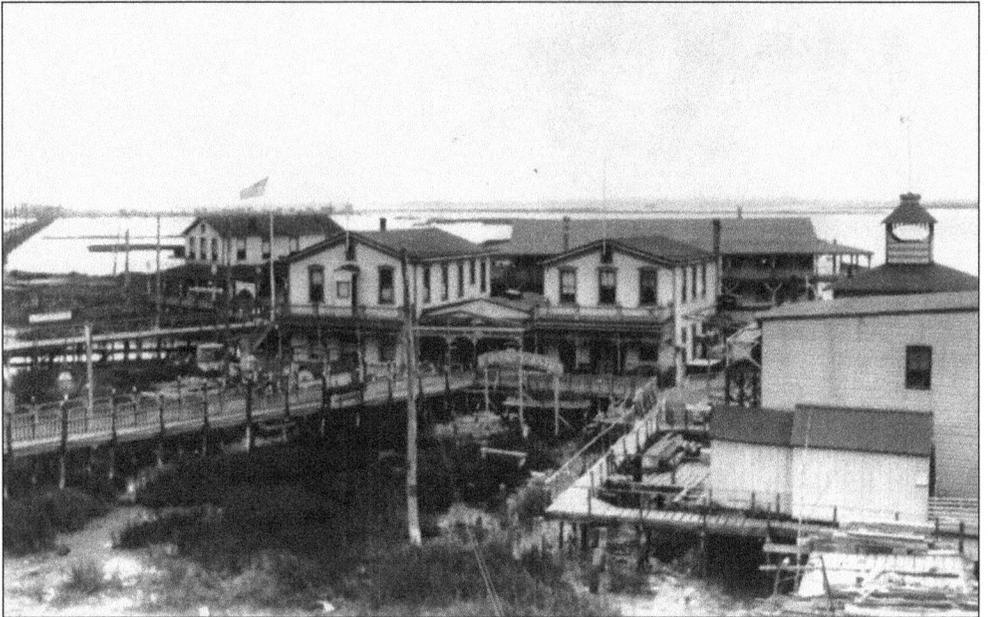

On the east side of the tracks of the LIRR stood hotels, the Broad Channel Yacht Club, and five privately owned bungalows. Walking from the Enterprise complex (three foreground buildings on the right) was accomplished by means of wooden boardwalks. Note that train tracks lie on far left side of photograph; the Raunt is seen in the distance. (Courtesy of Library of Congress.)

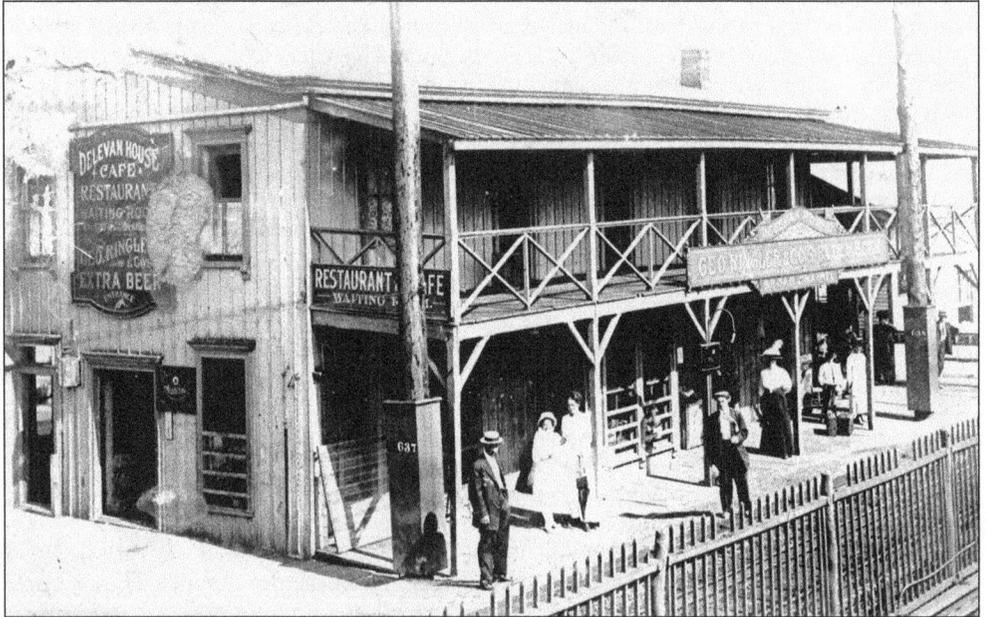

Situated on the LIRR train platform and at its southern end was the Delevan House around 1918. It consisted of three buildings. One was the two-story hotel, in which the first floor serviced the drinking and dining needs of its patrons. Guest rooms, covered entryways, and exterior corridors were on the second floor. The building sign at left reads "Delevan House-Café-Restaurant-Waiting Room" and advertises "Geo. Ringler and Co. Extra Beer." (Courtesy of Tim Tubridy and the Broad Channel Historical Society.)

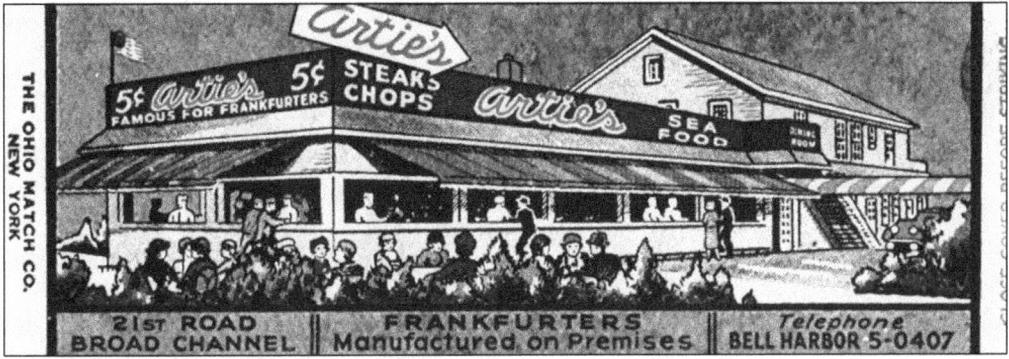

Matchbook covers became a well-used advertising item. As this one illustrates, Artie's restaurant at Twenty-first Road offered steaks, chops, seafood, and franks, at five cents apiece, were made right on the premises. Establishments like Artie's and the Channel Diner probably benefited from the crowds motoring to and from the Rockaways. (Courtesy of Jane Tubridy and the Broad Channel Historical Society.)

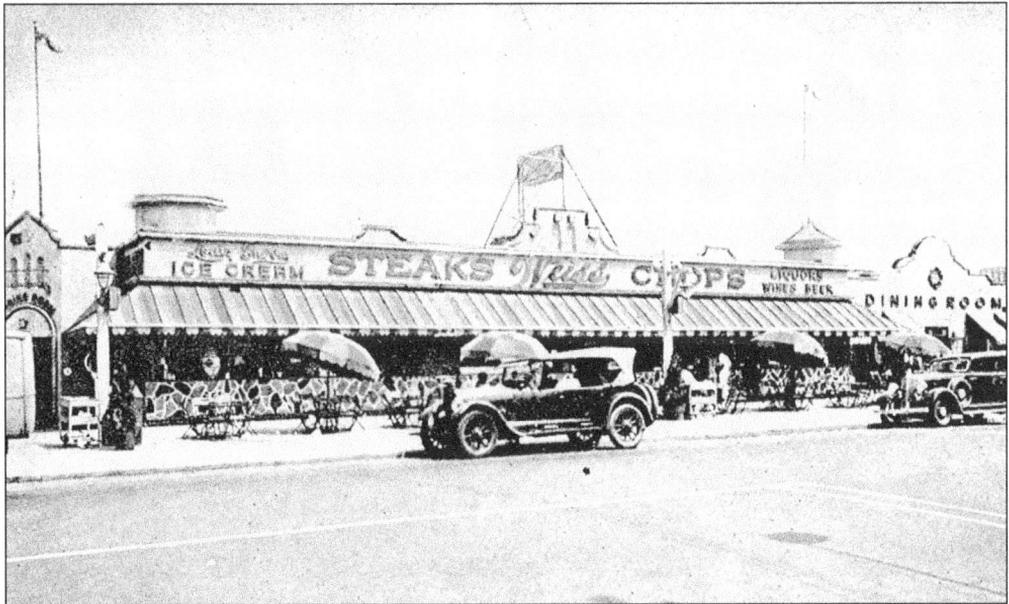

This reproduction of a postcard showed the exterior front of Weiss', a very popular eatery in the 1930s. In addition to a dining room, there were umbrella-covered tables along the sidewalk for eating during the day. The eatery was open all year. (Courtesy of Queens Borough Public Library, Long Island Division, Postcard Collection.)

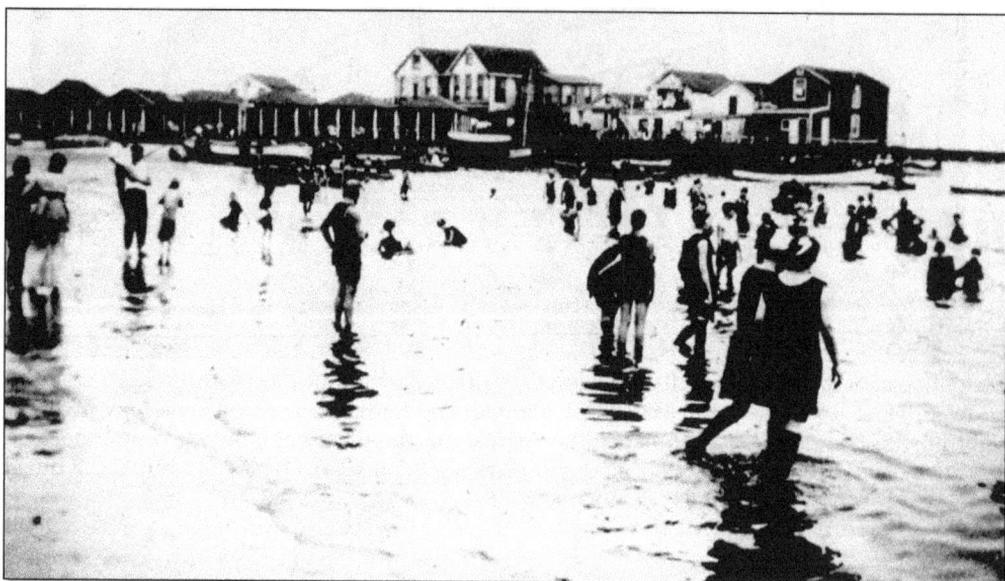

Shallow water at the shore of Jamaica Bay beach in 1918 allowed bathers to cool off. As yet, swimming for recreational pastime was not customary. Houses and bungalows held up with stilts and boardwalks are in background. (Courtesy of the Theis family and the Broad Channel Historical Society.)

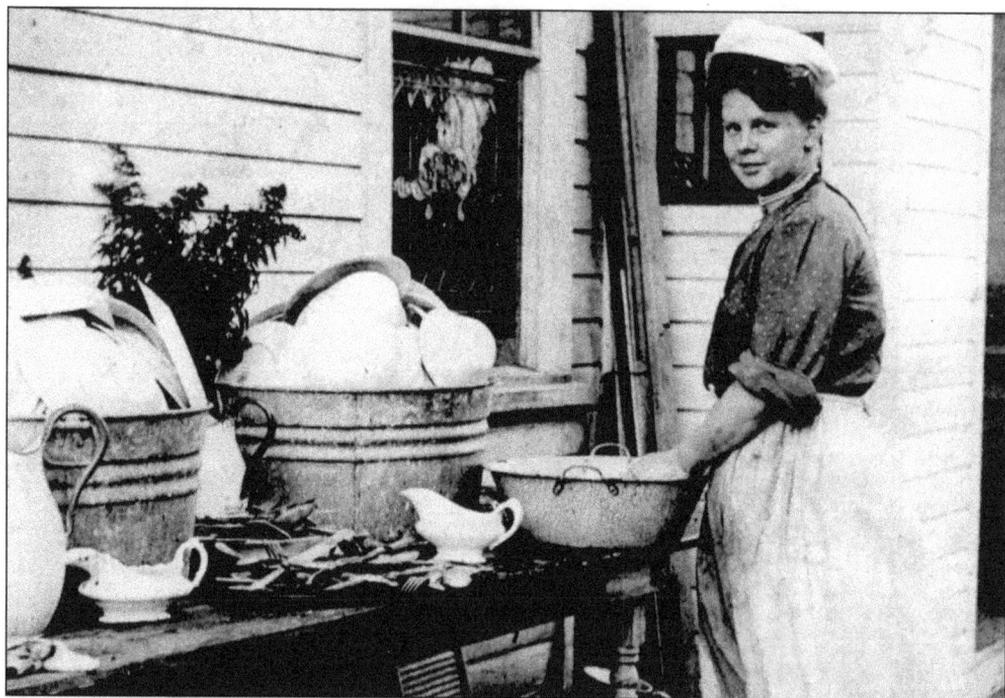

A maid from the Enterprise Hotel is washing dishes in this 1915 photograph. Under the table, leaning against the building is a washboard. The washboard was not the only thing under the table at the Enterprise Hotel; it was later known as "the bootlegging capital of Jamaica Bay," during the Prohibition years from 1919 to 1933. (Courtesy of Frank Fischer, Joan Stemmler Christian, and the Broad Channel Historical Society.)

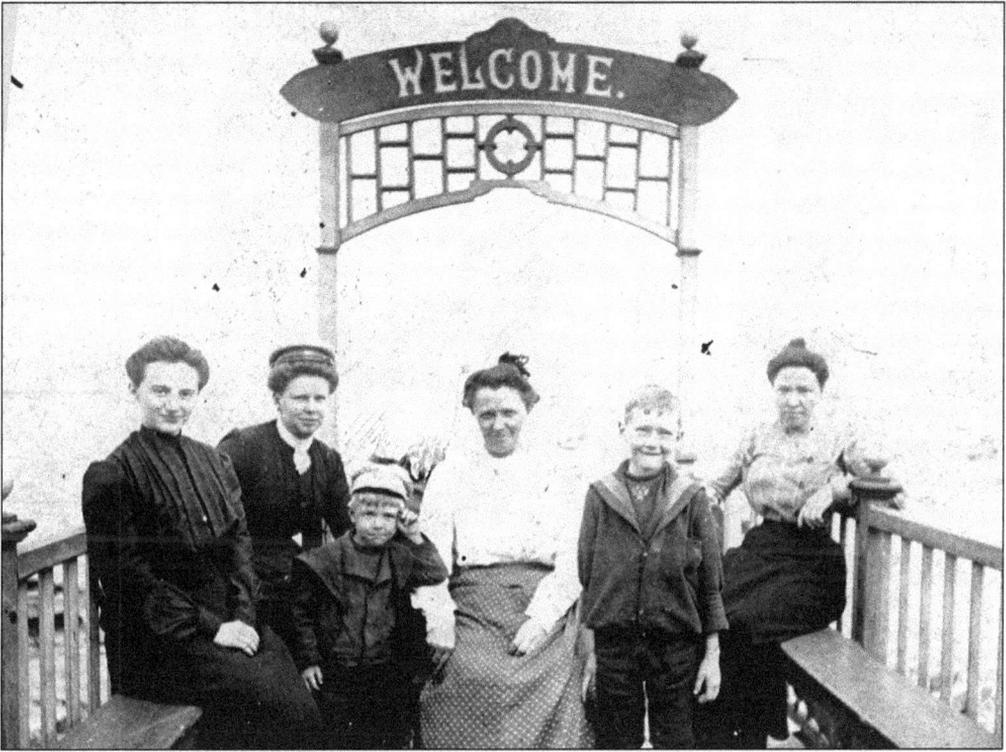

This photograph from 1915 taken outside one of the hotels shows a gazebo that allowed seating to visitors. It had long plank seats that extended along its length on both sides and room to add more seats inside the gazebo. The hairdos and dress styles popular at the beginning of the 20th century can be seen as well. (Courtesy of Frank Fischer, Joan Stemmler Christian, and the Broad Channel Historical Society.)

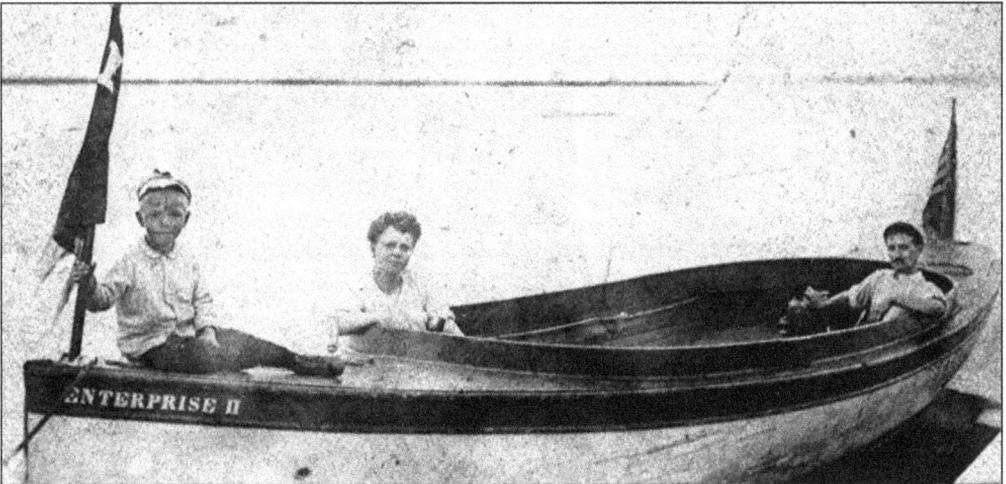

Some of the hotels, especially those that were built over the water, had a number of boats available for their guests to use. In this 1915 photograph, a family poses in a moored craft that belongs to the Enterprise Hotel. This boat was equipped with an inboard motor on which rests the man's right hand. (Courtesy of Frank Fischer, Joan Stemmler Christian, and the Broad Channel Historical Society.)

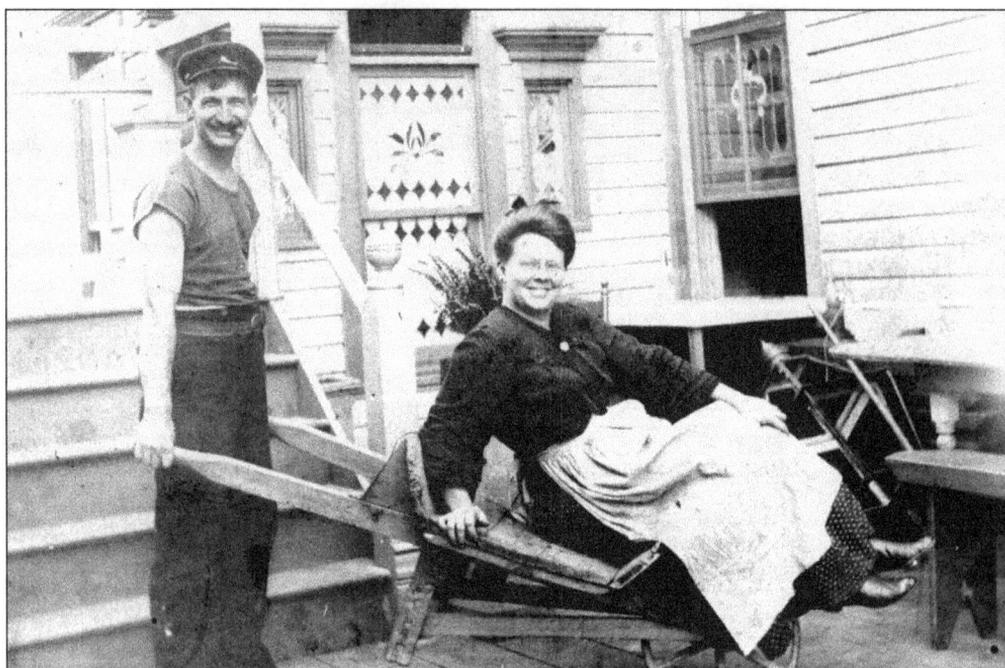

In this photograph from the early 1900s at the Enterprise Hotel, a man and woman display a sense of fun in front of the camera. Both people smile broadly and "ham it up" in an unusually lighthearted pose for photographs in this time period. Except for the wheel, the wheelbarrow is made entirely of wood. (Courtesy of Frank Fischer, Joan Stemmler Christian, and the Broad Channel Historical Society.)

Bars in Broad Channel ranged from the fancy to the very plain. This bar displayed no business sign, but it was named Big Nose Bill's Bar. It looked like an ordinary house of that era; it was on East Ninth Road. As the sign in the window showed, its price for beer was five cents. (Courtesy of Margaret and Patrick Mills and the Broad Channel Historical Society.)

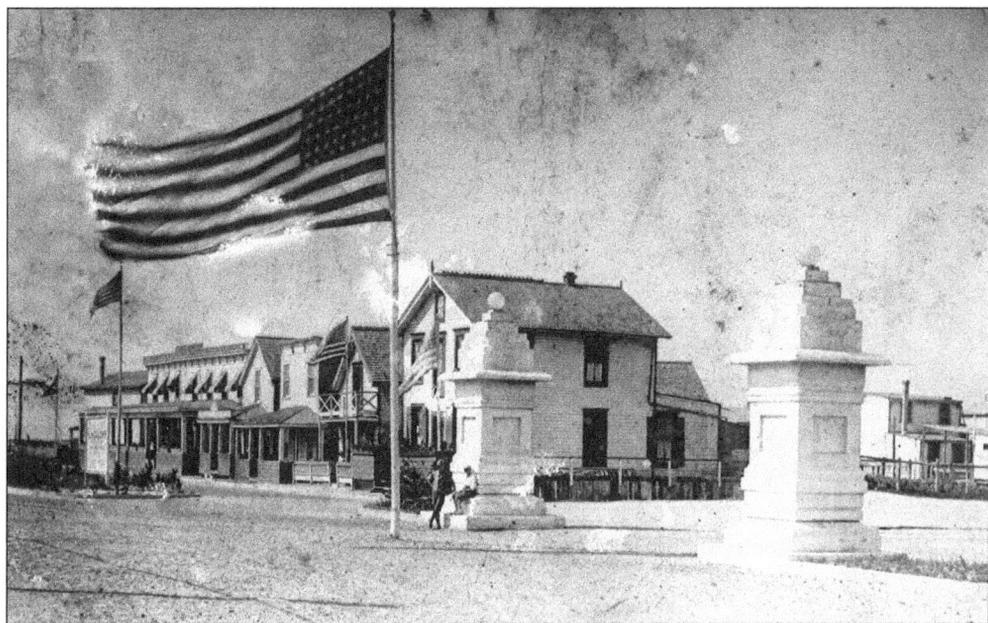

This *c.* 1917 view along Station Plaza (now West Road) shows the two white obelisks that stood at the foot of Noel Road across from the train station. The obelisks survived into the 1950s when the subway station was constructed. Also seen here are Sigwalt's "Fancy Grocery and Delicatessen-Tobacco and Confectionary," Billy Kuhn's saloon, and a sign advertising bungalows. (Courtesy of Tim Tubridy and the Broad Channel Historical Society.)

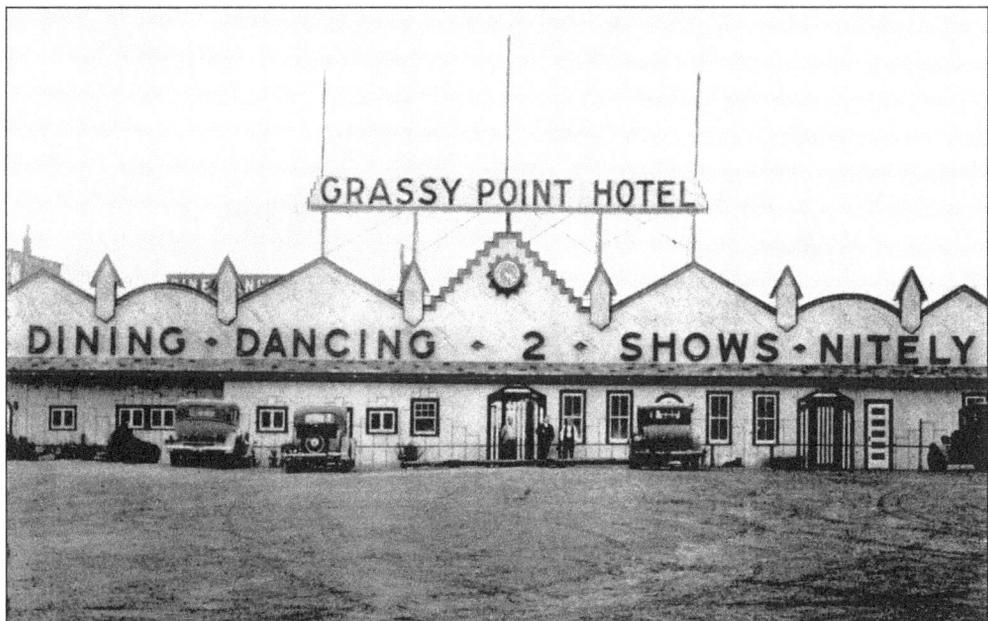

A popular hotel, Grassy Point provided patrons with dining and entertainment as well as hotel rooms in its long low building. This photograph is from the 1930s. The hotel was destroyed in a fire. The business is now located on Cross Bay Boulevard and East Eighteenth Road. Attending to the eating and drinking needs of its patrons, it is still flourishing. (Courtesy of Virginia Seyfried and the Broad Channel Historical Society.)

In the early 1900s, there was no running water in Broad Channel. Water was collected off roofs into rain barrels or from melted snow. When it did not rain, residents went to the train station to get water from the locomotive. The Broad Channel Corporation dug a well 720 feet deep, and after filtering techniques were used to clean the rust out, Broad Channel had fresh water. Shown at left is the Broad Channel water tower. (Courtesy of Stanley Reich and the Broad Channel Historical Society.)

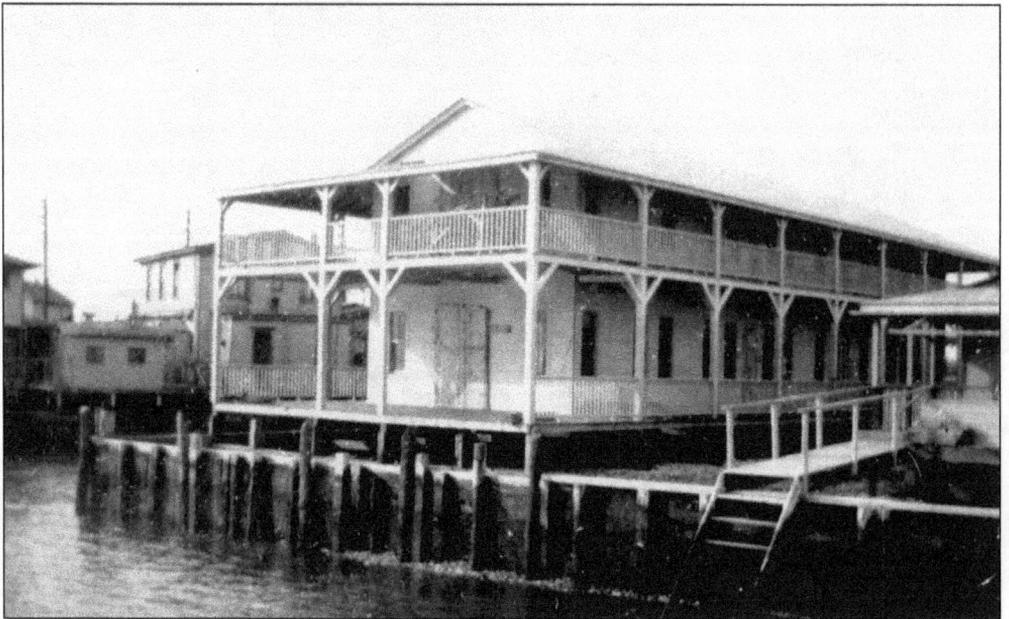

This imposing two-story building was the Broad Channel Yacht Club in the 1920s; it was subsequently destroyed by fire. Railings on both of the building's stories protected people from accidental falls, but one side was entirely open, allowing boat passengers on and off at high tide. This photograph was taken at low tide. (Courtesy of Jean Bohne Ryan and the Broad Channel Historical Society.)

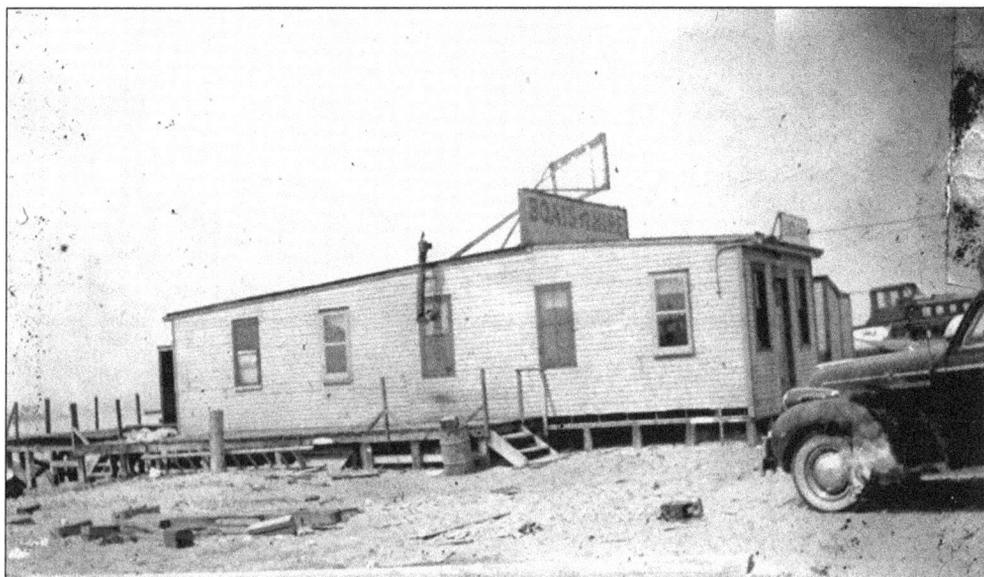

At the edge of Jamaica Bay, on the east side of Broad Channel near the train station, was located Smitty's Fishing Station, a business since 1936 that is still flourishing today. Boats were available for rent, and bait could be purchased by fishermen. Each boat currently sports a distinctive orange hull with the name "Smitty's" (and the phone number) stenciled on it. (Courtesy of Carol and George Boyle and the Broad Channel Historical Society.)

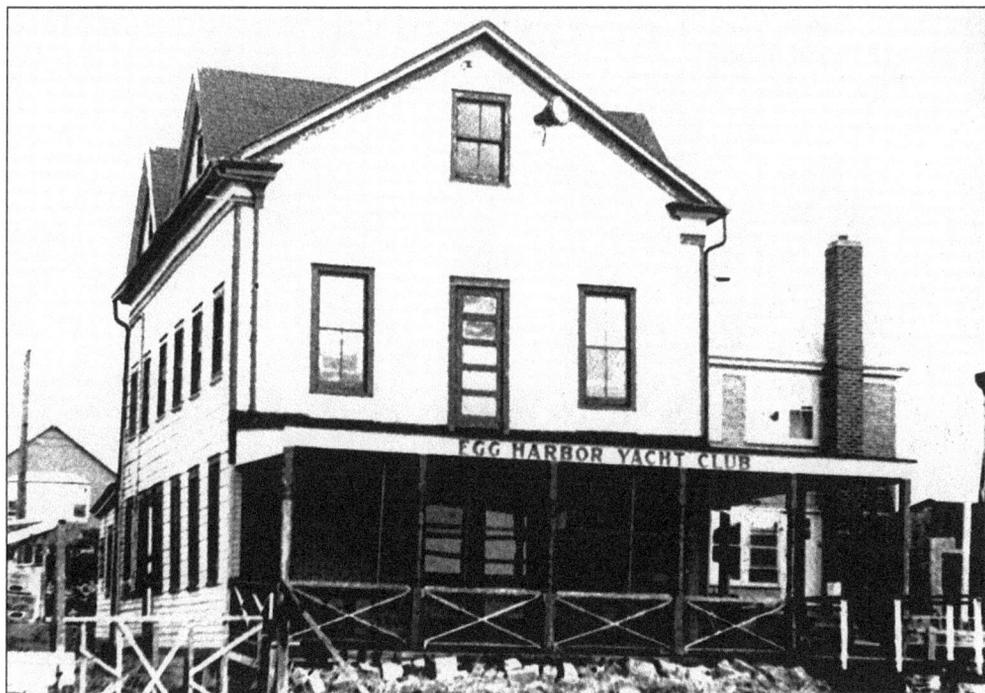

The Egg Harbor Yacht Club was built in 1905. The club was started by men from the National Athletic Club in Brooklyn. Members of the community joined it, however, and in 1955, it celebrated its 50th anniversary of operation. It does not exist today; the club was made over into a single-family house. (Courtesy of Victor and Marion Durchalter and the Broad Channel Historical Society.)

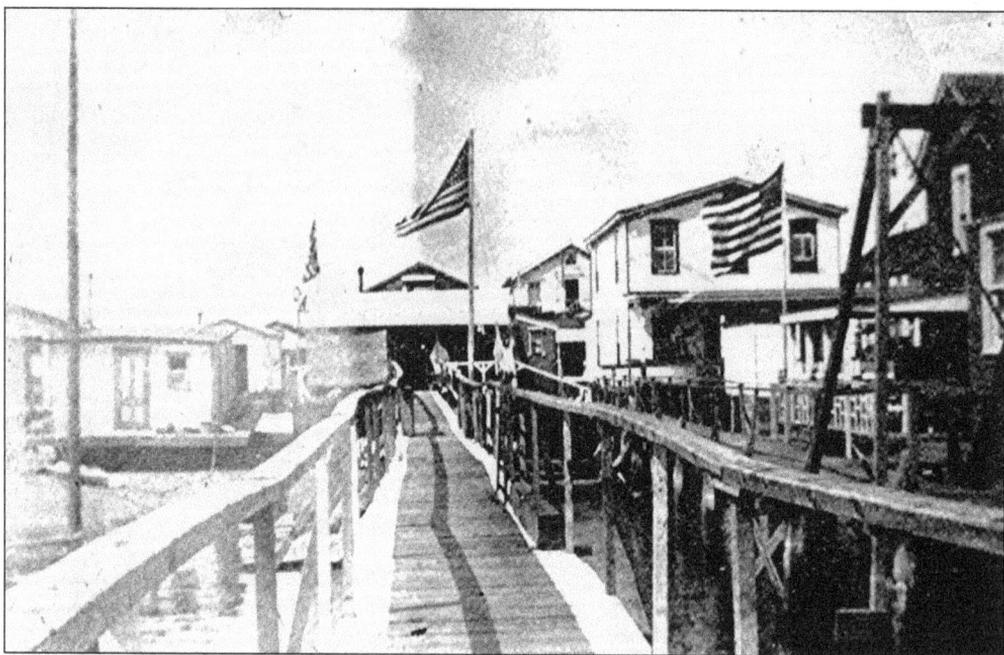

The boardwalk in this c. 1917 photograph, like the others in early Broad Channel, was rough, uneven, and probably rickety. It led to the Iroquois Yacht Club, which was organized in 1894. It was incorporated in 1914 at East Twelfth and Church Roads. It was one of many such clubs that flourished in Broad Channel of yesteryear, and it continues to flourish today. (Courtesy of Broad Channel Historical Society.)

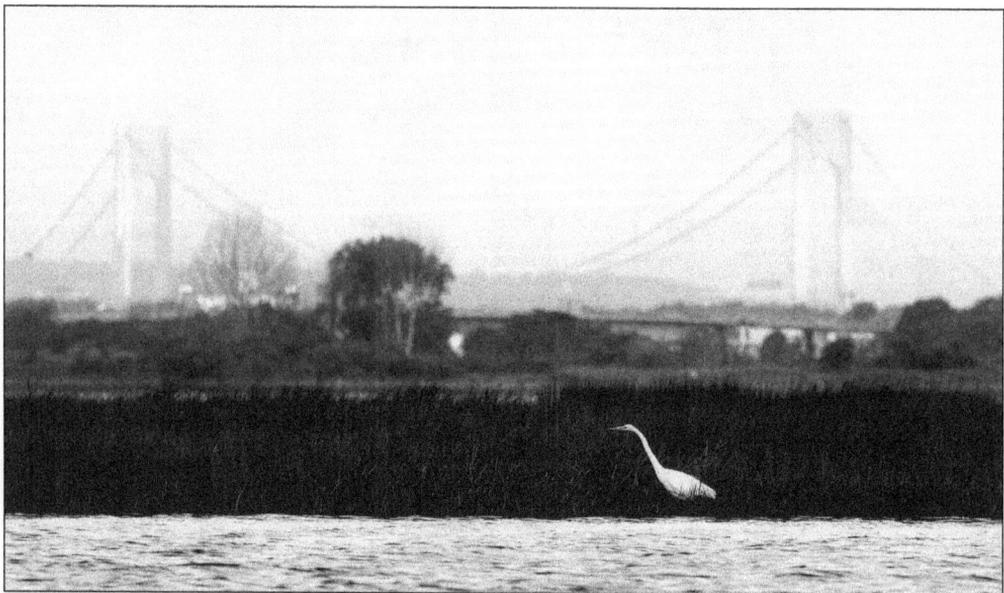

Federal land has been formed into the Jamaica Bay Wildlife Refuge of the Gateway National Recreation Area, with an energy-saving, ecologically friendly design. The refuge, encompassing 9,155 acres, was first opened in 1953 by the New York City Department of Parks. It was formed by adding fill to the marsh island and added to when the Raunt was cleared of settlers in the 1950s. (Courtesy of Don Riepe.)

Seven

SPORTS AND DIVERSION
FUN OF ALL KINDS

Like many things in Broad Channel, entertainments such as sports and other diversions were often home grown. Even in some of the oldest images of Broad Channel, which stretch back nearly a century, one can see women in bonnets and long dresses dangling lines from homemade fishing poles or a little boy in short pants swinging a bat on his unpaved road "playing field."

In summer, baseball teams were raised by local boys looking for something to do. From these arose groups like the Cardinals or the long-running Nut Club, which organized sports of kinds all year round. On December 8, 1948, St. Virgilius Parish Hall opened and the Police Athletic League set up sports and boxing programs. The land behind the Broad Channel Baths was allowed by its owners to be used as a ball field. During high tides, it was covered in water and had to be cleared before games by the local boys who used it.

There were other entertainments too. After the Protestant church was built, a Dr. Clinton, recently arrived from Ireland, was appointed pastor. His six children were all fine singers and delighted the congregation with their group singing when they, too, came over.

In the 1930s, St. Virgilius Roman Catholic Church's Fr. George B. Murphy, with the help and creativity of community supporters, organized several singing, dance, and floor shows at O'Hagan's Hall, the largest one on the island. A departure from earlier types of shows, they were elaborate affairs with costumes either hand sewn or sometimes even borrowed from Broadway productions. These were the forerunners of many shows to come.

Today the annual "Puttin' On The Hits," both children's and adults divisions, is a hotly contested competition. Broad Channel artists and performers take their talents far beyond the island. And of course, the Broad Channel Athletic Association continues to introduce a new generation to the bat and the ball.

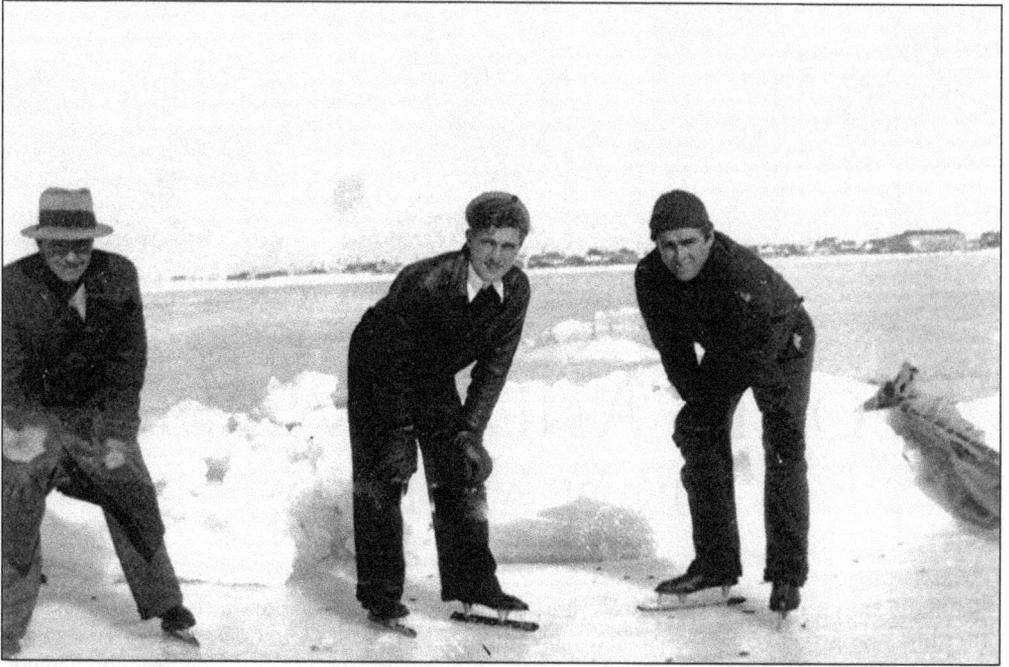

When the water on the bay around the island community froze during the late 1930s, these three residents—Ken Berry, Frank Mauro, and Russell Bradley—put on their skates and took to the ice. It can be dangerous to skate on a large body of salt water due to unexpected patches of thin ice. (Courtesy of Muriel Berry and the Broad Channel Historical Society.)

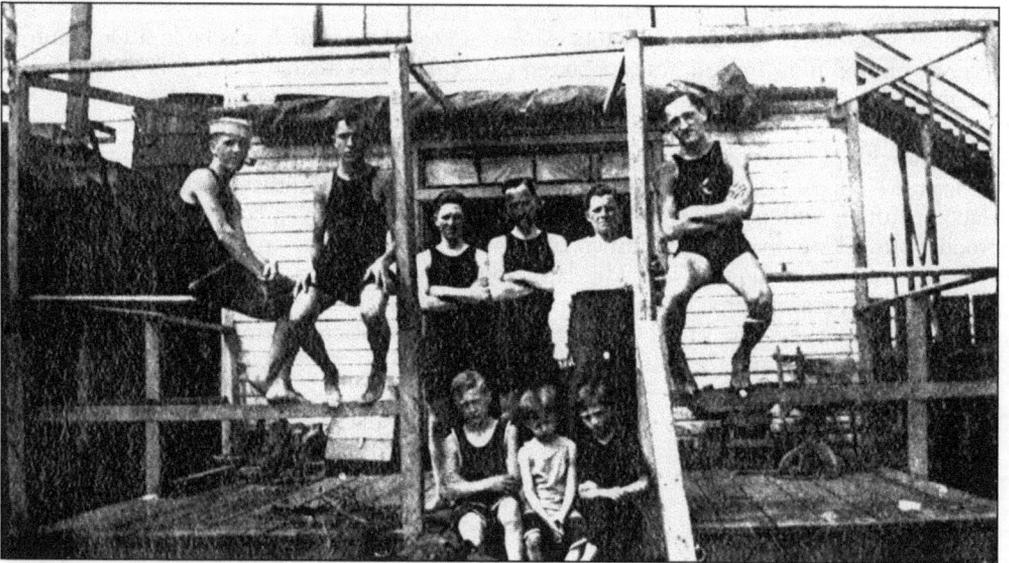

People pose on the back deck of the house built entirely over the water in 1918 in Broad Channel. Children sat on stairs that enabled them to enter the water or to climb in the family boat. Above doorway was a covering to unroll over wooden framework to provide protection from the heat of the summer sun. (Courtesy of the Theis family and the Broad Channel Historical Society.)

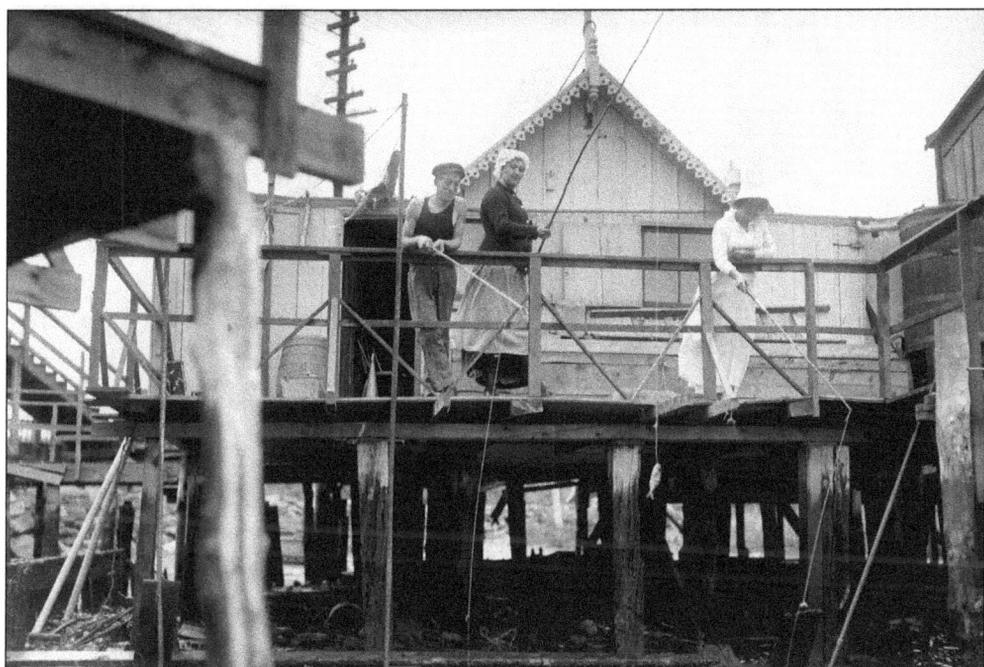

This 1915 photograph showed people fishing from a boardwalk near their home. "Snapper" fishing, as these people were doing, was a popular activity. It needed no reel or regular fishing pole. A bobber that floated on top of the water while the baited hook was below it underwater, signaled when it was time to raise the pole. (Courtesy of Library of Congress.)

Most of the boys in the back row clutch their baseball gloves in this 1938 photograph of the Broad Channel Condors. The team's coach is wearing a dark shirt in the front row. At one time, Broad Channel had as many as five organized baseball teams using a field they cleared and leveled themselves behind the Broad Channel Baths complex. (Courtesy of Rita and Stanley Reich and the Broad Channel Historical Society.)

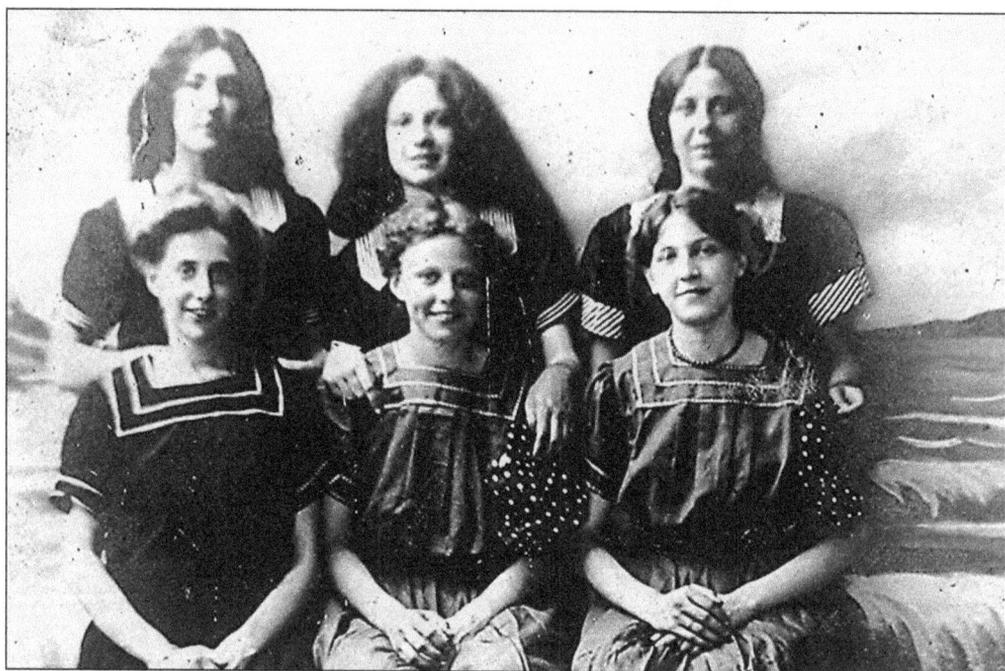

These young women are dressed in what was considered proper attire for a day at the beach from the early 1900s through the 1920s. They are wearing modest, dark colored, sleeved bathing dresses, with stockings and bloomers underneath. The outfits were often heavy, especially when wet. The backdrop signals this was probably a souvenir photograph taken by a professional photographer. (Courtesy of the Theis family and the Broad Channel Historical Society.)

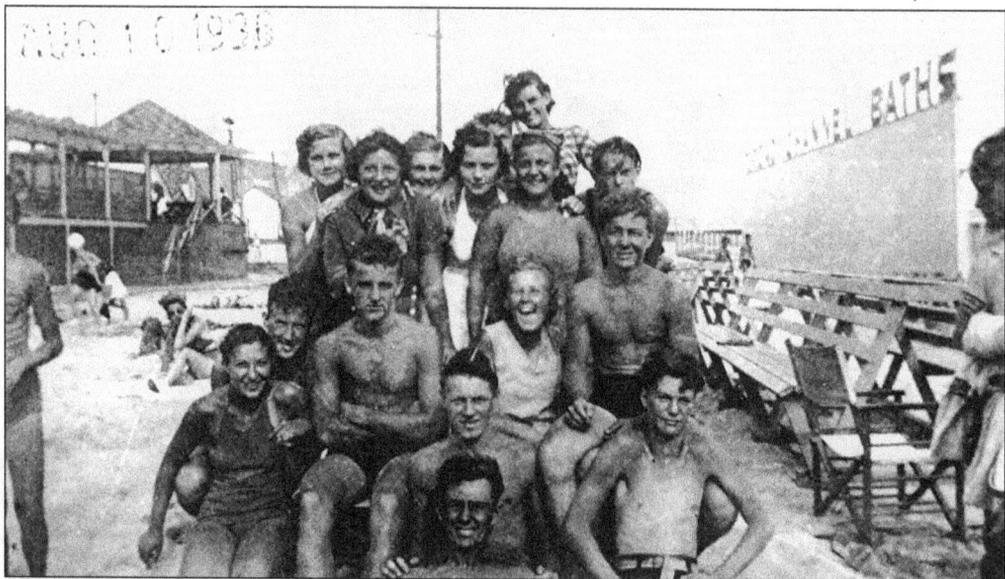

The Broad Channel Baths were built in 1927 on the southern end of the island community. The bathing park was very large; it had two swimming pools, bathhouses, handball courts, tennis courts, and a ball field. Residents, especially children, were very happy about the park as the happy faces show in this August 1936 photograph. (Courtesy of Jacqueline Brust and the Broad Channel Historical Society.)

90

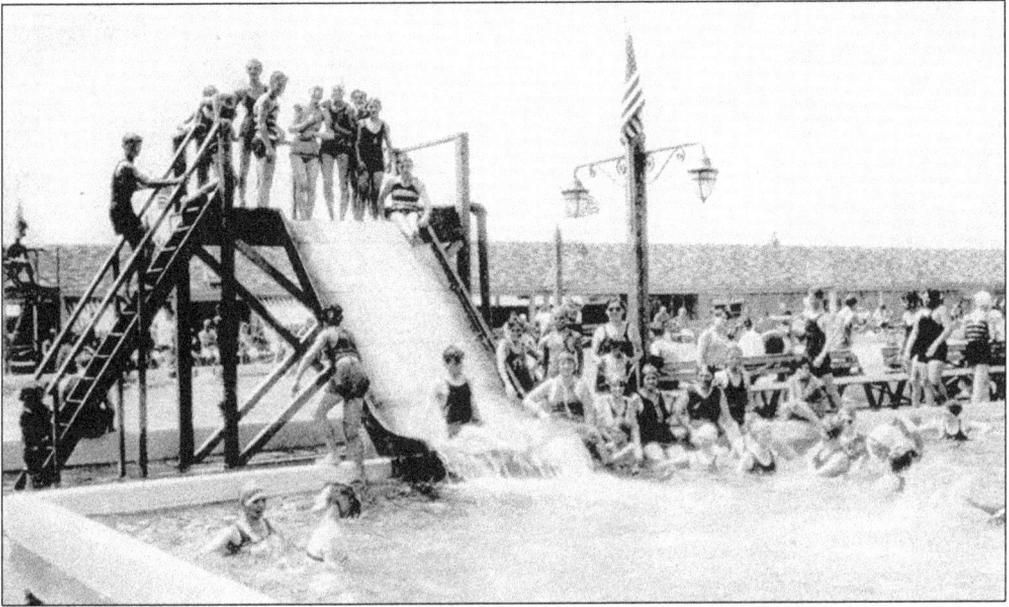

In the image above, the Broad Channel Baths, built by the Sayer brothers, featured a wide slide into one of the swimming pools. Season tickets could be bought "at a reasonable price," according to a local historian. The photograph showed a slack flag above the electric lights. As seen below, many people enjoyed the baths. Note the size of the crowd and the pool area. During World War II, with gas rationing, attendance dropped and a terrible storm ruined the pools, and the bathing park eventually went out of business. In the late 1940s, the Brooklyn Day Camp occupied the area, but that too is gone. The area now is a public park. (Courtesy of Broad Channel Historical Society.)

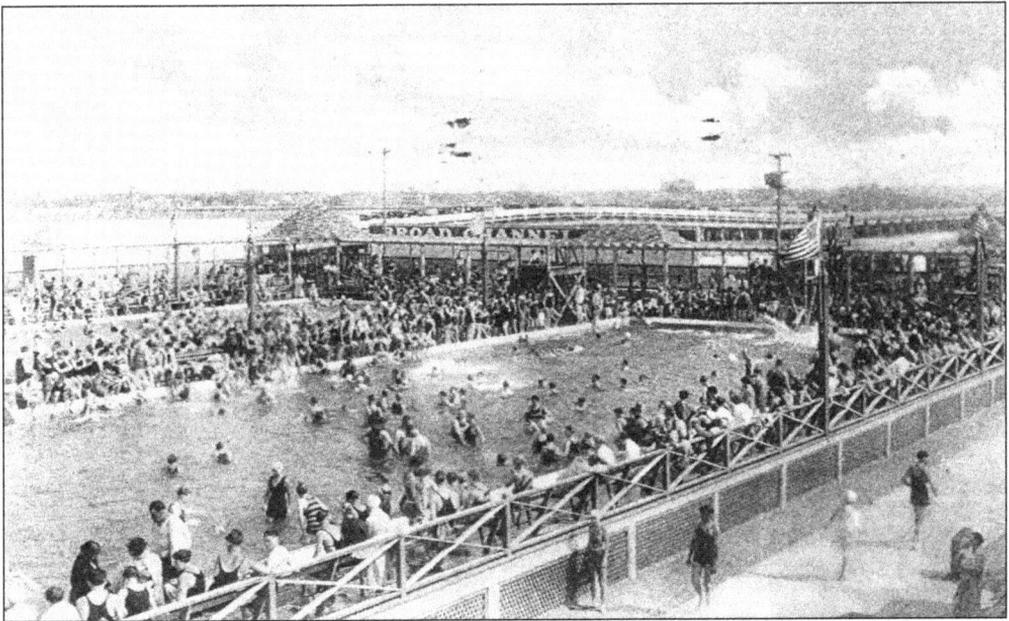

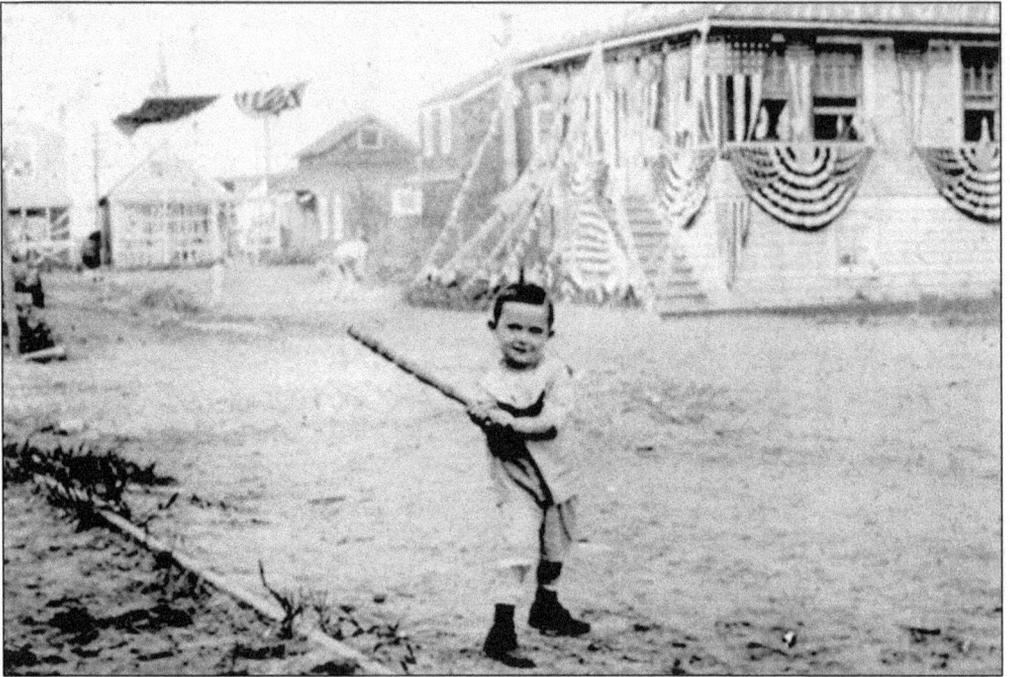

A boy is playing stickball, a familiar Brooklyn pastime, on an unpaved road in front of house decorated for Mardi Gras in 1918. Many of the original settlers of Broad Channel claim roots that hailed from Brooklyn. (Courtesy of the Theis family and the Broad Channel Historical Society.)

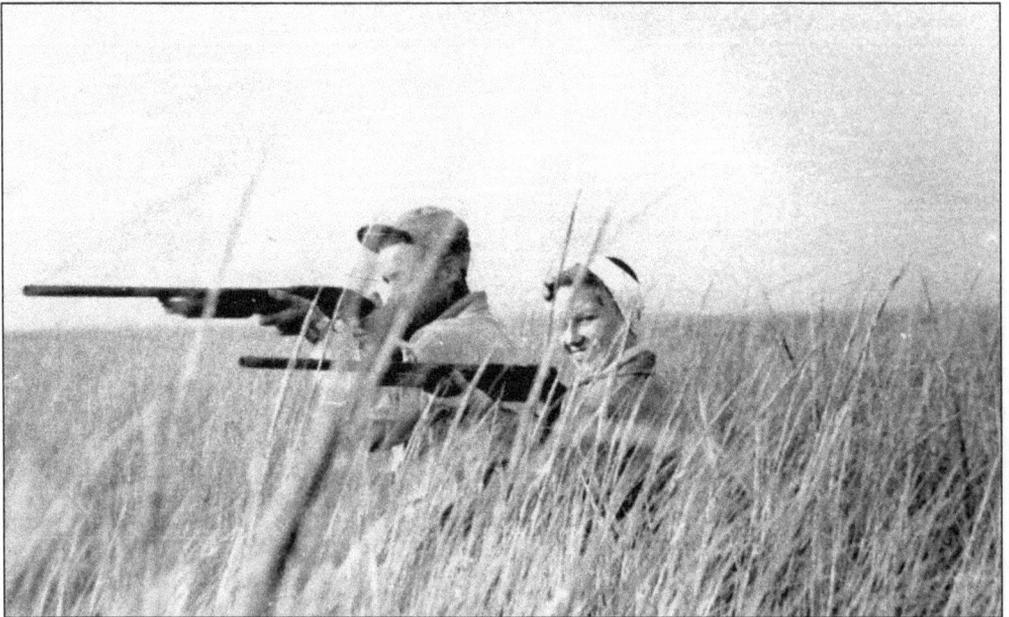

A couple, Dottie and Howard James, were almost obscured by marsh grasses when they aimed their rifles in the 1950s. Hunting in Broad Channel's marshes at that time was for ducks or geese. Hunting is now prohibited in every part of New York City. (Courtesy of Jeff James and the Broad Channel Historical Society.)

Located on the southwestern corner of Cross Bay Boulevard at West Twentieth Road was a popular carousel. Its rides thrilled children for many years. Seen above, a child rides one of the animal figures that moved up and down, a horse. The horse's eye has a furtive, playful gleam in it. The figures were beautifully carved and carefully painted. In the image below, a child rides one of the stationary animals on the carousel, a roaring lion. It faced to the right and had an upward tilt to its head. The carousel was open all year on weekends. It was dismantled in fairly recent years. (Courtesy of Broad Channel Historical Society.)

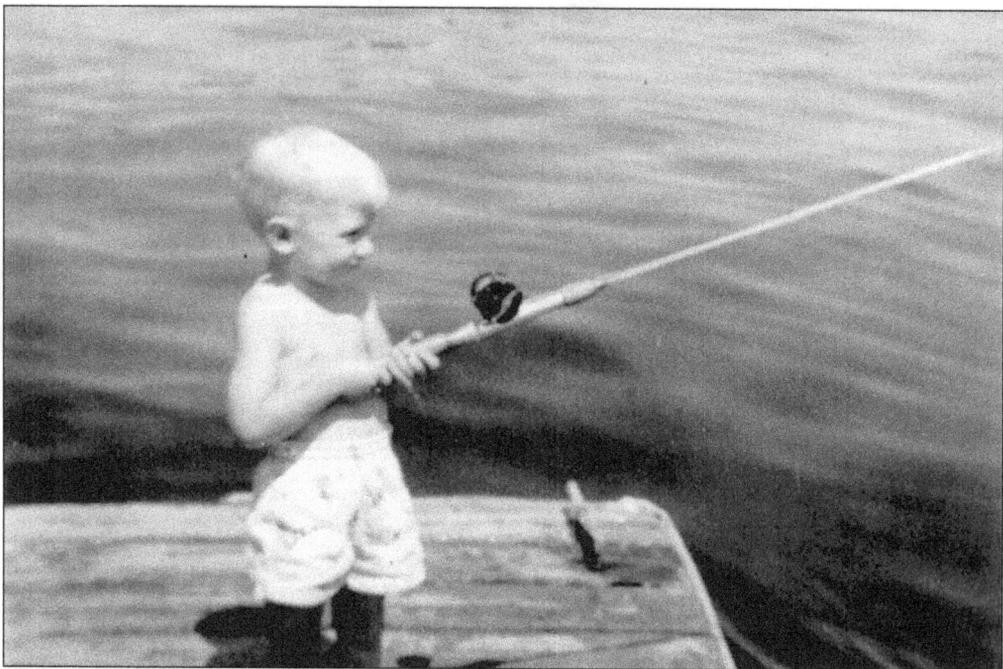

Young Greg Henkel waits for a fish to nibble his bait on the dock that juts into the bay outside his home in the 1950s. Broad Channel waters teemed with many different kinds of fish including bluefish, weakfish, eels, snappers (baby bluefish), striped bass, flounder, fluke, and porgies. Among the baitfish were killies, spearing, and brine shrimp. Fishing continues to be a popular activity. (Courtesy of Dr. Gregory Henkel.)

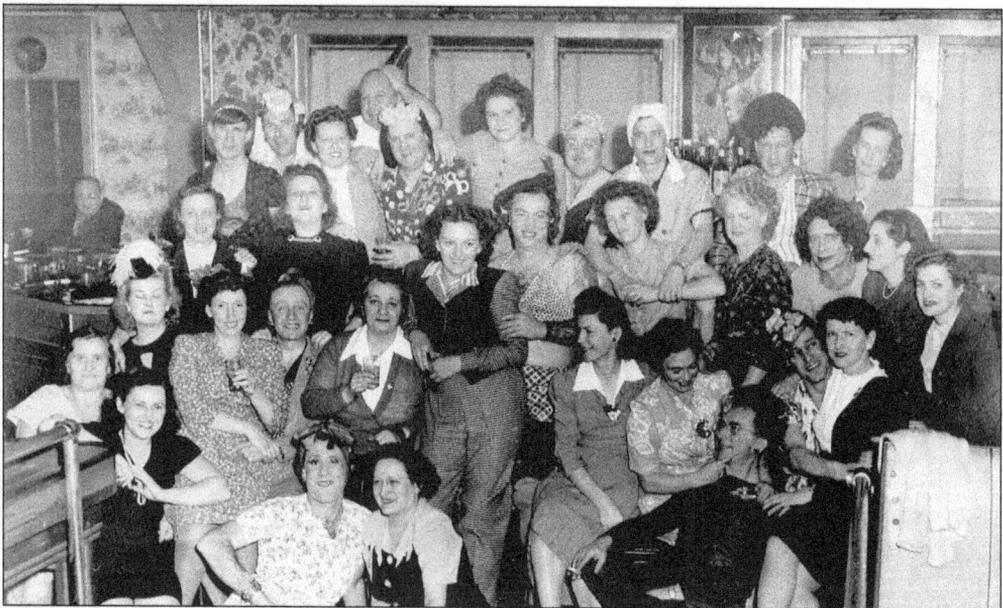

This photograph of a party at the Grassy Point Hotel underscores the fun-loving nature of many of the residents who made Broad Channel their home. This photograph shows a group of men and women; the men are in drag. (Courtesy of Marilyn Kass Stewart and the Broad Channel Historical Society.)

In the early years of the community, Mardi Gras had more traditional activities that suited those times. But as the decades passed and clothing became less fussy and cumbersome and allowed for more freedom of movement, family fun during Labor Day weekend added many different contests that more people could enjoy. Some of the fun resulted in games featuring physical prowess. Seen above, a group of women took part in the festivities by running a short distance footrace. In the image below, a group of boys hopped toward the finish line in a sack race. (Courtesy of Broad Channel Historical Society.)

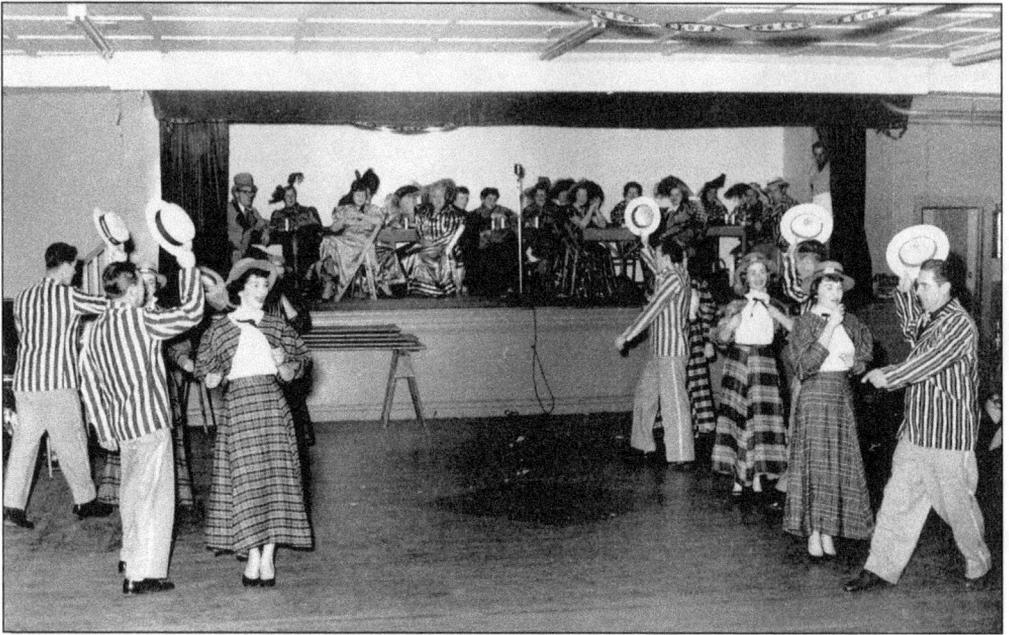

Performers do the "Cake Walk" as part of a show to benefit St. Virgilius Roman Catholic Church. This show was one of many choreographed by local dance studio proprietor June Hartel and was first performed at the Knights of Columbus Hall in Rockaway and then at St. Virgilius Parish Hall. The parish hall was located on the east side of Cross Bay Boulevard, set back from the boulevard between Eighteenth and Twentieth Roads. The hall has since been demolished. (Courtesy of Marilyn Kass Stewart and the Broad Channel Historical Society.)

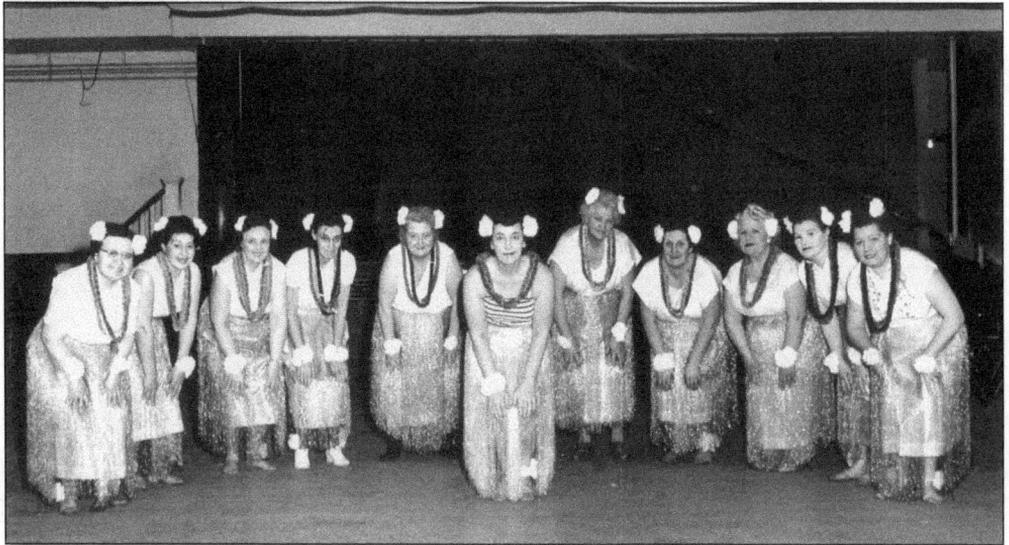

Costumes were often handmade, and shows were assembled with meticulous care, as in this 1950s production. Formerly a dance hall, the renovated building was open on December 8, 1945, and hosted many civic, social, recreational, and sporting events. It finally closed in the 1970s. The parish center previous to that, a remodeled O'Hagen's Hall, was nearly complete when fire broke out. The blaze destroyed the building and severely damaged Sun Toy's Chinese Restaurant next door. (Courtesy of Broad Channel Historical Society.)

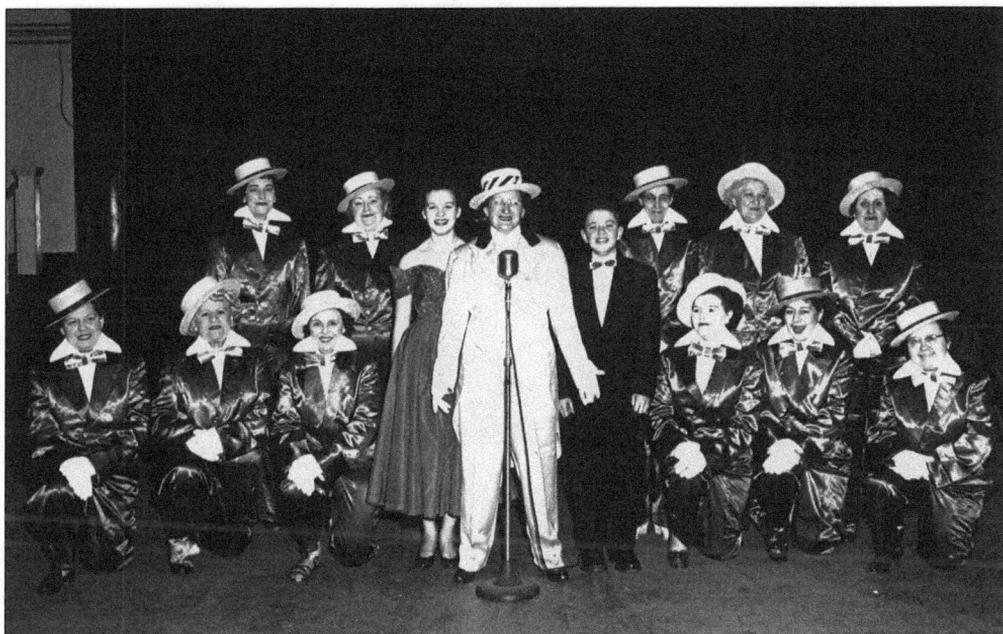

Except for the young man at right, this number features a sharply dressed, all female ensemble. Note the microphone. Amplification was first introduced when Gertrude and James McAleese began organizing St. Virgilius' shows. Their opener, "A Springtime Revue," reportedly shocked some old timers as it was the first dancing show presented there. (Courtesy of Broad Channel Historical Society.)

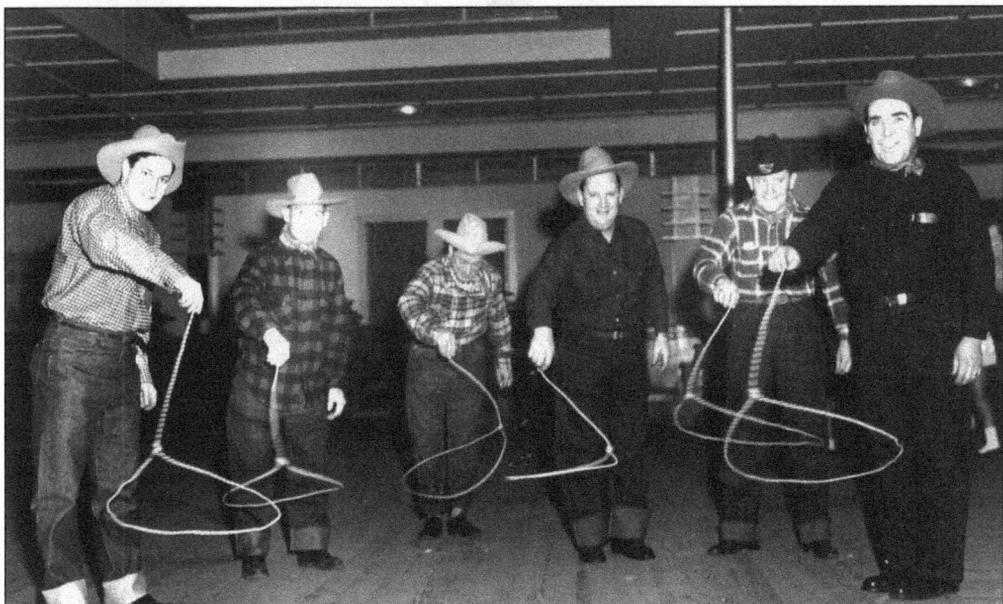

These 1950s "cowboys" demonstrate the fine art of lariat twirling for a show staged at St. Virgilius Parish Hall. Note the turned up jeans and black shoes. Even with their wagons in a circle they may have felt outnumbered. Out of the 24 performers in this number, there were 7 cowboys and 18 cowgirls. Some shows featured as many as 40 performers in their cast. (Courtesy of Broad Channel Historical Society.)

The Nut Club even sported its own cheerleaders, shown here with the distinctive intersecting "NC" on their sweaters. Most games were played at the ball field on First Road. The area is still used for ball games and community events today. The work of cleaning and keeping up the field was taken up by the Nut Club and another Broad Channel sporting organization, the Cardinals. Despite such difficult times as when most members were called to service in World War II, the Nut Club survived into the early 1950s. (Courtesy of Joan and Joe Fudjinski and the Broad Channel Historical Society.)

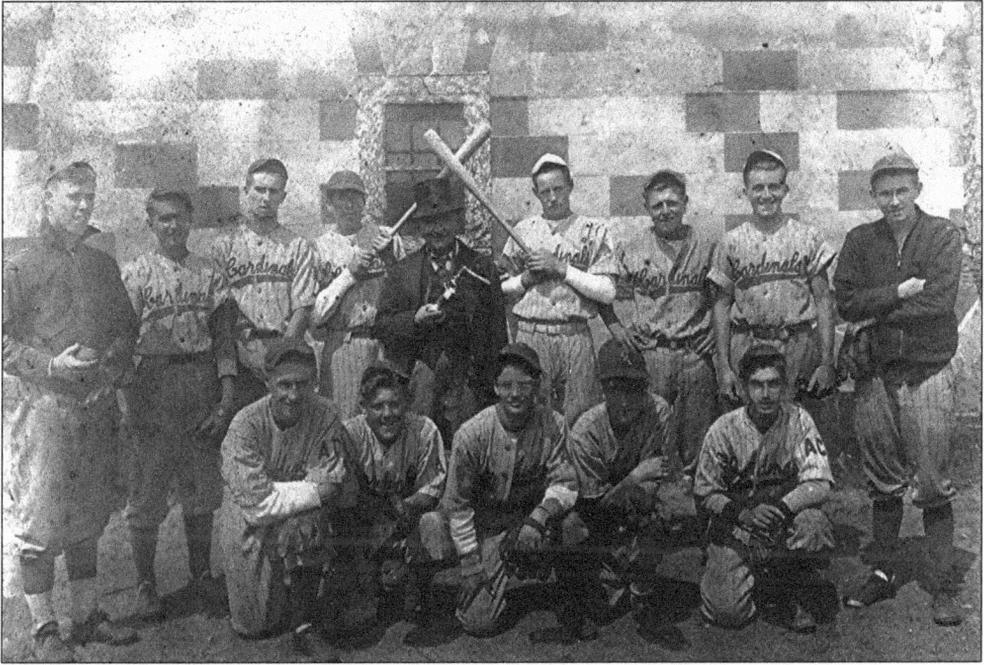

The Cardinals, originally organized for boys younger than those in the Nut Club, were active for several years starting in the 1930s. They played both baseball and football and ran a number of successful affairs to raise money for uniforms. In 1946, a reactivated Nut Club took in many of the younger boys of the Channel as members. The club finally dissolved at the onset of the Korean conflict. (Courtesy of Joe Carey and the Broad Channel Historical Society.)

During the Depression, with little else to do, some 20 boys met together in the basement of a local resident's home. On that date, January 3, 1933, they formed an athletic and social club and called it the Broad Channel Nut Club. Guided and coached by local candy store owner John Boyer, the club competed quite successfully in various Queens and Nassau County amateur football leagues. They are pictured here in 1933, in uniform and on the playing field. (Courtesy of Joe Carey and the Broad Channel Historical Society.)

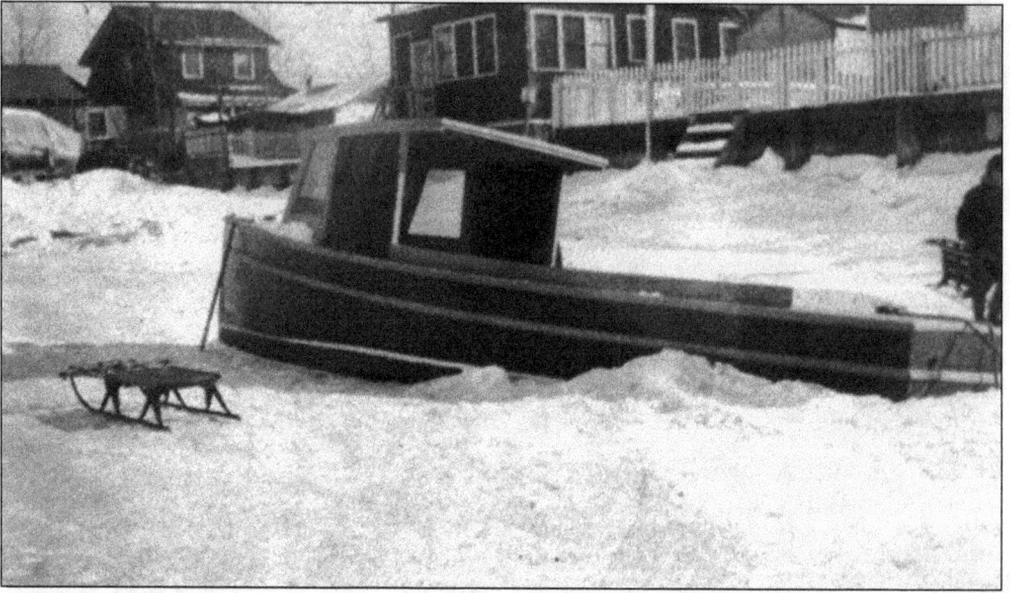

A boat named *Irene H* and a sled sit side by side in and on the ice in this photograph of the frozen Thirteenth Road canal from 1933. Other photographs show people walking along the frozen canal. In rear of this photograph is a bulk-headed property with a picket fence; the stairs led downward to the water. (Courtesy of Eva Hausman and the Broad Channel Historical Society.)

Feeding the hovering seagulls at the edge of the endless frozen white bay, where else could a youngster enjoy it all? An intrepid boat can be seen in the middle distance. Stretching from Brooklyn to the Rockaways Marine Parkway, Gil Hodges Memorial Bridge appears on the horizon at right. (Courtesy of Broad Channel Historical Society.)

The Wave Orioles take the field for the first time in the 2006 season, with a coach nearby. Both boys and girls join the Broad Channel Athletic Club (BCAC); children can be as young as age 3 and up to age 14, depending on the sport. The BCAC holds a Catholic Youth Organization (CYO) Olympic record set by Lillian Fosteris in the novice butterfly stroke in swimming. (Courtesy of John Blake.)

Girls wearing Rollerblades and carrying the BCAC banner march down Cross Bay Boulevard in 2007. The BCAC, in operation since 1961, has taught two generations of children from Broad Channel and other communities how to play various sports and exercise good sportsmanship. (Courtesy of John Blake.)

Broad Channel resident and firefighter Conrad Young and his wife, Mary, posed in front of a hand-drawn chemical wagon used by the volunteer fire department around 1915. To the right of it is a hose and ladder wagon. The black hard suction hose pulled water from the bay and pumped it through a hose to extinguish blazes. Volunteers were able to pull the equipment over rough and sandy ground. Horses were also used to pull this equipment, as the island had no wheeled, self-propelled vehicles until the first bridge to the Rockaway peninsula was built in the mid-1920s. The volunteers literally had to run to fire emergencies. (Courtesy of Jean Bohne and the Broad Channel Historical Society.)

Eight

THE VOLLIES
A CENTURY AT THE READY

The isolation of the Broad Channel community is never as sharply evident as when there is an emergency—a fire, a flood, or mishaps on the water or on the road. With typical self-reliant spirit, Channelites in these times have looked within themselves and to each other. There is no better example of this than the Broad Channel Volunteer Fire Department (BCVFD), one of the very few existing volunteer fire departments within all of New York City.

Started in 1905 as a bucket brigade, the Broad Channel Fire Association became a formal organization in 1907. The original firehouse, built the following year, is still standing and serving today like the company it houses, at the very same spot on Noel Road.

For over 100 years, the members of the BCVFD, or Vollies as they are called, men and women of the community, and volunteers from beyond the channel, have listened for the clanging bell or the pealing siren as they have gone about their everyday lives or been on duty at the firehouse. In that century and beyond, they have come running to answer that call time and again. Around 1913, they suffered their first and only death in the line of duty. Chief Chris Hoobs died of a heart attack while running to a fire. In 2001, responding to the September 11 attacks, they lost an ambulance with the World Trade Center's collapse, but thankfully, no additional lives.

The BCVFD has come a long way since the first firehouse walls went up, going from buckets to hand and horse-drawn engines and manual pumpers to the gleaming fire trucks of today. They have also established an ambulance corps and U.S. Marine unit capable of rapidly providing aid on Jamaica Bay or evacuating residents from homes on tide-flooded streets.

Day or night, the sound of the firehouse siren signals to everyone in Broad Channel that there is an emergency and also tells them the Vollies are there.

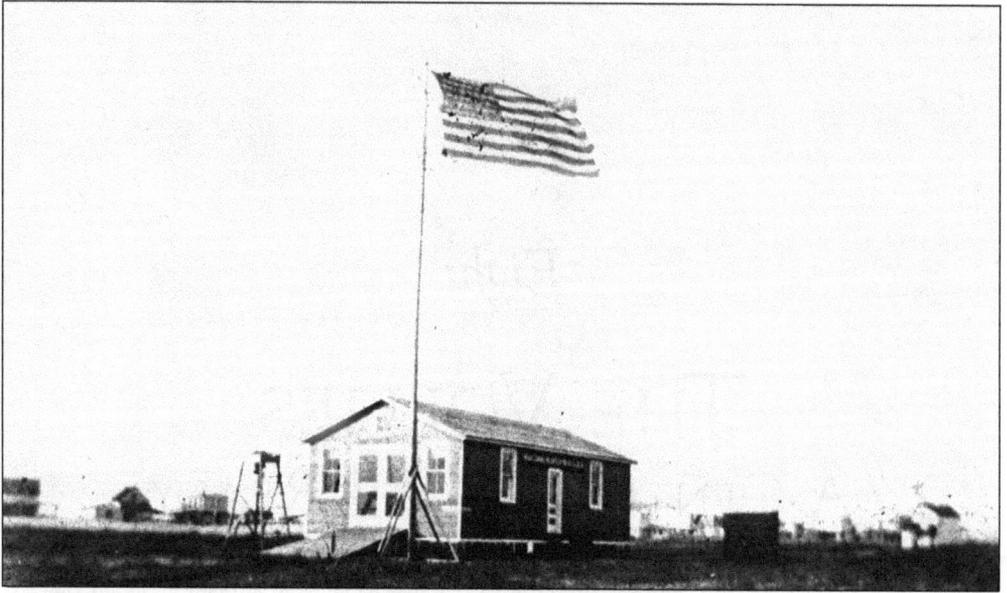

The firehouse seemingly sits in the middle of nowhere in 1908. Much later, rows of houses would be built behind it and also to the right across what would become Church Road. But Pierre Noel, for whom Noel Road is named, and the Broad Channel Company would not take over as land leasers until 1915, and the St. Virgilius Roman Catholic Church and Christ Presbyterian Church buildings would not be constructed until years later.

In summer of 1908, doors on the newly constructed firehouse are opened wide to reveal the silhouette of one of the pieces of firefighting equipment. The structure is built on wooden supports, which raise it off the ground. It features a large rear door opening and swinging "barn door" construction on the front, as well as wide ramp to roll large wheeled equipment easily to the ground. (Courtesy of the family of Gertrude McAleese and the Broad Channel Historical Society.)

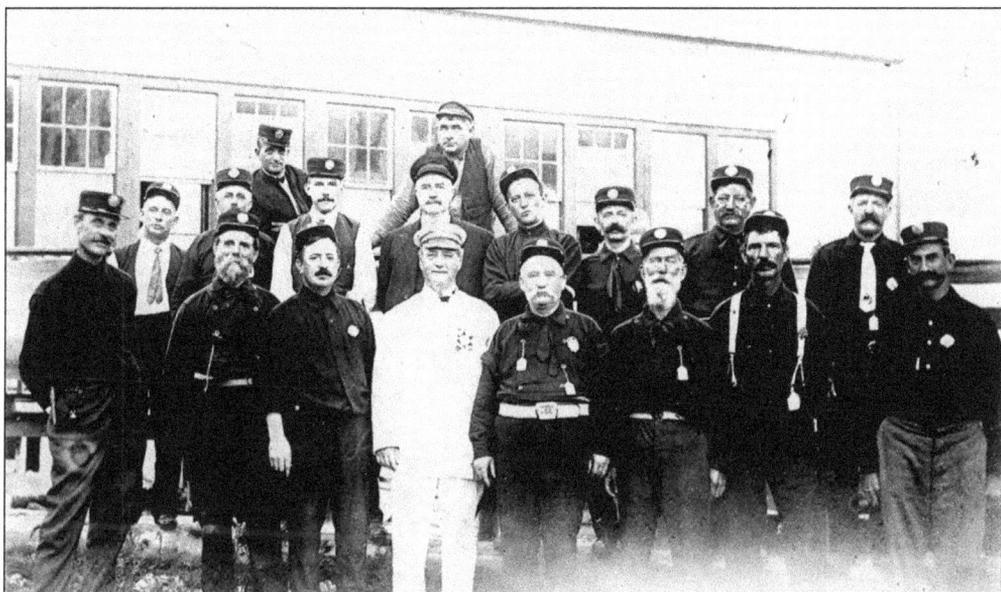

Here Broad Channel volunteer firemen pose together in 1910. With most structures on the island made of wood and susceptible to heavy damage from fire, the department began as a bucket brigade in 1905. Under Edward H. Schleuter the brigade was formally organized and became the Broad Channel Volunteer Fire Association in 1907. The owner of the Delevan House, he also became the fire company's first chief. (Courtesy of Broad Channel Historical Society.)

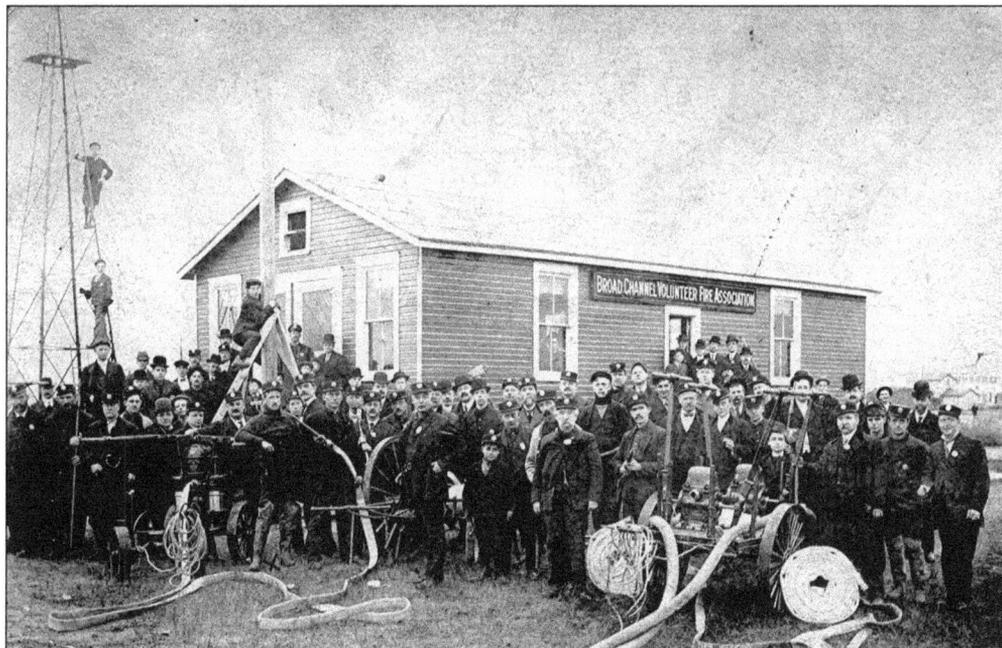

With their hand-pulled equipment next to them, the men of the Broad Channel Volunteer Fire Association posed in front of their building. Fires were swift moving among closely placed wooden structures; volunteers were essential to try and keep fires from having tragic outcomes. This photograph from the early 1900s shows unpaved Church and Noel Roads. (Courtesy of Albertina Reilly and the Broad Channel Historical Society.)

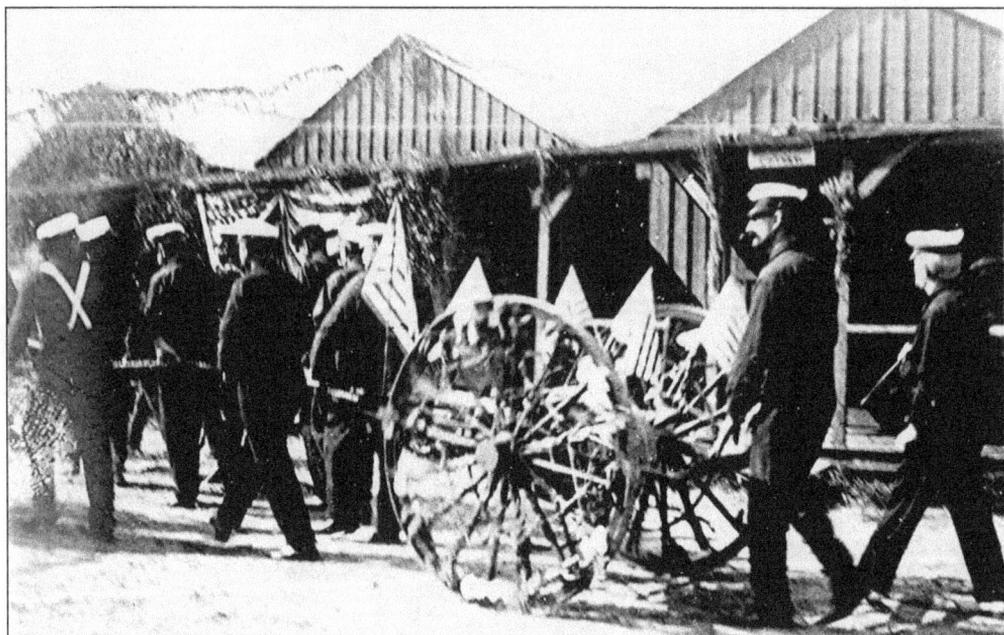

In the early days of the volunteer fire association, it was often easier to get hand-pulled equipment over dirt paths, sand and cinder roads, or rain-muddied tracks. Acquired in 1905, photographed here is the department's first hose wagon. Possibly homemade, it was kept at various volunteer's houses until the firehouse was built. Here uniformed volunteers march with it in the Mardi Gras parade celebrating the 1908 opening of the firehouse. (Courtesy of Broad Channel Volunteer Fire Department.)

Five officers of the BCVFD are pictured in the 1940s in front of the firehouse. Behind them appear to be the Engine Company No. 2 1938 American LaFrance pumper and the 1925 American LaFrance Engine Company No. 1. The peaked cupola above them was originally built to house the fire alarm bell. It was replaced by a roof siren. (Courtesy of Broad Channel Volunteer Fire Department.)

106

This 1925 American LaFrance vehicle was designated as Engine Company No. 1. The 250-gallon-per-minute pumper was acquired from the neighboring West Hamilton Beach Volunteer Fire Department, who in turn had gotten from the Valley Stream Volunteer Fire Department of Nassau County, New York. (Courtesy of Broad Channel Volunteer Fire Department.)

GEORGE WEBER BILL MAURO SONNY NEUER BILL KASS LOU WARNER JERRY BOURNE VINNY RYAN

Pictured here in the 1950s, current and former officers and color guard march up Noel Road at the head of a parade. They are marching towards Cross Bay Boulevard. The automobile to their right has been outfitted with an alarm bell, a siren, and a department emblem. (Courtesy of Broad Channel Volunteer Fire Department.)

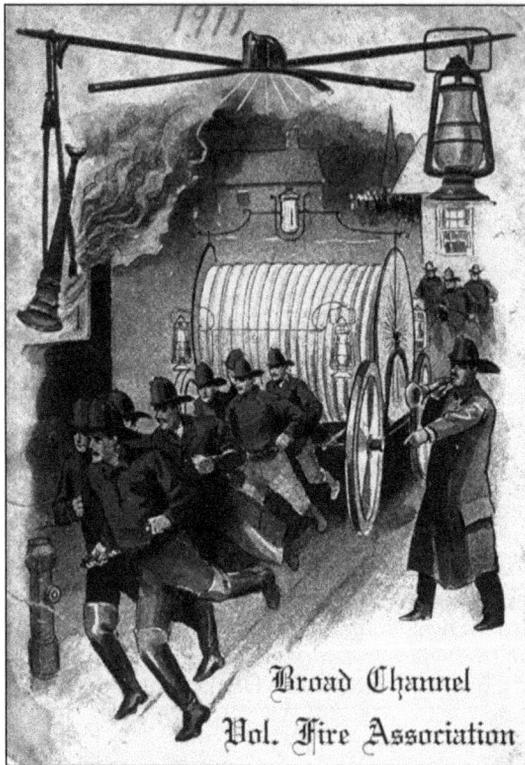

Broad Channel
Vol. Fire Association

Shown here is the cover and page four of the program, which lists "the Order of Dancing" for the second half of the evening. The title of the event was the "Summer Night's Reception of the Broad Channel Volunteer Fire Association." Shown below, to the left are the proscribed dances, on the right the music to be played by the band to accompany each. No doubt popular numbers of the day, the tunes included "Playland," "Sugar Moon," "King Dodo," "Funny Little World," the polka "Seeing Paris," and "Roses Bloom In Heaven." Among the dances were a two-step, barn dance, quadrille waltz, lanciers, caladonian, and a schottische. Signaling the end of the night's festivities, the dance card closes with a "Waltz Finale" and a reveler's destination "Home, Sweet Home." Page one notes, "Music by Prof. Wm. Loblenz." The gala was held at Hoob's Pavilion, named for owner and former chief Chris Hoobs, on Saturday, June 10, 1911. (Courtesy of Broad Channel Historical Society.)

...Order of Dancing...

PART SECOND

1.	GRAND MARCH	The Young Guard
2.	WALTZ	Without You
3.	TWO-STEP	Love Me with Big Blue Eyes
4.	LANCIERS	King Dodo
5.	WALTZ	Got to be Some One I Love
6.	TWO-STEP	Build a Fence Around You
7.	WALTZ	Gather the Myrtle with Mary
8.	QUADRILLE WALTZ	Burlington
9.	WALTZ	Playland
10.	TWO-STEP	Funny Little World
11.	SCHOTTISHE	Sugar Moon
12.	WALTZ FINALE	Clef Club

Home, Sweet Home

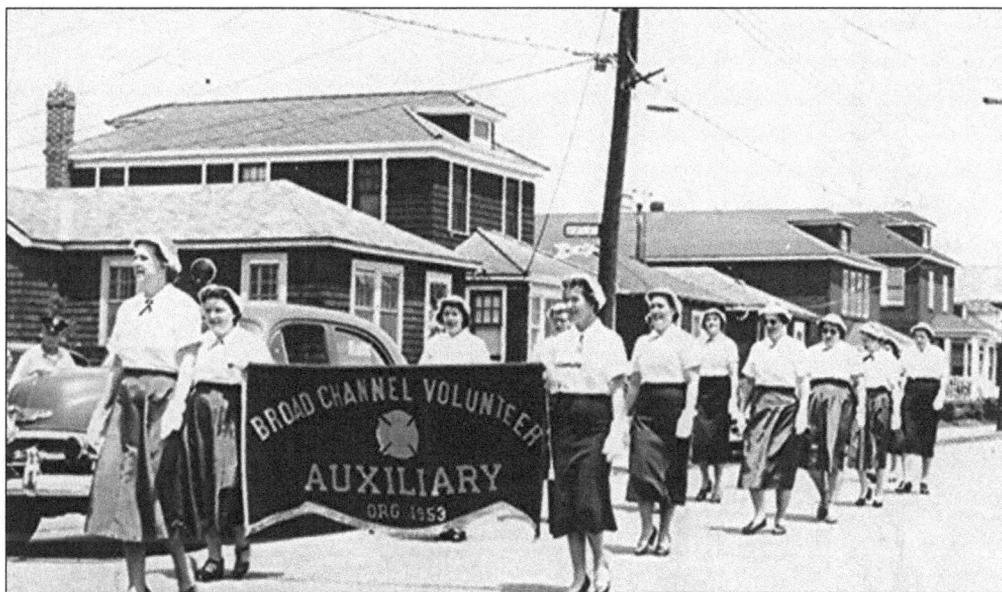

Going back at least as far as 1913 and probably to its beginnings, the BCVFD has been supported by the Ladies Auxiliary. Here the group marches in parade up Noel Road, past the firehouse in the mid- to late 1950s. The BCVFD Ladies Auxiliary was not officially recognized until April 30, 1953, hence the "ORG. [organized] 1953" on their banner. Today it is not uncommon for women to also serve as volunteer firefighters and emergency responders in the organization. (Courtesy of Broad Channel Volunteer Fire Department.)

Deputy Chief Robert H. Russell Sr. first organized the emergency medical response and ambulance corps in 1956. In the late 1960s, certified divers were added, and a rescue truck outfitted for water emergencies. The team was disbanded in the early 1970s due to insurance issues. However in 1994, Chief Dan McIntyre inaugurated the Vollies' Marine Company. The unit is equipped with a fully stocked, motorized, 16-foot inflatable boat that can be transported and launched from anywhere on the island. (Courtesy of Broad Channel Historical Society.)

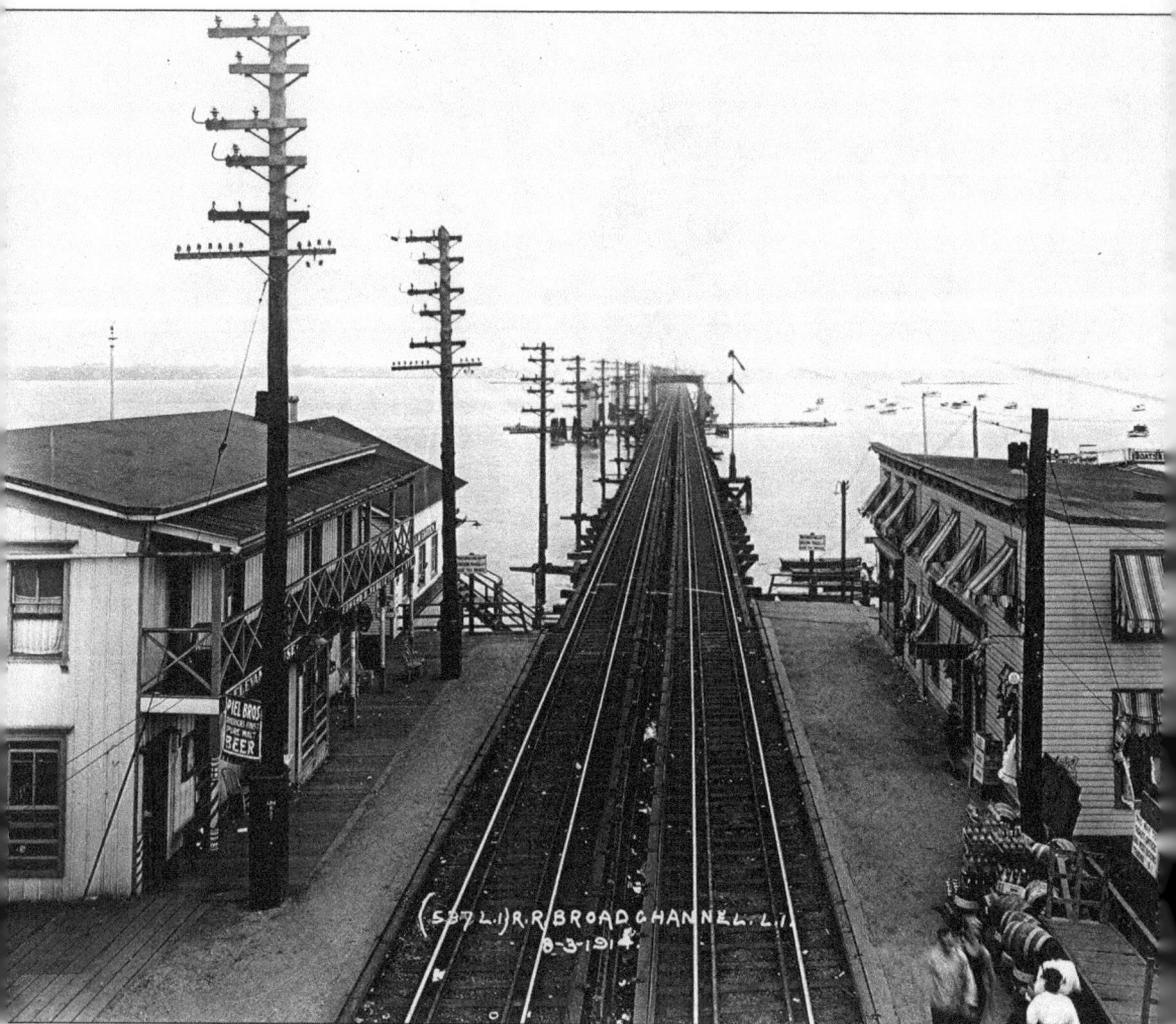

The southern end of Broad Channel station appears as it was in 1914. On the left side of the photograph (east side of platform) was the Delevan House. This photograph was taken from the elevated walkway passengers used to cross over from one side of the tracks to the other, which roughly lined up with Noel Road, looking down the tracks in the direction of the Rockaways and the Beach Channel trestle. At the end of the platform on the left, note the stairway leading down for crossing under tracks only at low tide. Later a cement enclosure was built to allow crossing at any tide, although it had to be cleared of water after a heavy rain. (Courtesy of Queens Borough Public Library, Long Island Division, Public Service Commission Photographs.)

Nine

COMING AND GOING
RAILROADS, TRAINS, AND
THE TRACK TO BROAD CHANNEL

Today the "A" train is the longest line in New York City's Metropolitan Transit Authority subway system, running as it does from the Bronx through Manhattan and out to Queens. The longest stretch of uninterrupted track is between Howard Beach and the Broad Channel station.

In the 1880s, the coming of the railroad, built by the New York, Woodhaven and Rockaway Beach Railroad, spurred the building of Broad Channel. Before that, the only means of getting on or off the island was by boat. It was not until the mid-1920s, 40 or so years after the railroad, when Cross Bay Boulevard was built and bridges were constructed that Broad Channel opened to overland travel of any kind.

Although the line was meant to ferry the masses back and forth to the popular resort playground of the Rockaways, adding a stop meant a lot to Broad Channel. For one thing, its construction meant large areas had to be dredged and filled, thus expanding the island. For another, it made Broad Channel into a vacation destination of its own.

Coal-burning steam locomotives, and later electric trains, brought summer residents as well as shorter term visitors. It brought hotels, restaurants, and attractions to cater to them. It brought businesses, services, and working people to fulfill their needs. It brought prosperity and more buildings and more businesses and more people. Finally, it brought those who wanted to stay, and turned Broad Channel from a summer stopover to a year-round community.

The Long Island Railroad (LIRR) first leased, then bought the line. A 1953 fire led them to relinquish it. Later reconstruction made it part of New York City's rapid transit system. Although it has changed hands more than once, the railroad runs deep through the history of Broad Channel. And even now in the early morning rumblings of the subway cars going out over the water, one can hear the echo of trains long since past.

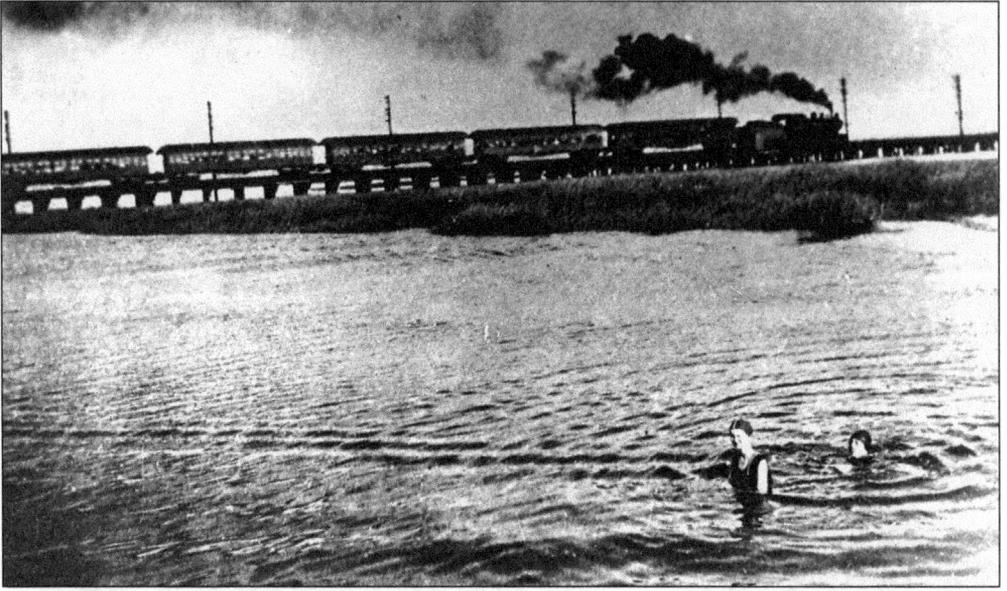

A coal-burning steam locomotive is pulling the LIRR train on an upgrade heading to the Rockaway peninsula in this 1914 photograph. Note the coal car behind the locomotive. Two women cool off nearby in the bay as the train passed. (Courtesy of Queens Borough Public Library, Long Island Division, Rugen Photographs.)

The elevated crossover at the Broad Channel station in this 1940s photograph shows the two flights of stairs residents had to climb (on both sides) to get from one side of the train tracks to the other side. On the left is the pair of white obelisks at the foot of Noel Road at Station Plaza (now West Road) that greeted visitors until the subway system took over transport by train in the 1950s. (Courtesy of the family of Gertrude McAleese and the Broad Channel Historical Society.)

The trestle on the LIRR was located south of Broad Channel and north of the Rockaway peninsula. In this 1914 photograph, the trestle was swung sideways to allow a boat to pass through it. At present, the current trestle is located at roughly the same place but hovers over the water at a greater height and swings in a semicircle to let boats pass. (Courtesy of Queens Borough Public Library, Long Island Division, Rugen Photographs.)

This photograph shows Broad Channel as seen from the height of the train track crossover. Station Plaza (now West Road) is at foot of stairs and the beginning of Eighth Road (on the left side of photograph) can be seen. Even though there are empty lots and Station Plaza is wide, the community shows itself to contain many houses. (Courtesy of Broad Channel Historical Society.)

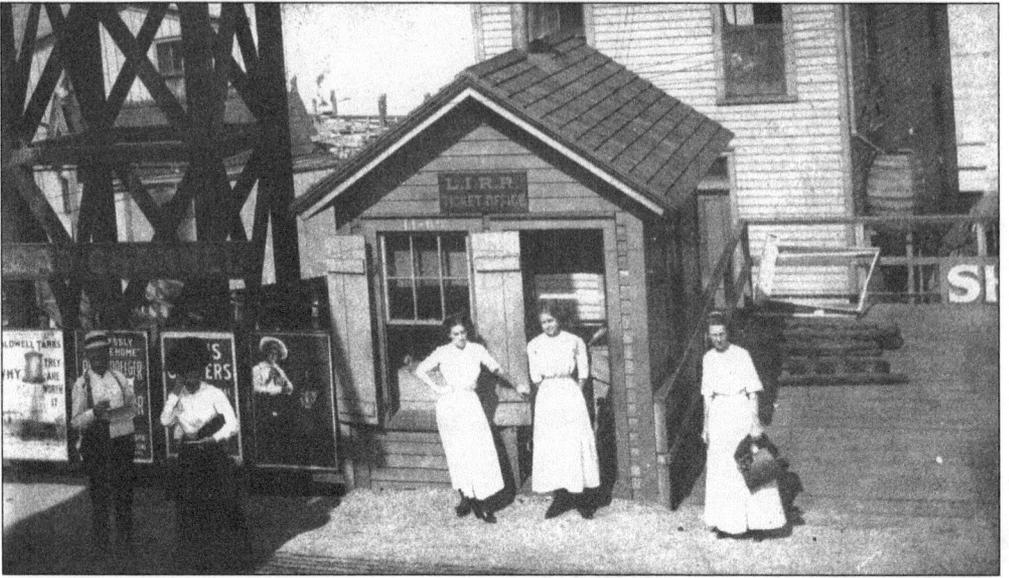

Women waited for the trains at the Broad Channel train station of the LIRR in the early 1900s. Note the advertising posters on platform at left of photograph. (Courtesy of Jean Bohne Ryan and the Broad Channel Historical Society.)

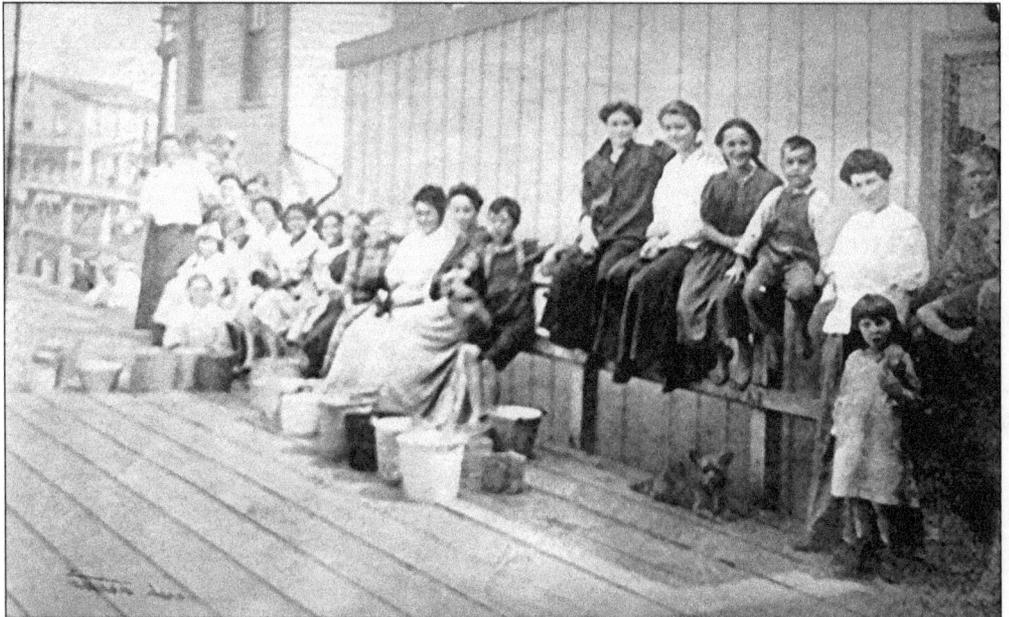

This photograph from 1908 shows a group of people—mostly women with containers of different sizes, shapes, and colors sitting on the platform near them and children—waiting for the train to come in so they could fill their containers with water. In times of drought, the trainmen would provide water to the community. (Courtesy of Jean Bohne and the Broad Channel Historical Society.)

114

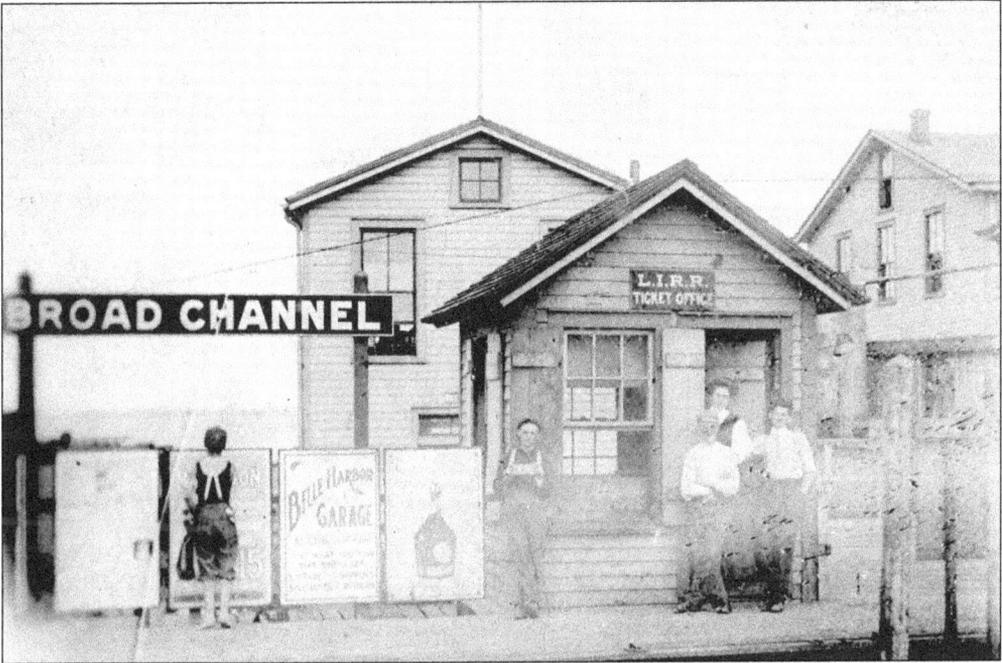

This was the Broad Channel station of the LIRR. The small building in this 1919 photograph is the office where tickets could be bought. They were punched on the train by the conductor after it left the station. (Courtesy of Jean Bohne Ryan and the Broad Channel Historical Society.)

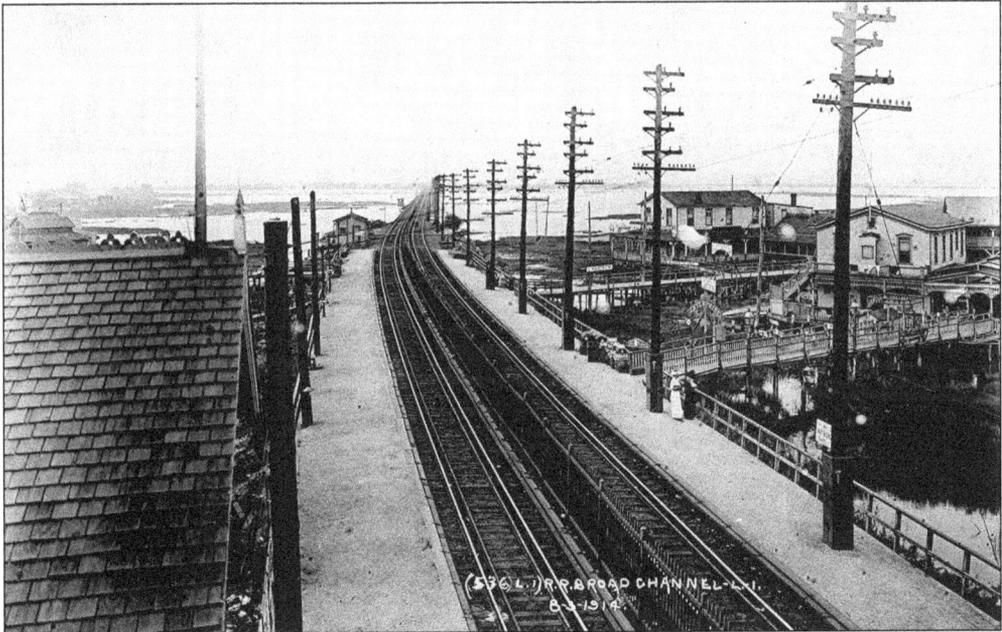

The north end of the Broad Channel station of the LIRR is shown in 1914. North of the station was a break in the third rail to allow passage to the east side of the tracks. On the right were the Atlantic Hotel and the Broad Channel Yacht Club. There were some bungalows situated on the boardwalk, but most of the private dwellings were located west of the tracks. (Courtesy of Queens Borough Public Library, Long Island Division, Public Service Commission Photographs.)

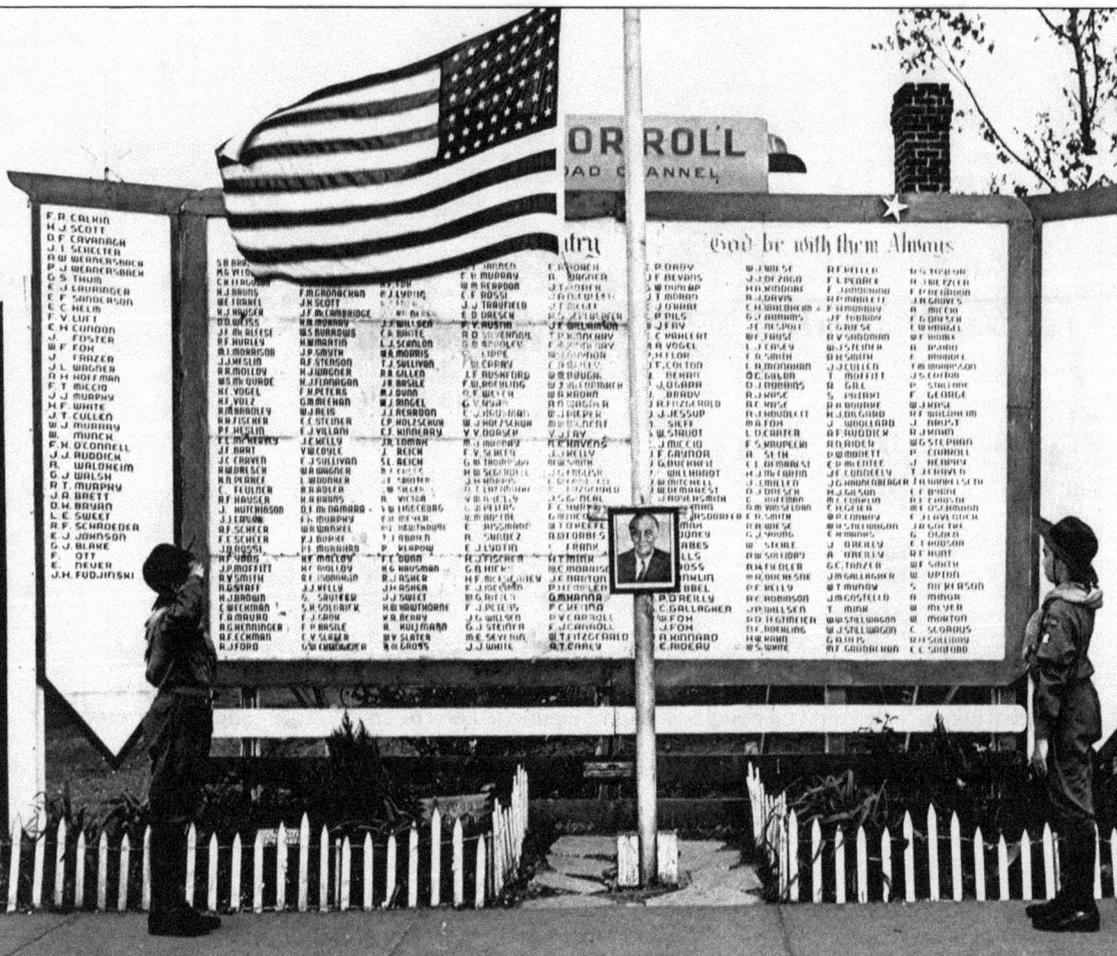

The Broad Channel Honor Roll, listing the names of those who served their country in the armed forces, was displayed on Cross Bay Boulevard at Noel Road during World War II. It was used as both the starting and ending points for an impromptu parade that honored the late Franklin Delano Roosevelt shortly after his death in 1945. Note the black-bordered photograph of Roosevelt on the flagpole. The American flag in front of the display is at half-mast. The honor roll is flanked by the Bruckner twins, who represented the Boy Scouts at the time; both are saluting. To support the war effort and the troops, the scouting groups collected tin cans and used newspapers. (Courtesy of the family of Gertrude McAleese and the Broad Channel Historical Society.)

Ten

GIVING BACK
YOUNG AND OLD
IN SERVICE TO THE COMMUNITY

Broad Channel historian Gertrude McAleese once wrote,

> Broad Channel is somewhat like a principality, a closely knit group of inter-related people. Since people began living on the stretch of marshland and sand dunes which came to be known as Broad Channel . . . it has had its share of griefs and joys and civic wars. But the people have always been close to one another, sharing when in trouble, and acting as one when their homes were threatened.

Amid the history she helped record, and in the reminiscences of those who have since added to that story, there are many examples. The Broad Channel Volunteer Fire Association, now over 100 years old, began as neighbors passing buckets of water to neighbors to extinguish fires and protect their homes and businesses.

Some recall that during the Depression it was the Ladies Welfare Association that raised funds and helped families in need with food, money, new clothes, and warm coats. They paid power bills before services were cut off.

Others remember the tremendous aid the Broad Channel chapter of the Red Cross rendered during the 1938 hurricane. Still others speak proudly of brothers, uncles, sons, and fathers from Broad Channel who served all over the world in times of war. Many themselves answered "the call of the colors," as Gertrude McAleese aptly phrases it. She herself edited the *Broad Channel Banner* newspaper, which brought news of Broad Channel and a connection to home to many during World War II. Others served as air raid wardens and first aid responders.

Today there is the Broad Channel Athletic Club coaching children of all ages and the Civic Association working hard to improve the community and yes, still fighting city hall when needed. There is the Golden Age Club making quilts for terminally ill babies to comfort them in life and wrap them in death; one woman made 20 quilts. There are the VFW and the American Legion raising money for good causes, and the American Littoral Society working to protect Jamaica Bay. They embody, today, the idea of service to others.

One Broad Channel resident recalled the recent image of a young woman pelting barefoot across Noel Road in the rain in answer to the firehouse alarm's shrill call. It may be over 100 years later, but neighbors still come running in time of need.

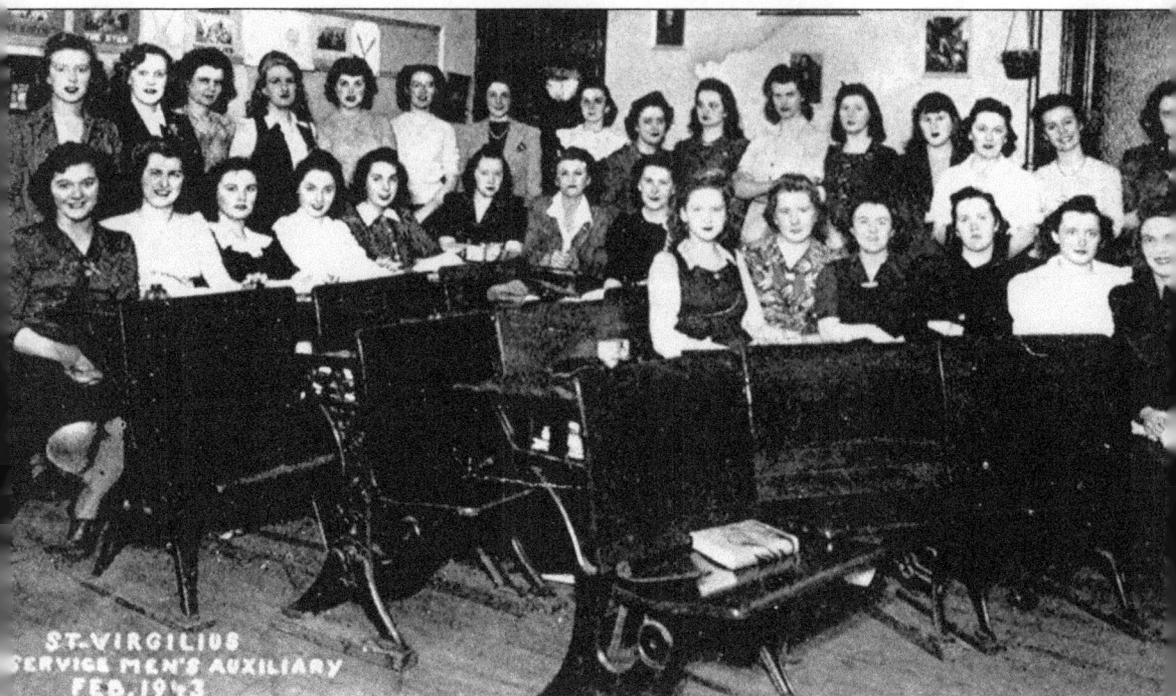

Fr. George Helfenstein organized these young women to write letters to the community's servicemen. Father Helfenstein and others wrote letters, which this group copied over and over by hand to make it more personal, and added their own remarks. Through this letter-writing campaign, each serviceman received a letter a month. (Courtesy of Edna Wiese and the Broad Channel Historical Society.)

Larry Sweet, in his U.S. Navy uniform, and his parents pose in front of their home on Eleventh Road in 1945. The home was bought by Sweet's grandfather Garrett Whelan in 1910 from a fisherman. The bungalow no longer looks as it did, but it is still owned by descendants of Whelan. Homes in the community were often passed down through families, as banks would not give mortgages since residents did not own the land under their homes. (Courtesy of the Sweet family.)

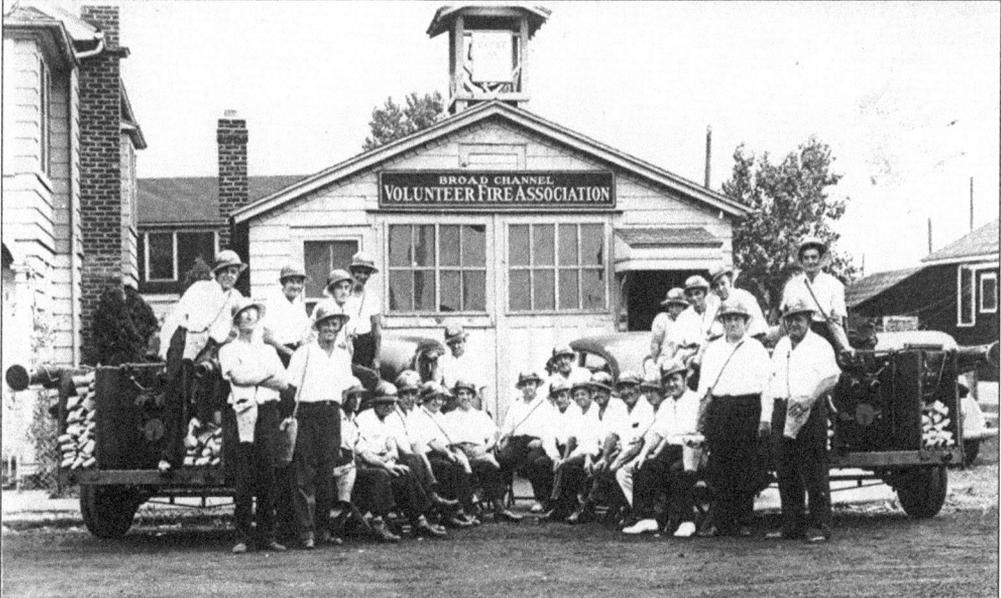

During World War II, air raid wardens assembled in front of the Broad Channel Volunteer Fire Association building. About 150 residents registered to perform this volunteer service; they were frequently commended by city officials as being the most outstanding in New York State. They conducted mock air raid drills, took lessons, gave demonstrations, and were on call 24 hours a day. (Courtesy of Frank Peters and the Broad Channel Historical Society.)

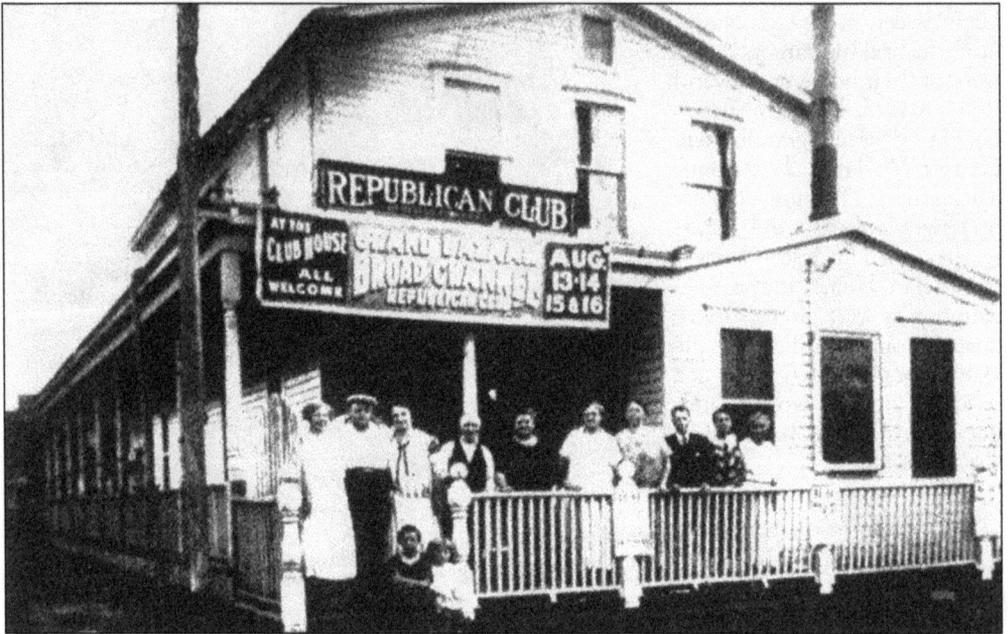

The Broad Channel Republican Club started out about 1922 with a group of women, and a men's Republican club was organized shortly thereafter. Around 1929, the group founded their own clubhouse by purchasing the Lafayette Fishing Club on Ninth Road. To pay off the bonds used for the purchase, a portion of the clubhouse was rented out to a bar. On February 11, 1934, the structure caught fire, possibly due to an overheated, untended stove. Fire hydrants were frozen and by the time water could be brought to bear on the building, it was gone. (Courtesy of Broad Channel Historical Society.)

Before 1925, the men's and women's regular Democratic clubs met in rooms above the Broad Channel Corporation's offices. As membership grew, the groups joined forces and adopted a plan to build a clubhouse of their own. Shares were sold to members, which covered all building costs. At its opening on June 13, 1925, Broad Channel became the only community in Queens County to own its own Democratic clubhouse. It was a distinction that they held for many years. (Courtesy of Broad Channel Historical Society.)

The Broad Channel Auxiliary of the Queens Chapter of the American Red Cross held its first meeting in January 1935. During World War II, many other residents also joined in to produce socks, sweaters, and other needed items. Prepared for any emergency, the auxiliary also recruited blood donors and raised record amounts for the war fund drive. Many members also joined the Air Wardens Emergency Aid Corps. (Courtesy of Broad Channel Historical Society.)

The installation of men and women officers of the Broad Channel Democratic Club is seen here in 1938. Early in its history, Broad Channel had no polling places. A community committee was formed to get all residents out to vote. When they went to Ramblersville en masse, it was found that Broad Channel had registered more voters than Ramblersville, Aqueduct, and Howard Beach combined. In a first test of group strength, the island won its polling place. The first vote took place in 1922 at the firehouse. (Courtesy of Broad Channel Historical Society.)

Civic worker, editor, writer, and local historian comprise a description of Gertrude McAleese. She wrote and edited the *Broad Channel Banner* during World War II; it kept the servicemen from the island community up on matters of importance to them from their hometown. McAleese was honored on several radio programs for the work she did with the *Broad Channel Banner*. She also wrote for the *Broad Channel Record*, a newspaper owned by Eugene Powers. She wrote community news for 17 years for the *Wave*. The writings of this wife and mother of two sons have become an authoritative voice in recording the history of Broad Channel. She wrote page after page of history on a portable typewriter with amazing recall, including names, dates, and details. Without her, much of Broad Channel's history would have been lost. (Courtesy of the family of Gertrude McAleese and Broad Channel Historical Society.)

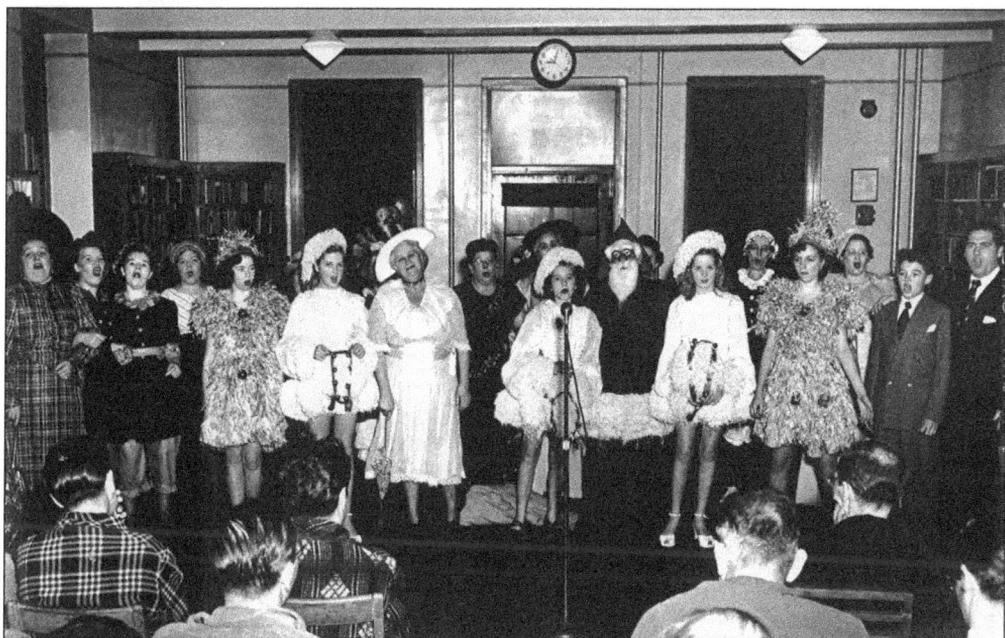

Broad Channel had no shortage of performers for its many productions. Willing to take the show on the road, residents perform at a nursing home on the Rockaway peninsula. Two women are dressed as Christmas trees, while Santa Claus has a distinctly slender appearance. Note the dark hair on many of the nursing home residents. (Courtesy of Broad Channel Historical Society.)

The Ladies Auxiliary of the BCVFD is pictured here at a dinner in the 1950s. The event, Volunteer Fireman's Association of the City of New York Dance, was held at the Parish Hall. Although not officially recognized until 1953, since the beginning, the auxiliary has supported and been an important part of the community and the Vollies. (Courtesy of Broad Channel Volunteer Fire Department.)

The desirability of and need for positive extracurricular activities has been passed from one generation of Broad Channel residents to each succeeding generation. The idea of giving back to the community has always been a time-honored way of giving young people a sense of the needs of others in the community. This quality is firmly entrenched in the community's young people who are pictured in this photograph of the Broad Channel Girl Scouts in 1962. (Courtesy of Edith Kinnaird and the Broad Channel Historical Society.)

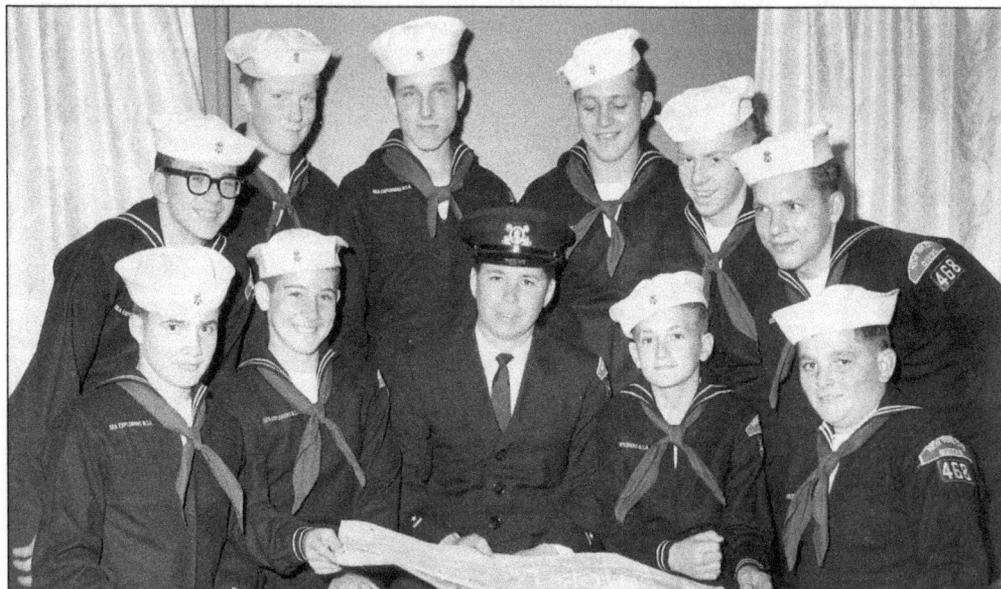

In this 1964 photograph by Ed Clarity, the Broad Channel Sea Scouts are seen in their uniform, grouped around scoutmaster Dan Mundy. Troop 468 was granted its charter by the Boy Scouts of America and sponsored by St. Virgilius Church. It, too, promoted the Scouts' principles of trustworthiness, self-reliance, good citizenship, and service. Carrying these ideals forward, Dan Mundy went on to become a strong voice in community affairs, a coordinator and leader of community projects, spokesperson, and president of the Civic Association. Today, among many other activities, he is involved in actively protecting and preserving Jamaica Bay. (Courtesy of the family of Ed Clarity.)

124

At one time, Broad Channel residents were not permitted to own the land under their homes. After residents waged a long battle with New York City, this changed. In this 1973 photograph, then–New York State governor Nelson Rockefeller (seated, center) signs the Broad Channel Bill into law, which will allow residents and New York City to negotiate to buy the land under their homes. Another 19 years will pass before the first deed is transferred to a Broad Channel resident. Witnessing Rockefeller's signature are Broad Channel leaders who carried on the struggle to buy the land. They are, from left to right, Fr. Kieran Martin, Henry Wachaitis, Charles Fay, Robert Russell, and John F. McCambridge. Others pictured are Mel Klein and Terrance Flynn, a local lawyer. (Courtesy of St. Virgilius Rectory and the Broad Channel Historical Society.)

The American Legion has been integral to the community for decades. For a time, they even organized and ran Mardi Gras. Legion Post 1404 not only offers a welcome to those who have served, but also sponsors senior citizen's days and children's Christmas, raises funds for worthy causes at home and across the nation, and frequently hosts and supports other veteran's groups. The legion hall has been the center for many civic and social community events. (Courtesy of Carol Corbett and the American Legion.)

The Prince-Wynn VFW Post 260 was established in Broad Channel on June 15, 1976, having originally been in Brooklyn. The group honors and supports all veterans and is also very active in the community, sponsoring blood drives, food distribution, health testing, and fund-raisers among many other activities. The VFW is quartered in the former Democratic club building. Its distinctive exterior and many interior features seen in 1920s-era photographs remain in evidence today. (Courtesy of the Veterans of Foreign Wars Prince-Wynn Post.)

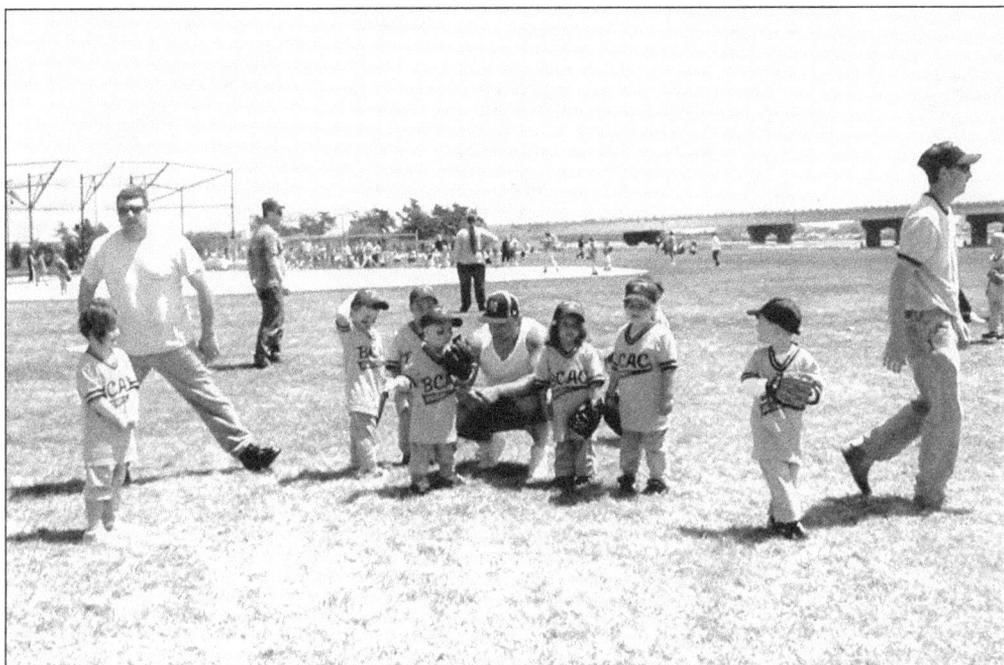

Seen here is the BCAC. Assisted by the coaches, young players prepare for their first game of the 2006 season. For 46 years, coaches have promoted teamwork, sportsmanship, and the value of practice in addition to teaching children how to play baseball, basketball, football, and soccer. Cheerleading and swimming are also taught by the BCAC. (Courtesy of John Blake.)

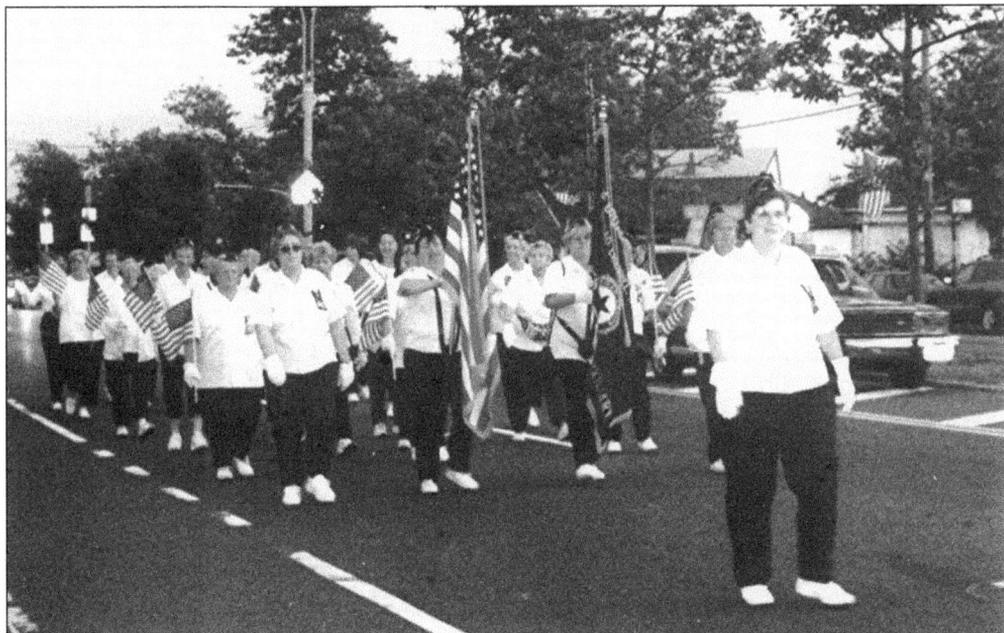

The Ladies Auxiliary members "serve side by side with the members of the Legion in a spirit of unselfish devotion to the well being of the American republic." Here they are seen recently, marching possibly during Mardi Gras or on Memorial Day. The Ladies Auxiliary is a vital and tireless part of the organization. (Courtesy of Carol Corbett and the American Legion.)

Visit us at
arcadiapublishing.com